AILEY SPIRIT

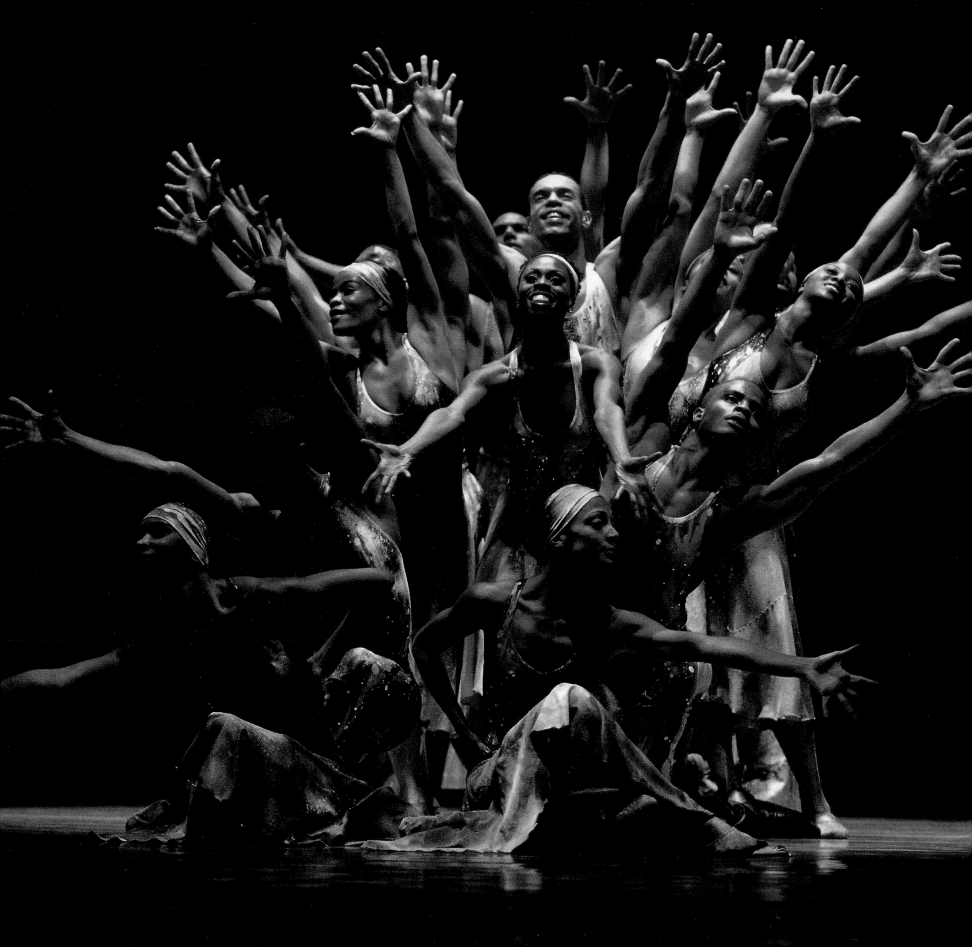

AILEY
SPIRIT

The Journey of an American Dance Company

ALVIN AILEY AMERICAN DANCE THEATER

Foreword by Wynton Marsalis
Text by Robert Tracy

STEWART, TABORI & CHANG ✕ NEW YORK

PUBLISHED IN 2004 BY STEWART, TABORI & CHANG
115 West 18th Street, New York, NY 10011

Canadian Distribution:
Canadian Manda Group, One Atlantic Avenue, Suite 105
Toronto, Ontario M6K 3E7 Canada

Library of Congress Cataloging-in-Publication Data
Tracy, Robert.
 Ailey spirit : the journey of an American dance company / byAlvin Ailey American Dance Theater ; foreword by Wynton Marsalis ; text by Robert Tracy.
 p. cm.
ISBN 1-58479-364-3 (hardcover)
1. Alvin Ailey American Dance Theater. 2. Modern dance
—United States—History. 3. Dancers—United States—Interviews.
I. Alvin Ailey American Dance Theater. II. Title.
GV1786.A42T73 2004
792.8'0973—dc22 2004005580

Designed by Galen Smith and Amanda Wilson
Photo Editor: Anne Kerman
See page 166 for photographers' copyrights and credits.

The text of this book was composed in Interstate.
Printed in China

10 9 8 7 6 5 4 3 2 1
First Printing

Stewart, Tabori & Chang is a subsidiary of

LA MARTINIÈRE
GROUPE

PAGE 2: Ailey Celebrates Ellington: *Night Creature;* the company in 1999.

Photographer: Jack Vartoogian

OPPOSITE: Gary DeLoatch in Ailey's 1961 solo, *Hermit Songs* with music by Samuel Barber, sung by soprano Leontyne Price. These poems of anonymous monks and scholars of the 8th–13th centuries speak of a simple life close to nature, to animals, and to God.

Photographer: Beatriz Schiller

PAGE 6: Billy Wilson's *The Winter in Lisbon;* the company in 1992.

Photographer: Johan Elbers

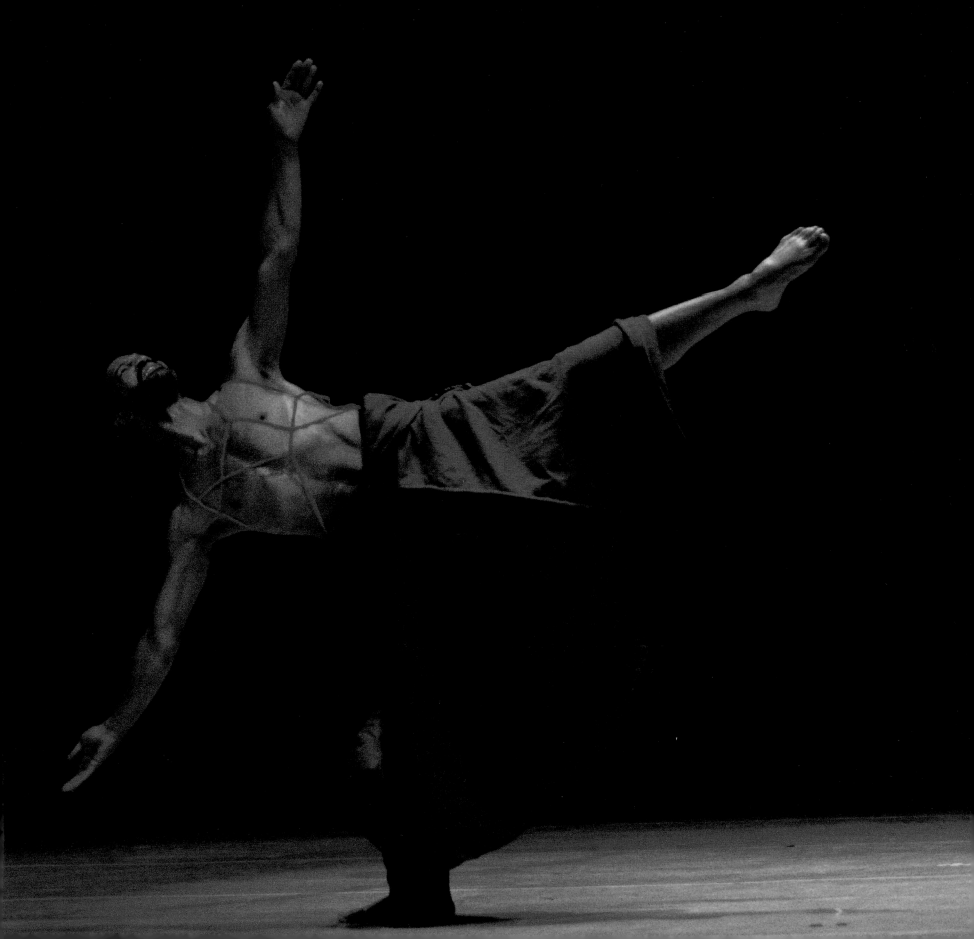

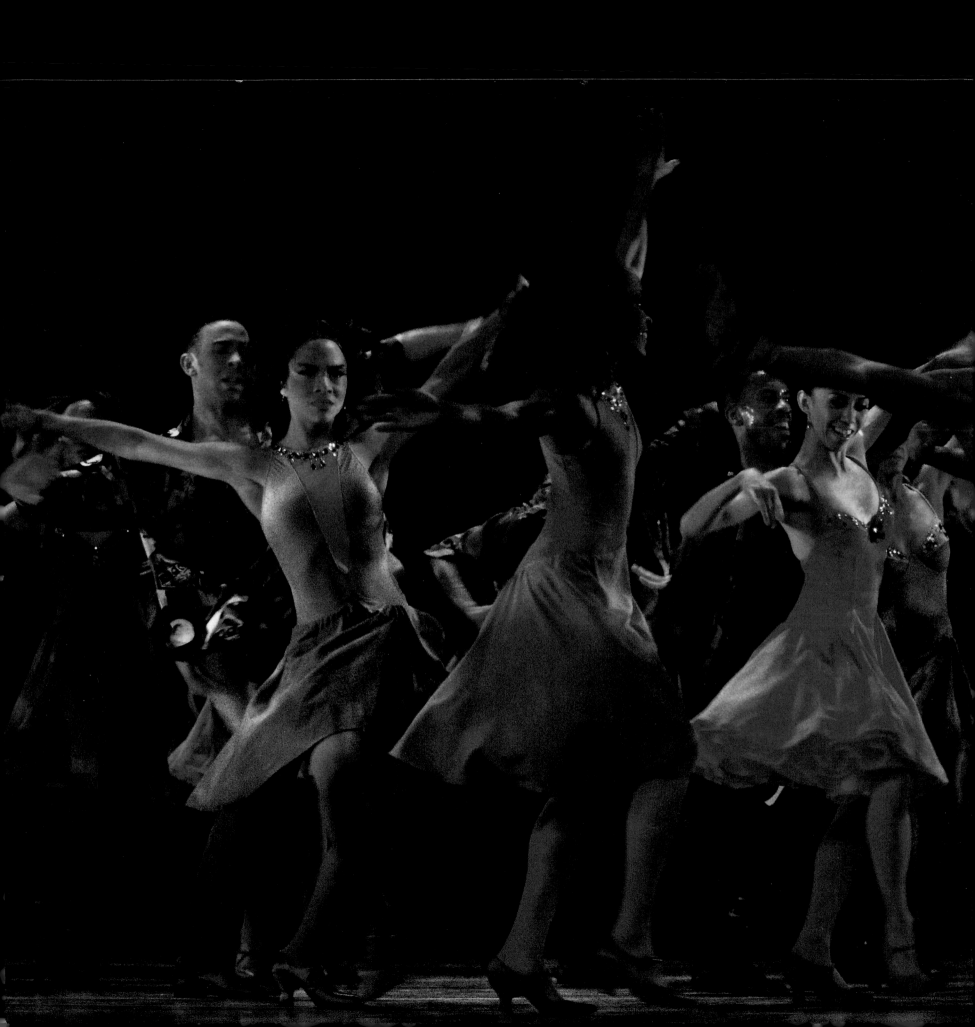

Contents

9 Foreword

12 Early Days
 Revelations

38 Creating a Company
 Muses

62 Developing a Repertory
 Ulysses Dove

90 Rehearsal and Development
 A New Work

110 The Next Generation
 Ronald K. Brown

134 Transitions
 In Memoriam

156 Repertory and Timeline

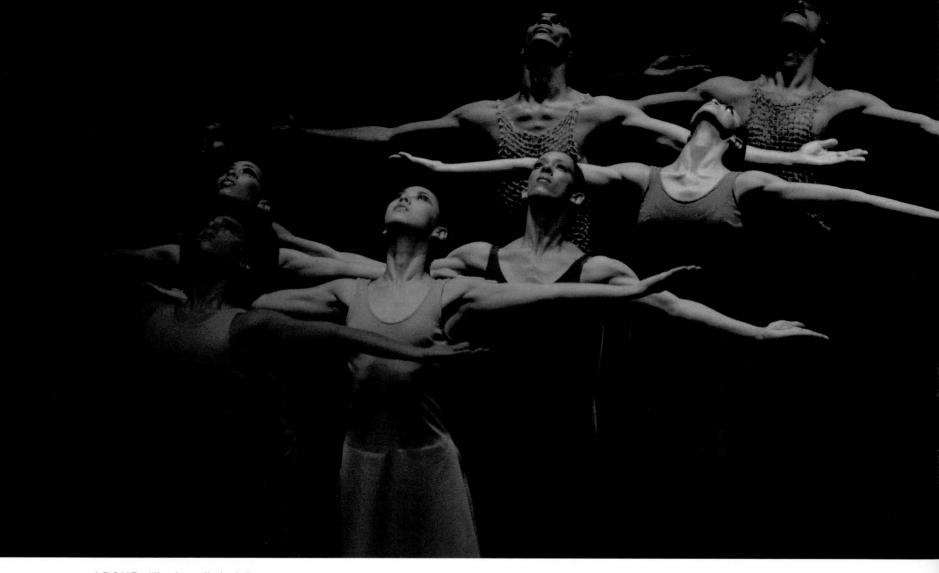

ABOVE: "I've been 'buked, I've
been scorned," *Revelations;*
the company in 1981.

Photographer: Johan Elbers

Foreword

I envision people a long time ago telling stories around a campfire, all of a sudden someone breaks out into a physical reenactment of a hunt or something. The next thing you know, there's a whole group reenacting some important communal activity. Then here come some musicians.

Even though we musicians hate to admit it, people danced before there was music. Through storytelling we used dance to express what had happened, what should happen, or what should have happened. From the beginning, dance could teach, it could heal; it could be prayer, enticement, negotiation, or celebration. It could be barbaric, elegant, and above all, sensuous: a living testament to the vitality of a given people. Dance has always been a means—one of the fundamental means we human beings use—to master our experiences. If nothing else, the experience of living is unpredictable, and art is the way we cope with the craziness of it all.

Artists have the opportunity to speak for the soul of a nation. They are part shaman, intellectual, and romantic, creating works that acknowledge and fulfill our emotional, spiritual, and technical needs. They testify to their cultures' grandeur, or lack thereof, and ultimately, if their vision is rich enough, their art speaks across epochs to the overall glory of human life.

In the twentieth century there was a flowering of Afro-American culture in all the arts. Despite an imposed social marginalization, they, like all Americans, reveled in the culture of democracy. They heard the American message: If you possess the ingenuity, great and new things can and do come from anyone. You can make something glorious happen with grit, "it," and mother wit. A legion of Afro-American artists showed us a new way of making art. Grounded in folkways, in church rituals and in the fantastic, utilizing syncopation, improvisation, and collective expression—brothers and sisters, they were talking about the Blues. The Blues is America's gift to the world of the arts—tragic and comic, earthy and ethereal, bawdy and sensual, bittersweet— it is an art for all possible circumstances.

Three men, in three different arts, emerged and have remained: in music there was Duke Ellington; in the fine arts, Romare Bearden; and in dance, Alvin Ailey.

Ailey reinvented American dance. He believed that the Afro-American sensibility was national, not for "Negroes only." He applied his special style of dancing to all sorts of music and settings, drawing on many forms and music traditions—spirituals, Afro-Latin music, European classical, jazz, pop, and avant-garde—to adopt

Artists have the opportunity to speak for the soul of a nation. They are part shaman, intellectual and romantic... and ultimately, if their vision is rich enough, their art speaks across epochs to the overall glory of human life.

one of Ellington's favorite phrases, his art was "beyond category." Recognizing the democratic power of individualism, Ailey respected diversity in the appearance and movement of each dancer. He believed in a "die for the moment" intensity and inspired his dancers to reflect this same attitude.

Today, Ailey's passion and the principles of diversity, intensity, and individuality continue to inspirit the Alvin Ailey American Dance Theater. This is very much a family affair, with many nuances, subtleties, and unwritten rituals. That's why it was so crucial to the continuation of the Ailey tradition that one of Alvin's greatest dancers, Judith Jamison, was appointed artistic director in 1989. She carries the torch of innovation into the twenty-first century.

In addition to his choreographic genius, Alvin was a great spirit. He taught and encouraged other dancers. He created a home for the works of other choreographers. He saw and realized things in other artists that they were not even aware of themselves. The company's legacy, ever expanding, flourishing, and evolving under Judith's vision, comes straight from a version of American art that celebrates the greatest experiment in human possibility ever to grace the planet—American democracy. Alvin loved it, and he told the truth about it, too.

WYNTON MARSALIS

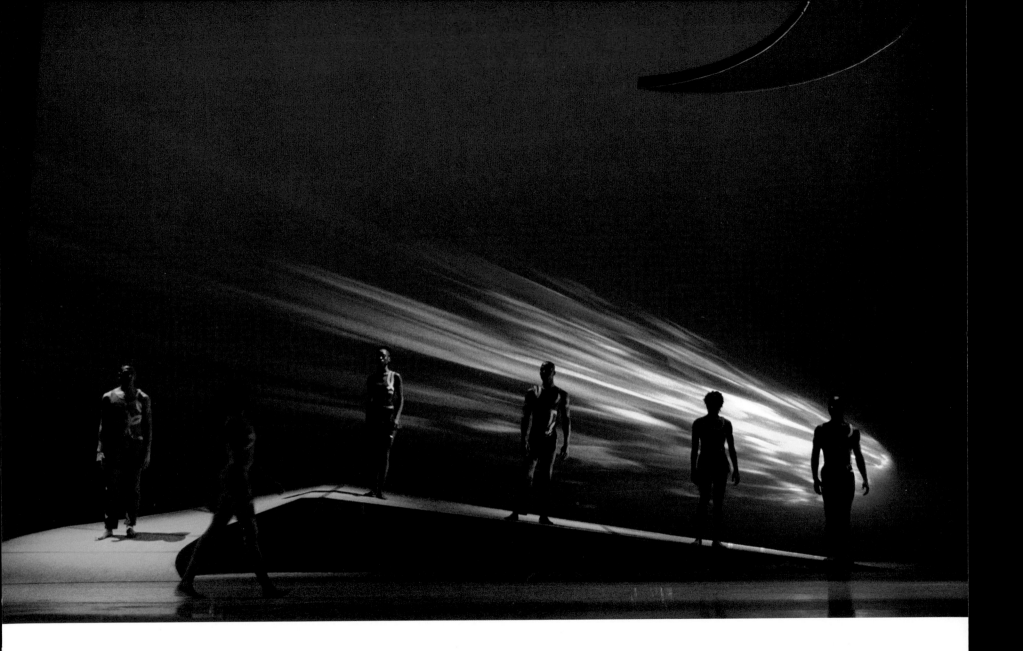

There is no way we can thank Alvin enough. The best we can do is continue what he started and broaden it. Because I agreed with Alvin so much and devoted so much of my life to working with him, the least I can do is make sure that the light he started in me shines as brightly in this generation of dancers.

Judith Jamison

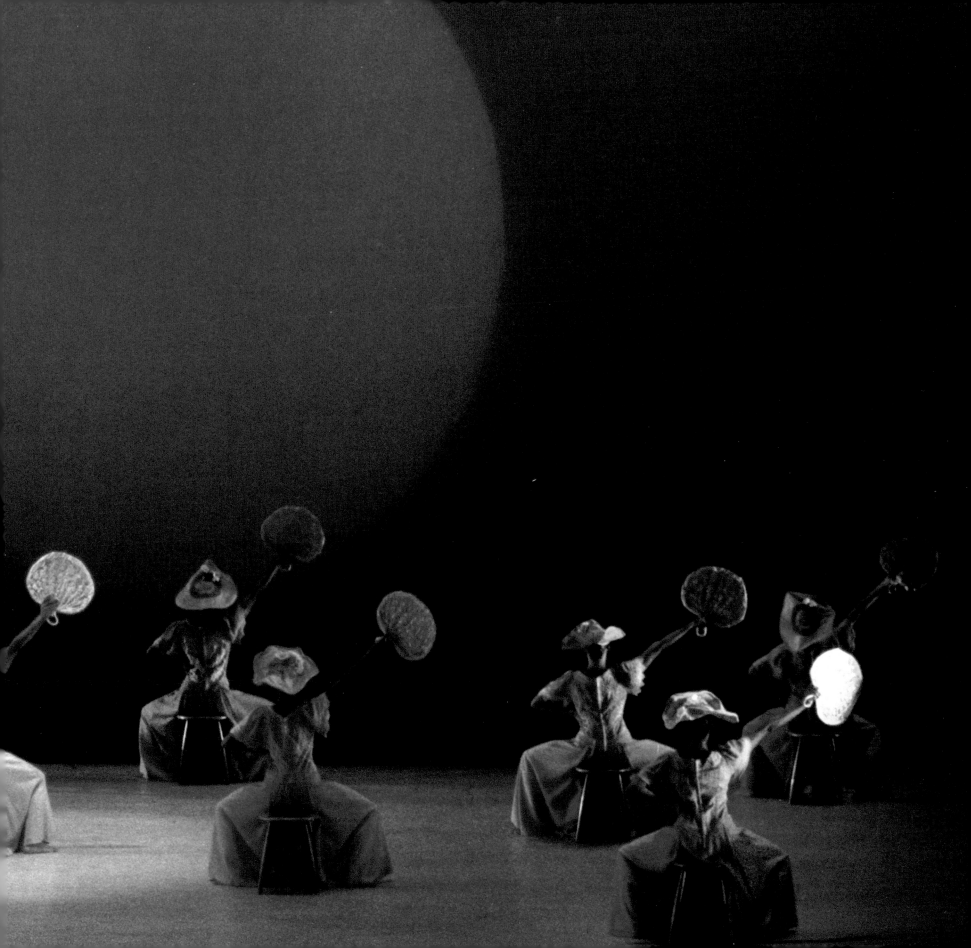

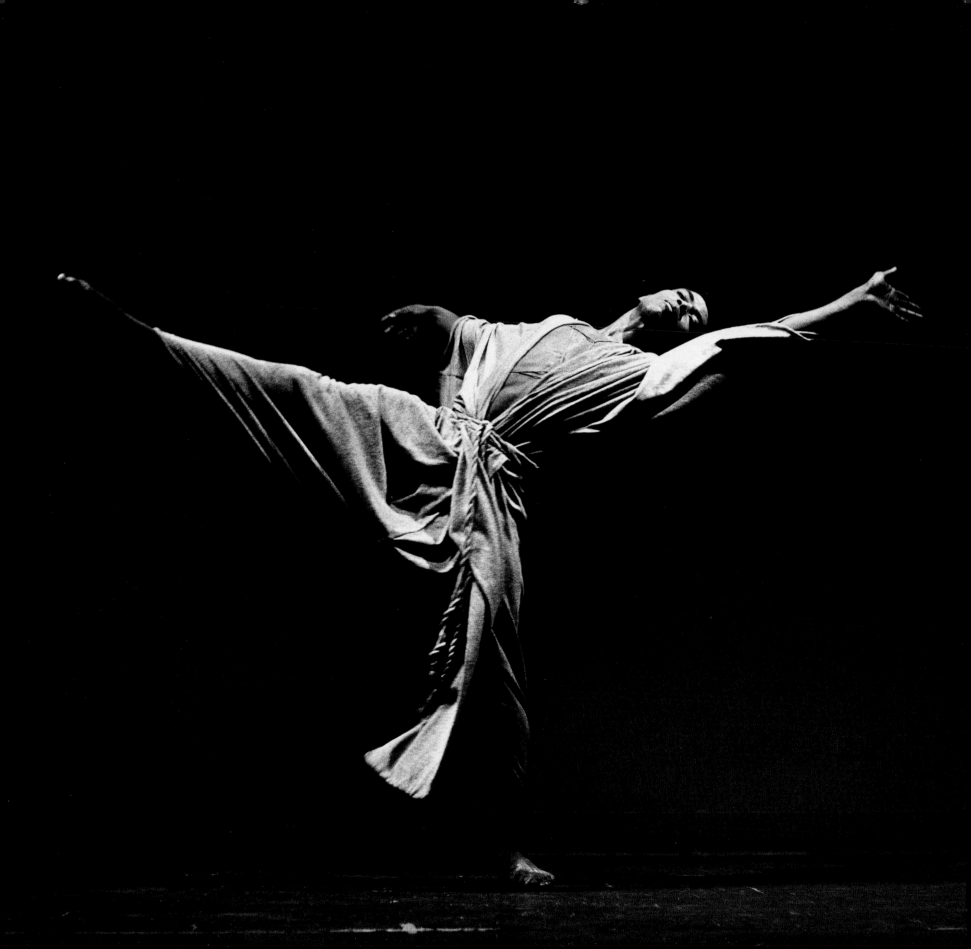

Early Days

ROGERS, A TOWN IN THE COTTON COUNTRY ALONG THE BRAZOS RIVER IN CENTRAL TEXAS, WAS home to fewer than a thousand souls when Alvin Ailey was born there in 1931. With its cotton gins, churches, and Dew Drop Inns, it was as far away as one could get from the concert stages of New York, where radical innovators Martha Graham and Doris Humphrey were developing their idioms of modern dance. Yet decades later, young Alvin would connect those two worlds by translating his earliest "blood memories" of his childhood to the dance stage in the revolutionary passion of *Blues Suite* and *Revelations*. The company he founded would express an energetic and moving new vision of American dance. Over four decades Ailey's dancers and choreographers would open up the language of American dance to worldwide acclaim.

Alvin was raised solely by his mother, Lula Cooper. They moved to Los Angeles in 1943, and there, while he was still in junior high and high school, Alvin's eyes were opened to a new world of contemporary art. He saw black dancers, singers, and musicians performing in Katherine Dunham's *Tropical Revue* at the Biltmore.

Alvin heard the jazz music of Duke Ellington and Stan Kenton. His junior high school teacher took his class to see the Original Ballet Russe in Fokine's melodramatic *Scheherazade.* Later he also saw Alexandra Danilova in *Coppelia*. At the movies he saw Lena Horne in *Stormy Weather*, with Dunham and her dancers, Bojangles, and the Nicholas Brothers. He studied the dancing of Fred Astaire and Gene Kelly in the musical films of the forties. (In 1954 Ailey himself would appear in *Carmen Jones* with Carmen de Lavallade, Dorothy Dandridge, Harry Belafonte, and Pearl Bailey.)

Back at Thomas Jefferson High School, his classmate Carmen de Lavallade was already giving dance recitals. One day when she saw Alvin doing gymnastics, she told him, "My God, you ought to be dancing." As she later explained, "he was doing free exercise, and that always looked like dancing to me."

By the early fifties, Alvin was studying with the multiracial dance company of Lester Horton. Always interested in all forms of communication, Alvin pursued college courses in the Romance languages. (At various times he was enrolled at UCLA, Los Angeles City College, and Berkeley.) He absorbed certain authors—James Baldwin, Langston Hughes, Carson McCullers, Tennessee Williams—whose works nurtured his intellectual appetite. Alvin was naturally attracted to Horton's work—dance theatre pieces based on pictures by Paul Klee, poems by Garcia Lorca, music by Ellington and Stravinsky, and even Mexican themes.

Lester Horton died of a heart attack in 1953. (It so happened that the Horton dancers, with Alvin and Carmen, were performing that night at Ciro's nightclub.) Alvin, age twenty-two, was chosen to fill the shoes of his mentor and surrogate father, becoming the director and resident choreographer for the Lester Horton Dance Theater. Although he had barely begun to train as a dancer and performer, he took on the task with amazing gusto. Don Martin, another high school friend and Horton dancer, recalls that Alvin was always interested in movement. "I didn't have the choreographic ability that Alvin had. Alvin didn't think he did either, but we would improvise and dance together and he would make up these conformations with poses and lifts."

Within one year Ailey had choreographed three original dances for Horton's company: *Creation of the World,* to the music of Darius Milhaud; *According to St. Francis,* to the music of Gershon Kingsley; and *Mourning Morning,* to the music of Gertrude Rivers Robinson. About *Mourning Morning,* Alvin said that he took everything Tennessee Williams had ever written and he put it into this dance. He created these works for the company's stars: Carmen de Lavallade, Jimmy Truitte, and Joyce Trisler. "Joyce and I became good friends later in New York," recalled Ailey. "She had a fantastic sensibility as a dancer. Lester created several ballets for her while I was around."

Ailey was interested in experiencing all the arts he could find in the expanding western metropolis. An important milestone for him was seeing *Magdalena,* choreographed by Jack Cole, who would later become another mentor. Ailey was supposed to appear in the 1952 film *Lydia Bailey,* which Cole had choreographed for Alvin and Carmen, but at the last moment Alvin became injured. So Cole made himself up to look like a Haitian and stepped in to replace him. Jack Cole became Alvin's idol.

Despite the lure of Hollywood, Carmen and Alvin were determined to become modern concert dancers. In 1954 they were summoned to New York by choreographer Herbert Ross, who had worked with them on the film *Carmen Jones*, to make their Broadway debuts in Truman Capote's musical *House of Flowers*. Ross had replaced George Balanchine on the musical because, according to Ailey, Balanchine's choreography was both too good and not showy enough for the Broadway stage. Carmen and Alvin were lead dancers in the musical for five months.

Alvin plunged into the New York arts scene. He found time to study with the giants: Martha Graham, Hanya Holm, Charles Weidman, and Katherine Dunham (and her protégée, Syvilla Fort). He studied ballet with Karel Shook, composition with Doris Humphrey, and acting with Stella Adler. After *House of Flowers* closed, Alvin danced with the companies of Sophie Maslow, Anna Sokolow, and Donald McKayle. In 1955 he took on a role in the off-Broadway play *The Carefree Tree*. In 1956 he toured the country in two shows: first Harry Belafonte's *Sing Man Sing*, choreographed by Walter Nicks, with Mary Hinkson as the leading female dancer; then Geoffrey Holder's *Caribbean Calypso Carnival*, with a cast that included McKayle and Maya Angelou.

Cristyne Lawson—another dancer, five years younger than Alvin—had lived around the corner from him growing up. She was with him on the beach in Los Angeles in the summer of 1957 when he announced that he intended to form a dance company.

Determined to put some sort of act together, Cristyne and Alvin managed to co-choreograph a duet. In the fall they auditioned for Jack Cole with that duet and were hired as lead dancers for the cast of *Jamaica*, which became a smash hit on Broadway. Choreographed by Cole, the show starred Lena Horne and Ricardo Montalban, along with Ossie Davis and Josephine Premice. The dancers included Billy Wilson, Audrey Mason, Pearl Reynolds, Barbara Wright, and Claude Thompson.

"I remember Jack Cole telling Alvin there wasn't a stage in the world big enough for him to dance on because he was all over the place," recalled Lawson. "Alvin had that incredible look! He looked like a truck driver but he was a lyrical mover, which was a terrific dichotomy to behold."

I did everything I thought Lester would do. I designed the costumes, I did Noguchi-type sets, I went to the shops for fabrics. And I began to choreograph dances. I didn't know anything about form and such. I only knew how to imitate Lester. *Alvin Ailey*

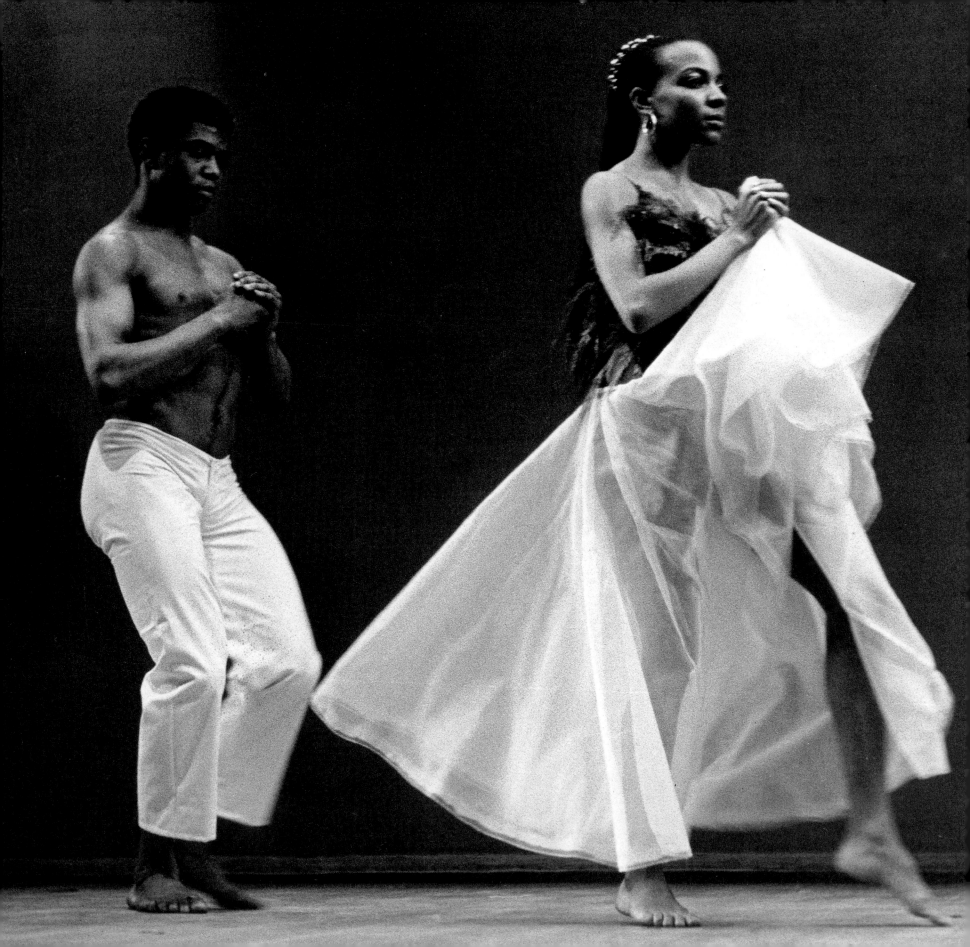

During the free time between the matinee and evening shows, Lena Horne allowed Alvin and his dancers to rehearse on the stage of the Imperial Theater. There Alvin created his first choreographic masterpiece, *Blues Suite*. Set in a barrelhouse, a cheap saloon, the work celebrates the musical heritage of southern blacks. In the dance Alvin sought "to explore the pain, desolation, frustrations, heartaches, lost love, and social discontent of his people." The work was greatly influenced by the folk singer Brother John Sellers, who was performing in Greenwich Village. Ailey happened to hear him one evening and incorporated not only his music, but the musician himself, into the piece. Sellers's onstage performance in *Blues Suite* led to further collaborations, culminating in *Revelations*, a work he continued to perform for almost 40 years.

Claude Thompson, who helped Ailey learn the intricacies of Cole's jazz steps in *Jamaica,* said that the character Alvin created for him in *Blues Suite* changed his life as a performing artist.

He was much older than me but I thought he was like a god. He was absolutely beautiful, with that gymnast's body, and extremely intelligent, but he was wild. *Cristyne Lawson*

"Alvin took me places with his choreography I hadn't personally been," said Thompson. "I could identify with my character because he was a frightened human being. I felt I was born that night when we premiered *Blues Suite*."

The premiere of *Blues Suite* at the 92nd Street YMHA on March 31, 1958, marked the birth of the Alvin Ailey Dance Theater.

Jacqueline Walcott Goldman, who had left the Katherine Dunham Company to appear in *Jamaica,* became a close friend of Ailey's and performed in his first concerts with the Alvin Ailey Dance Theater.

Another dancer, Harold Pierson, recalls being tremendously surprised yet excited to be included in the group of men Alvin chose to dance in *Blues Suite*. "I thought Alvin reached a personal choreographic plateau with *Blues Suite*, his first masterpiece. I always thought Alvin was brilliantly talented, but it never occurred to me that he would reach the success he did."

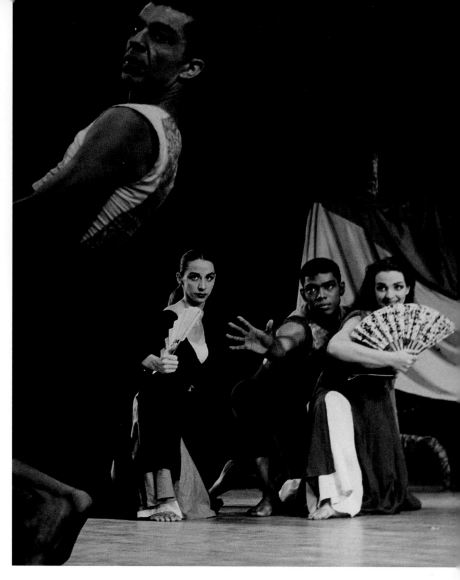

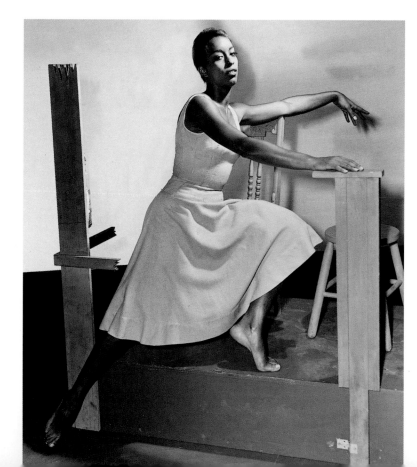

On January 31, 1960, also at the 92nd Street Y, the Alvin Ailey Dance Theater presented Alvin's masterpiece *Revelations* set to a suite of negro spirituals and gospel music. The songs, Ailey explained, recalled for him his earliest roots.

"They are intimately connected with my memories of the Baptist church when I was a child in Texas. Baptisms by tree-shrouded lakes, in a lake where an ancient alligator was supposed to have lived, the Holy Rollers' tambourines *shrieking* in the night . . ."

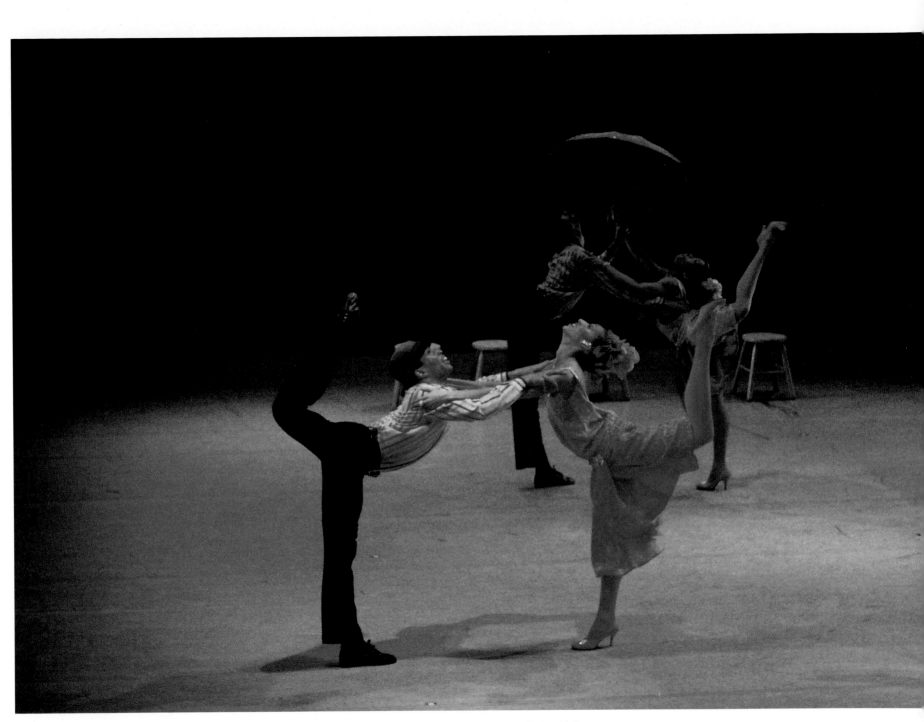

OPPOSITE, ABOVE: Lila
Goldoni, Alvin Ailey, Joyce Trisler,
and Jimmy Truitte in Alvin Ailey's
St. Francis of Assisi. Ailey chore-
ographed this dance in honor of
his mentor, Lester Horton.

Photographer: Jack Mitchell

OPPOSITE , BELOW:
Georgia Collins in Ailey's blues
piece, *Been Here and Gone*, 1962.
"Anybody ask you who made up
this song, tell 'em Jack the
Rabbit, he's been here and gone."

Photographer: Laurie Richards

ABOVE: *Blues Suite* by Alvin
Ailey; April Berry and Keith
McDaniel in front, Deborah
Manning and Daniel Clark in back.

Photographer: Jack Vartoogian

LEFT: Brother John Sellers, Isia Arnele, and Bill Louther in *Blues Suite*, on tour in London, 1964.
Photographer: Zoe Dominic

RIGHT: *Blues Suite* on tour; Australia in the early 1960s with Minnie Marshall. Bruce Langhorne is on guitar.
Photographer: Eric Smith

Merle Derby and her sister Joan had both trained in African dance traditions before joining Alvin's company. Ailey was inspired by the diversity of their techniques. In fact, the Derby sisters, along with Jay Fletcher and Nat Horne, danced the central section of *Revelations*, "Wade in the Water."

Nat Horne, whose father was an evangelist minister, remembered his father singing the songs that Alvin was using in *Revelations*. He said to himself, "Oh my God, this is sacrilegious, what I'm dancing. My father would turn over in his grave."

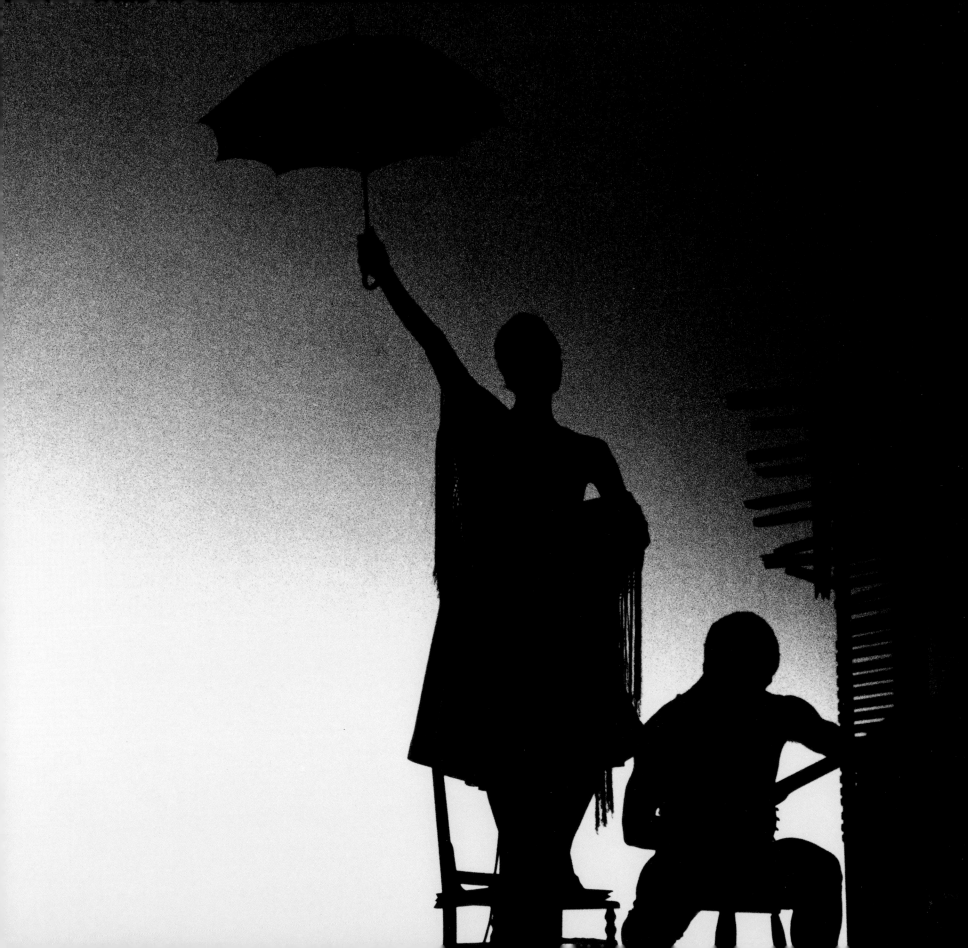

Although he became a dancer, Horne could still hear his father proclaiming that dancing was a sin. Yet when he saw Alvin's *Revelations*, he saw his father's church. The church had always been a powerful social force among black people; now Alvin was bringing that sensibility to the world of concert dance. Horne especially liked to dance and perform the section of *Revelations* called "Sinnerman."

"Alvin's movement fit so well with the words of the song. I was trying to run and hide on stage, and I remembered in my father's church him saying, "You cannot hide from God. There is no place to run!"

Many people regarded Alvin as deliberate, careful, and well organized, yet inspiration and instinct led him to some wonderfully unexpected artistic inventions. His spontaneity "could also scare the hell out of you," recalls Ella Thompson Moore. Working with Alvin, she recalls, was like studying with an acting teacher.

"He would give you wonderful images, so you could see exactly what he wanted choreographically. The movement then came along with the images, which was part of Alvin's choreographic process. Then Alvin kept developing it and refining it. He would tinker until he got what he wanted from it."

One of the few performers who danced in both of Ailey's first two masterpieces, *Blues Suite* (1958) and *Revelations* (1960), Dorene Richardson received a short letter and a flower after the tremendous success of *Blues Suite*. The gesture exemplified Alvin's generosity of spirit and devotion to his dancers: "Do me the favor of accepting the enclosed as a small, small token of my great appreciation for the time and energy you so willingly devoted to my dances for the concert—needless to say, I learned a great, great deal—only hope I can apply it well enough to make a noticeable difference in the next one. . . ."

By 1958 Ailey had established his own company as a living testament to Lester Horton. In a relatively short time Ailey had poured his dreams and his youth into a reinvention of dance. He had reimagined dance as a profound and thrilling expression of the universal humanity at the core of the African American experience. Now he and his young company would carry that vision to the world.

From 1959 on, and especially after the first performances of *Revelations* in 1960, Ailey and his company were constantly on the road. With his loyal friend Mickey Bord as driver, the group did one-night stands on what Ailey called the "station-wagon tours." They performed at the World Dance Festival in New York's Central Park in 1959; at Jacob's Pillow in 1959, 1961, and 1963; the Boston Arts Festival; and in Philadelphia (where Bord's station wagon was stolen, with all the props and costumes for *Blues Suite* and *Revelations* inside).

President Kennedy's International Cultural Exchange Program began germinating in the early sixties, and in 1962 the de Lavallade-Alvin Ailey Company represented the United States on a fifteen-week tour of Australia and the Far East, bringing their special version of Americana to international stages. Beginning in

I have vivid memories of Minnie Marshall doing "Fix me, Jesus"—I mean, that was *it* for me. Minnie looked so eloquent and elegant. I remember "Wade in the Water" because Alvin moved like water; rippling water like a brook. *Judith Jamison*

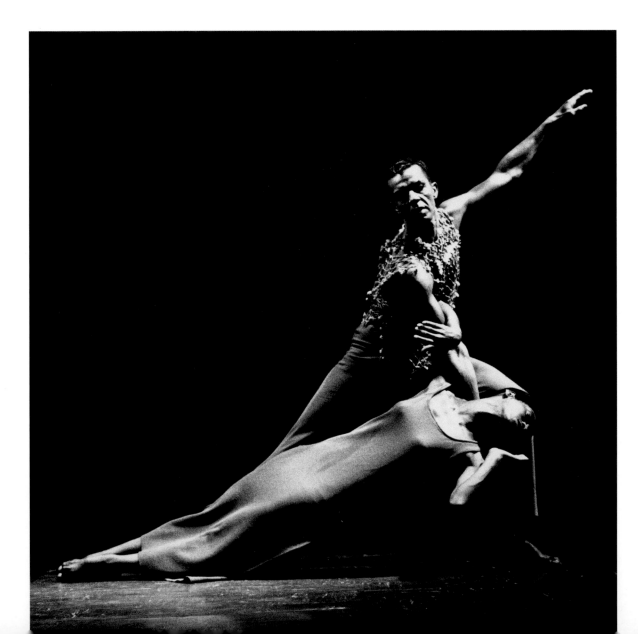

Minnie Marshall and James Truitte in "Fix Me, Jesus" from *Revelations.*

Photographer: Jack Mitchell

Sydney, the company traveled the entire continent of Australia and made further stops in Burma, Thailand, Taiwan, the Philippines, Vietnam, Malaya, Indonesia, Hong Kong, Japan, Laos, and Korea. The programs consisted of seven pieces by Ailey and one dance each by Lester Horton, John Butler, and Glen Tetley. Through sixty performances, the tour forged the group into a tightly-knit traveling company. The experience refined the troupe's techniques and repertory, and it gave the young dancers an incomparable exposure to the world.

In 1963 Myrna White, whose mother hadn't let her go on the Far Eastern tour because it was too far away, was determined to go with the company to the International Music Festival in Rio de Janeiro. This time her mother agreed. White had performed the "Wade in the Water" section of *Revelations* with Alvin on the nationally televised program *Lamp Unto My Feet*. On the Brazilian tour she took over most of Carmen de Lavallade's roles, including *Roots of the Blues*, "Wade in the Water," and *Gillespiana*.

> My master was an American choreographer named Lester Horton. Horton discovered me, he taught me everything I know, and he left his mark on my technique and my ideas. In everything I am and everything I do, there is, I hope, the lifeblood of his message.
>
> *Alvin Ailey*

Meanwhile Alvin was building his company. Late in 1963 he asked Dudley Williams to join. Williams had been dancing with Martha Graham's company. "With Martha, I discovered I was a modern dancer," says Williams, but by then he had done all that he could with her troupe. Dudley was about to quit Graham and move to Germany. "I was all packed," recalls Williams, "and Alvin called me. He knew I had danced the Talley Beatty ballets that were in the Ailey repertoire at the time. Alvin also needed someone who could pick up his own choreography quickly."

Williams joined Ailey in time to tour England and the Continent in 1964-65. (The company would return to Europe every year from 1966 through 1968, playing in Portugal, Holland, Israel, Italy, Spain, Germany, France,

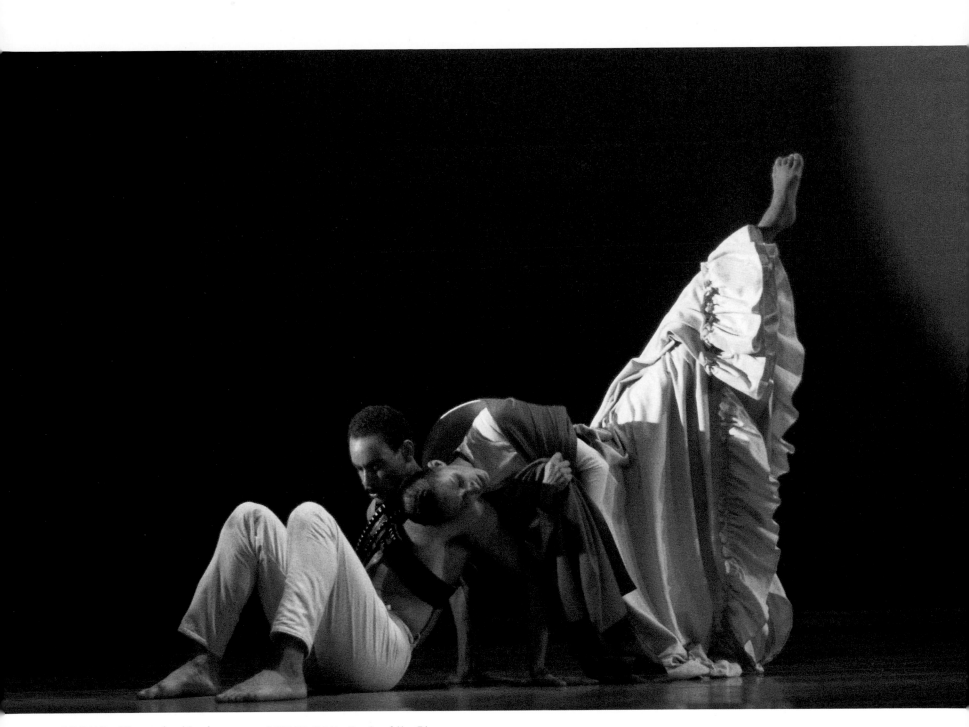

ABOVE: Ailey revived Lester
Horton's *To Jose Clemente
Orozco* with April Berry and Kevin
Brown in 1983.

Photographer: Jack Vartoogian

OVERLEAF: *Roots of the Blues*
in 1962; Carmen de Lavallade
with Alvin Ailey (left), Bruce
Langhorne (guitar), Horace Arnold
(percussion).

Photographer: Jack Mitchell

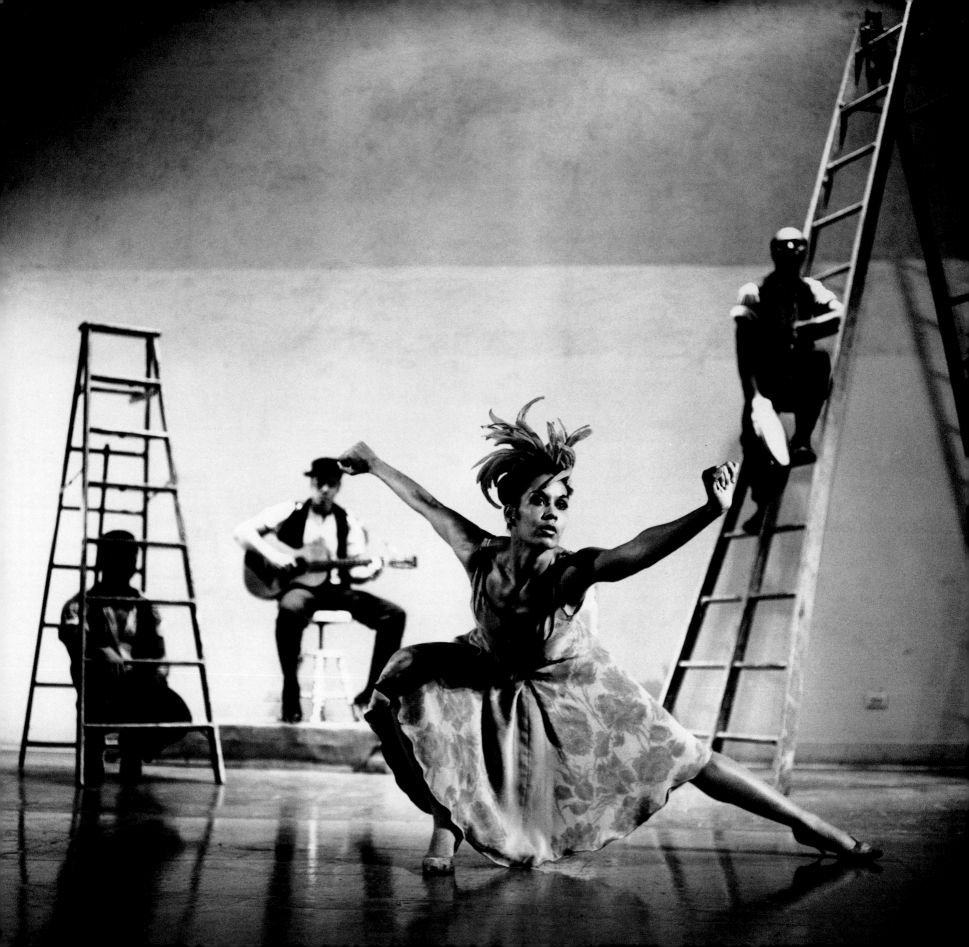

Yugoslavia, and at the Edinburgh Festival in Scotland.) The troupe also returned to Australia for a three-month tour in the spring of 1965. The Ailey company continued to travel all over the world, staying on the road for almost a year at a time. In 1966 an integrated Ailey company represented the United States in the first World Festival of Negro Arts in Senegal, Africa.

The year 1965 was a watershed for Alvin Ailey. First, Judith Jamison became a member of the company. A striking, elegant presence and a fearless artist, she would become his muse and the iconic Ailey dancer to audiences around the world.

Tina Yuan remembers seeing the Ailey company when she was a child in Taiwan, never imagining that she would eventually join the company in the early seventies. "I was so excited to see the company because of the energy and the rhythm," says Yuan. "The memories of watching Alvin perform on stage have stayed with me forever. He looked like a panther."

But performing, on top of all his other endeavors, was too much to sustain. "I was doing everything—administration, publicity, fundraising, choreography, teaching, costume designing," Ailey later recalled. " I was going out of my mind. I was losing my jump

Alvin's favorite expression was that we were "a Family of Man." Elevate the spirit of man. *Sarita Allen*

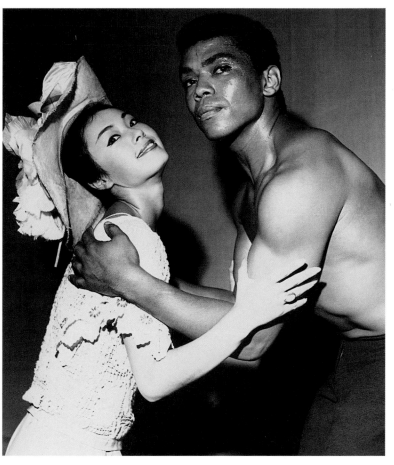

LEFT: Alvin Ailey in *Roots of the Blues*, 1962, with Horace Arnold in the background.
Photographer: Jack Mitchell

ABOVE: *Revelations* on tour in France; Takako Asakawa and Alvin Ailey.
Photographer: Studio Lipnitzki

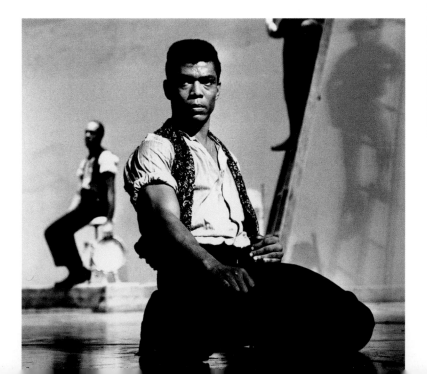

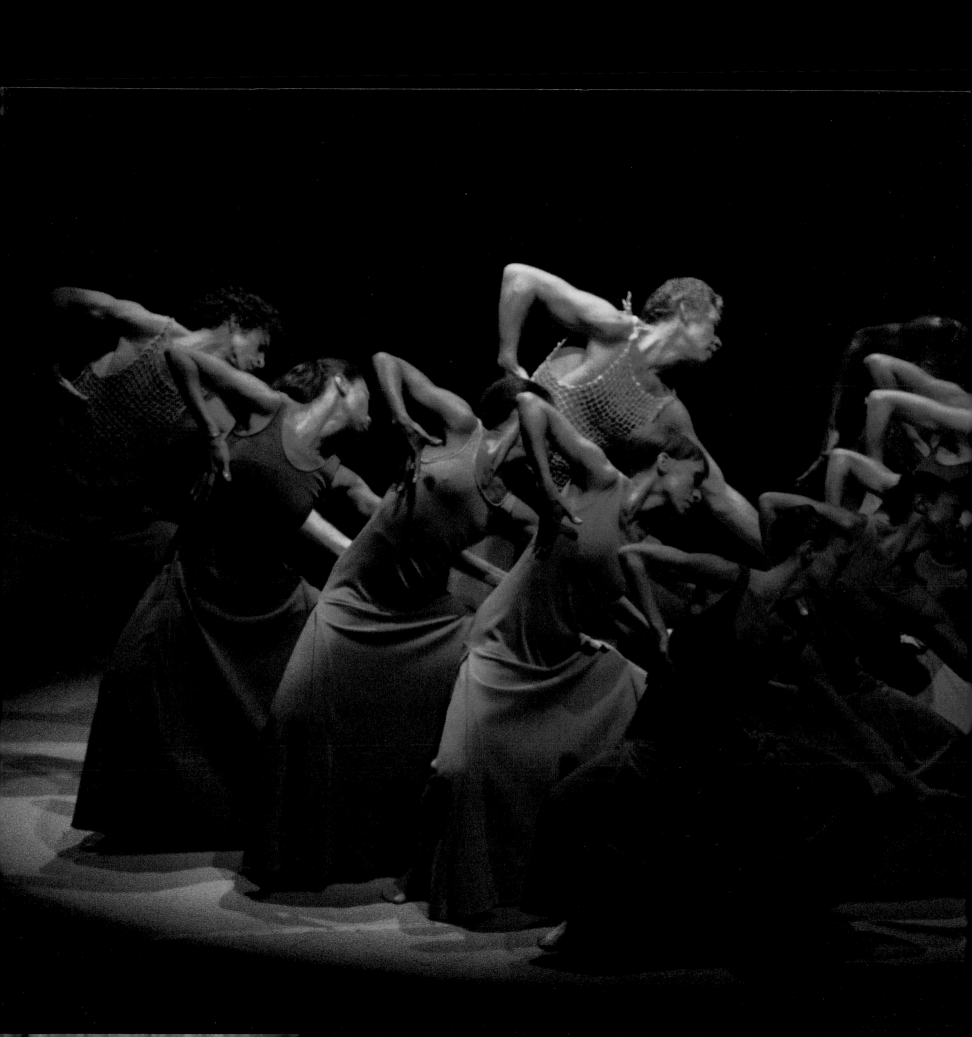

> Alvin's dream was to have black concert dancers performing in his spirit. Of course he didn't know what it was then, and we didn't know what it was, but we eventually got it, didn't we?
>
> *Jacqueline Walcott Goldman*

and never had time to take a class. I had some wonderful dancers coming up. I didn't want to compete with them. And I didn't want to be on stage in the back, loudly whispering, 'Everybody move over to the right.' In July of 1965, while on tour in Italy, Alvin Ailey ended his career as a dancer. He was thirty-three years old. "I remember it with pleasure; after the last performance in Florence, I took all of my rehearsal clothes and put them in the wastebasket in the hotel."

Once he was no longer dancing, Ailey was able to focus on being an artistic director and resident choreographer for his company. "It's become much more enormous than I ever would have dreamed of back in the fifties," he said in 1969. "I never even thought I would have a company of my own, much less something of this dimension." He had not set out to found one of the great institutions of the dance world. "Originally, I just wanted to say something about the black experience in my own choreography," Ailey remarked. "I started out to create a trilogy of works along these lines, and two of them, *Blues Suite* and *Revelations*, we've been dancing ever since."

LEFT: *Revelations,* 1977;
Linda Kent is in front.
Photographer: Johan Elbers

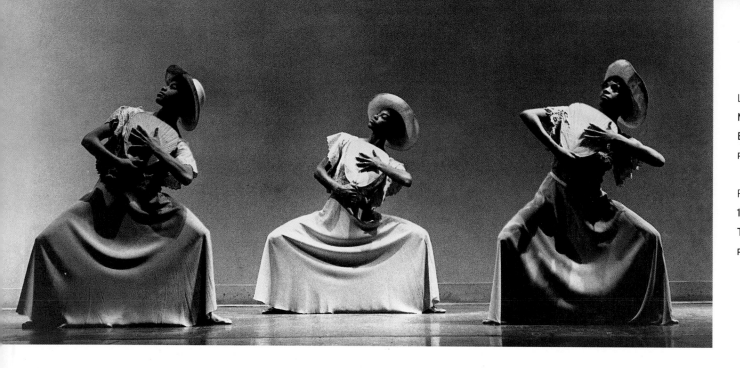

Revelations was the black spiritual experience that Alvin wanted to celebrate. It was impossible not to get involved emotionally while you were performing, because it was so vibrant, alive, and vital to our existence. *Merle Derby*

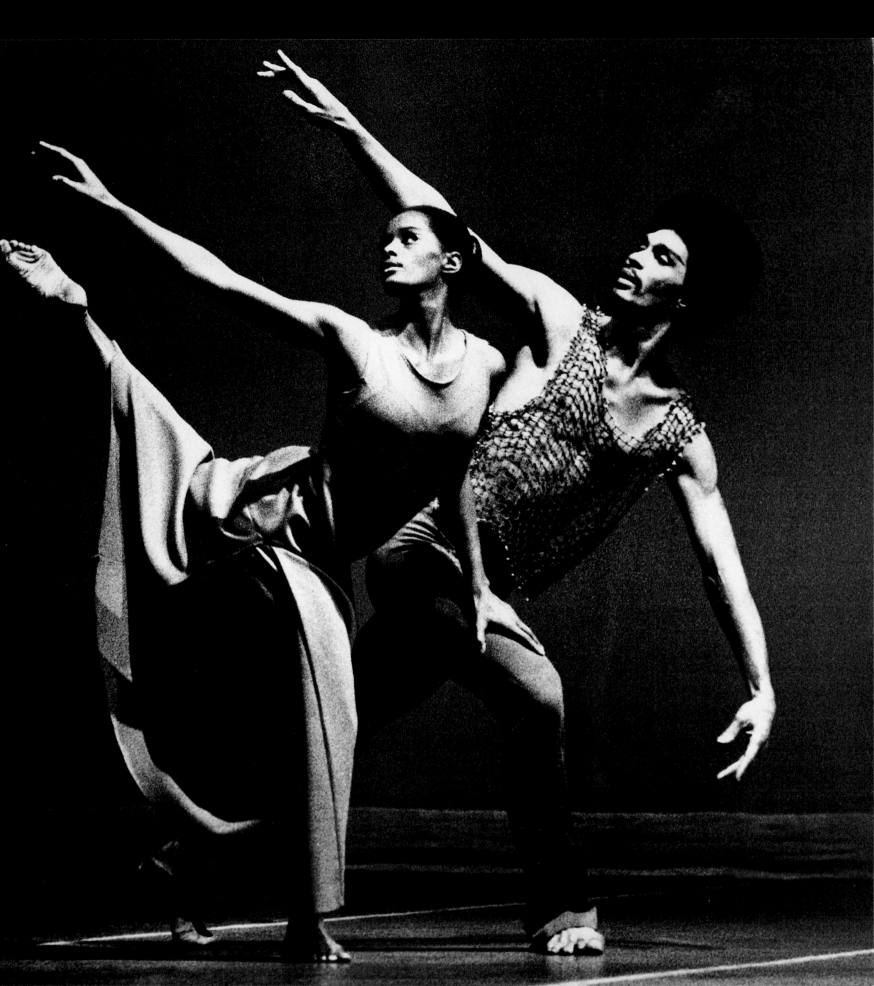

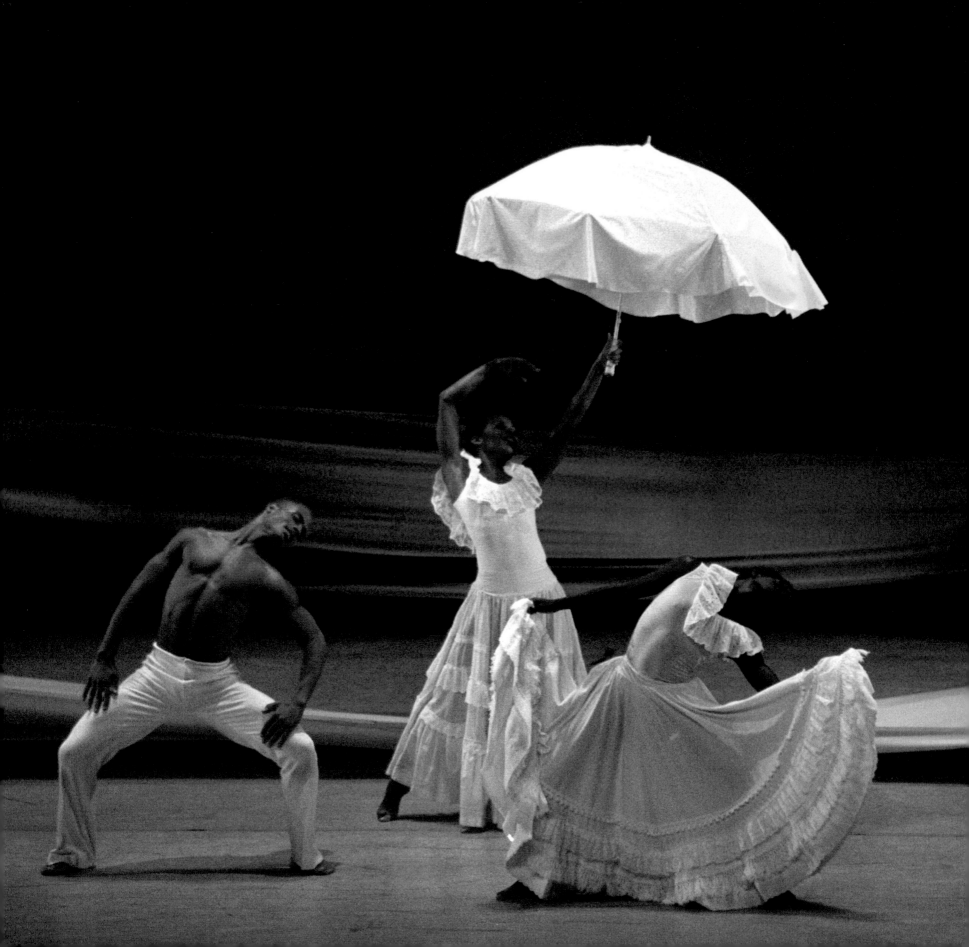

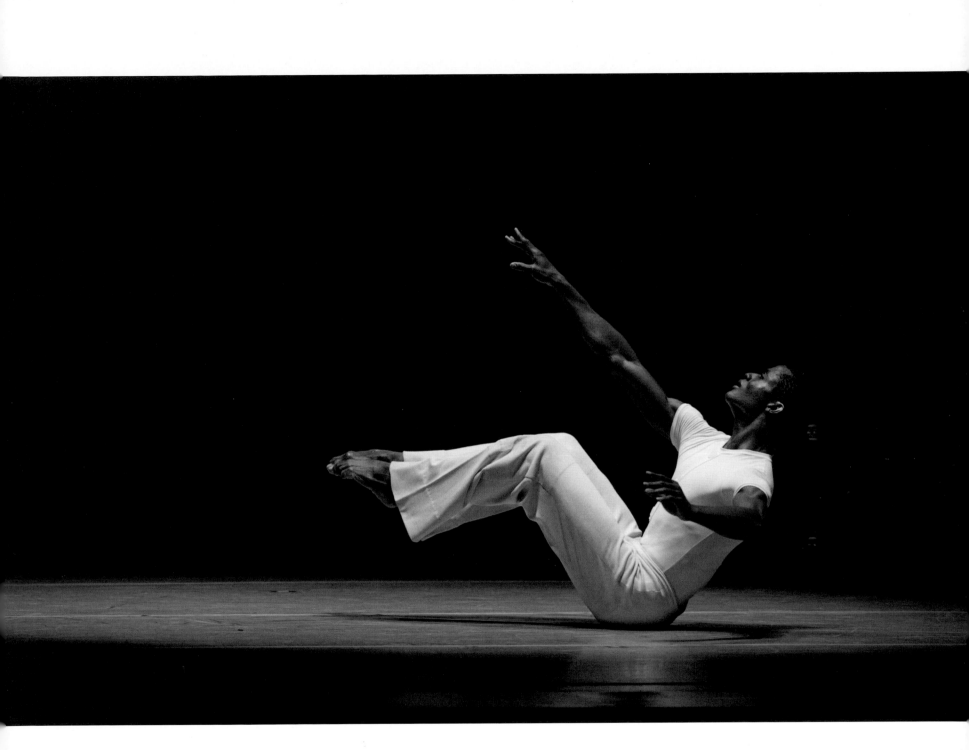

LEFT: "Wade in the Water," from *Revelations;* Vernard Gilmore, Bahiyah Sayyed-Gaines, and Désirée Vlad.

Photographer: Paul Kolnik

ABOVE: "I Wanna be Ready," *Revelations,* 2003; Amos Machanic.

Photographer: Basil Childers

Revelations

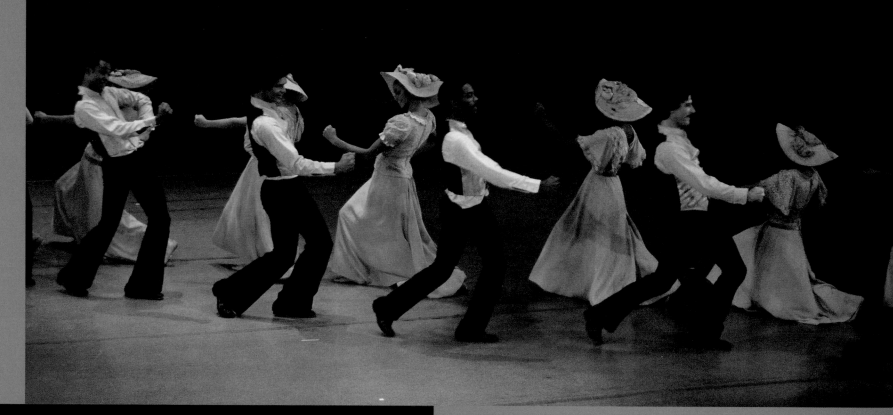

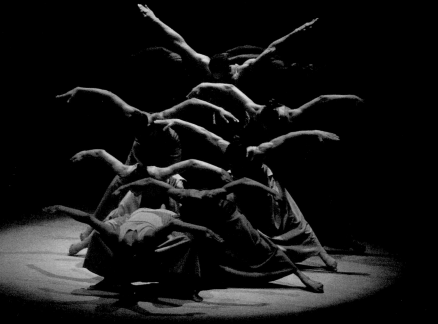

LEFT: *Revelations*, 1982; the opening, "Pilgrim of Sorrow."
Photographer: Jack Vartoogian

ABOVE: *Revelations*, 1978; Melvin Jones, Clive Thompson, Ulysses Dove, and Peter Woodin. Alvin called this section "Sister Choo-choo" after a woman who used to go around his church acting like a locomotive train.
Photographer: Jack Vartoogian

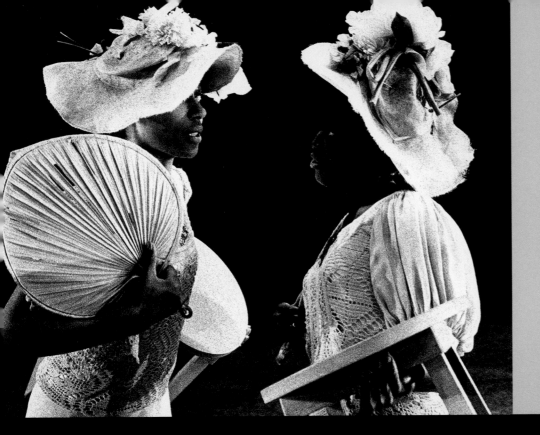

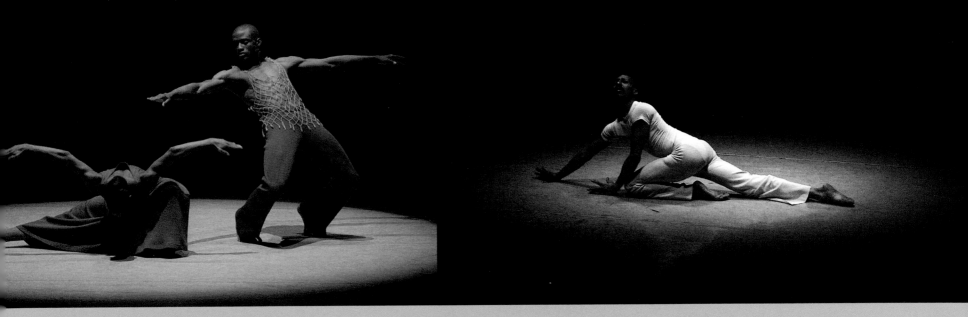

LEFT: *Revelations*, 1964;
Hope Clarke and Joan Peters.
Photographer: Zoe Dominic

BELOW LEFT: *Revelations*,
"Fix Me, Jesus"; Brianna Reed
and Amos Machanic.
Photographer: Paul Kolnik

BELOW RIGHT: *Revelations*,
1983; "I Wanna be Ready";
Dudley Williams.
Photographer: Linda Vartoogian

Alvin's genius as a choreographer made what he had
to say universal. It's why *Revelations* has lasted as
long as it has—it's about all of us. *Judith Jamison*

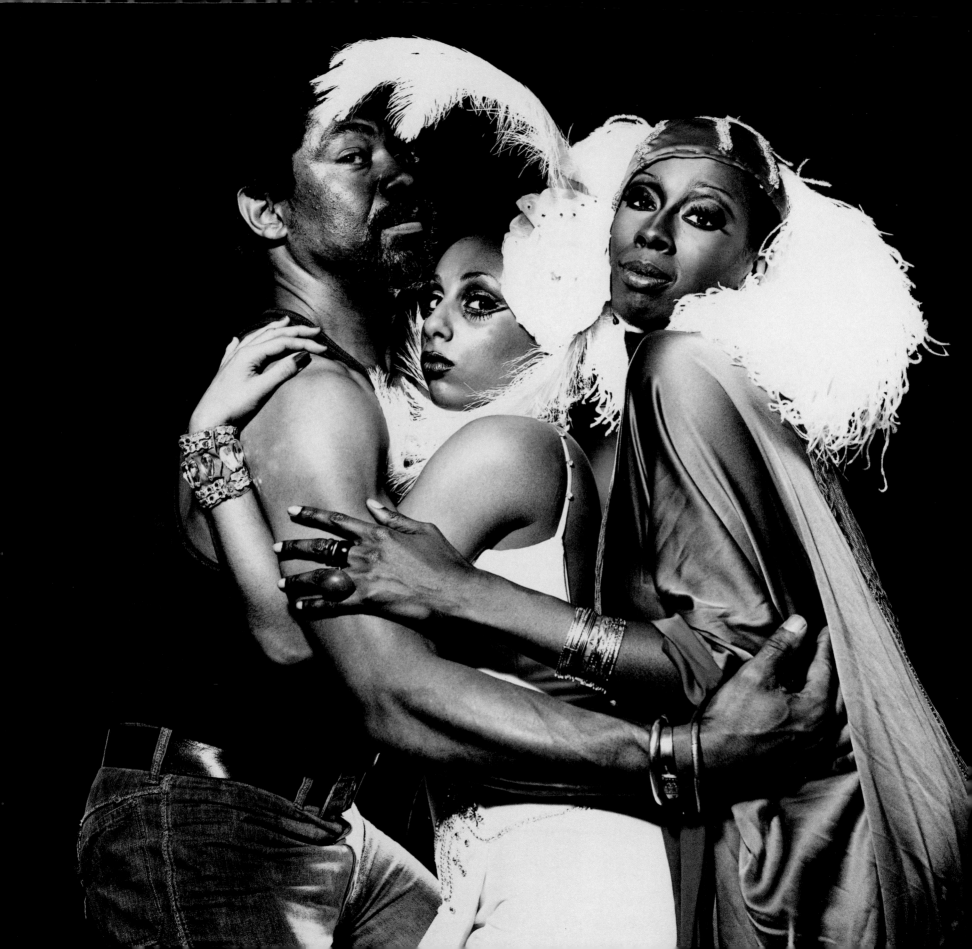

IN THE EARLY DAYS, AILEY WOULD TRY OUT HIS CHOREOGRAPHY ON HIS FRIENDS AND whatever other dancers were available to work with him. By 1960 he was ready to perform as a company. It was his choice of dancers that made the Ailey company into the most renowned modern dance company in the world.

Mabel Robinson remembers going to meet Ailey with her friend from the Juilliard School, Sylvia Waters. Alvin said to her, "Mabel, Mabel, how does your garden grow? With *evil* things, I suppose!" Robinson recalls, "I just blushed and carried on, because Alvin knew that he had penetrated

Creating a Company

my heart forever. I worshiped Alvin Ailey!" Still in her teens, Robinson began dancing for Ailey on the blues pieces and episodes from *Revelations*, as well as some jazz dances.

As a young dancer in 1965, Judith Jamison auditioned for a Harry Belafonte television special. Although she didn't get the job that day, three days later she got a call from Alvin Ailey, who had been watching the auditions. He needed dancers for his company; would she like to join? "I said 'Yes!'"

"When I first walked into the rehearsal for the company, I said something stupid like, "I'm surrounded by stars!" In front of me was the tall and magnificent Jimmy Truitte, who would become my first partner. Jimmy just looked at me and said, "Oh stop, girl, and get on in here."

Jamison was one of the lead dancers for Ailey for fifteen years, and became the muse for whom he created twenty roles in his various ballets over the course of his choreographic career. He respected and admired her "musicality, discipline, and taste—marvelous taste. Above all, Judith is able to justify movement." For the rest of his life, Ailey and Jamison remained dedicated to each other and to their shared vision of American dance.

Lucinda Ransom danced at the Apollo Theater in one of Alvin's early pieces, titled African Holiday. She remembers seeing the Ailey company and being enormously moved.

"I had never seen another company so well balanced and explicit. I was impressed with the men's strength in the way they danced with their balled-up fists and the way they hit the stage . . . Alvin was showing the black man coming forth very strong and purposeful. He is in his own element and he is not dancing in white society. He is dancing for himself with others like him. He is not being judged or evaluated."

One of the greatest ballerinas of the twentieth century, and a favorite of Alvin's, was Lynn Seymour, the prima ballerina of the Royal Ballet in London. She became one of the first guest artists to perform with his company in 1971, when he choreographed *Flowers*, his tribute to Janis Joplin. Seymour believes that Alvin's work was intended to create and nationalize another dance form.

"He was trying to bring into focus American black concert dance. Alvin was concerned about present-day life and what was happening to our society in the seventies. He wasn't talking only about the black situation, because everything he was doing was universal. His brand of dance theater was visual and kinetic. People are unaware of the intellectual rigor behind all of Alvin's creations."

Linda Kent was one of the dancers who understudied Seymour as Joplin in *Flowers* and performed it after Seymour finished her season with Ailey. "Lynn only danced four perform-

Because of our dramatic powers, Judy and I worked together superbly. *Clive Thompson*

ances with us," recalls Kent, "and boom! Three days later in Washington, DC, I was dancing *Flowers.*"

Sara Yarborough had been one of the few African Americans at the School of American Ballet and was the daughter of famed Dunham dancer Lavinia Williams. Sara met Alvin in 1967 when he was choreographing *Feast of Ashes* for the Harkness Ballet, where she was a company member. She joined Ailey in 1970 for the Russian tour.

"They had never seen anything like us," she recalls. "They kept coming up to feel the boys' Afros." Back in the U.S. she performed many signature works, notably *The Lark Ascending.* "During the season I set myself on a high and I didn't come down until the very end."

Donna Wood joined the company in the spring of 1972. She impressed Alvin with her classical technique. Having broken down the barrier between modern dance and ballet with his collaboration with Duke Ellington, *The River*, for American Ballet Theatre in 1970, he was using a lot of classical steps in his own choreography.

PAGE 38: *The Mooche:* Alvin
with Sarita Allen as Marie Bryant,
Judith Jamison as Bessie Smith,
in 1975.

Photographer: Jack Mitchell

RIGHT: John Butler's *Carmina Burana;*
Clive Thompson and Judith Jamison,
in 1975.

Photographer: Alan Bergman

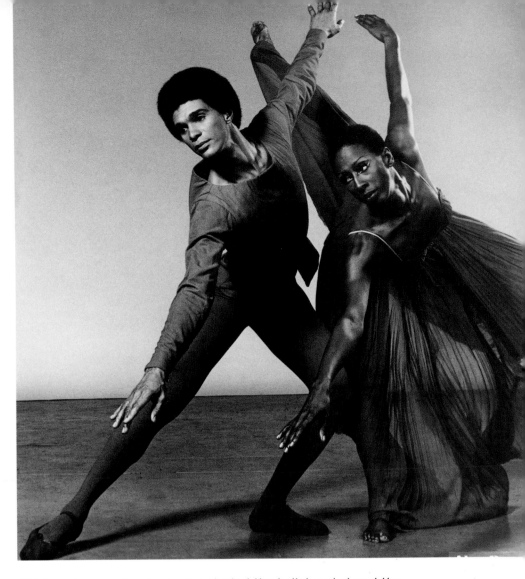

"I think he adored my height," recalled Wood. "He would have two women, Judith Jamison and Donna Wood, who were relatively the same size. I'm five-eight and a half and Judy is five-ten. Alvin had John Parks and Clive Thompson who were tall and could partner us, but even so it was a problem. I remember Alvin teasing me, asking, "Who am I going to get to partner you, Wilt Chamberlain?"

Estelle Spurlock was studying at the Boston Conservatory of Music when the Ailey company was on tour in the city in 1972. She met Dudley Williams, who introduced her to Ailey. Alvin said, "Come join us in class." When she had come back two more times, he said, "I like you and I'll be in touch." Ailey then called her on Easter Sunday and asked her to be in rehearsal on May 25. Alvin gave Spurlock the solo in John Parks's *Nubian Lady,* originally created for Judith Jamison. She recalls, "The first time I danced *Nubian Lady* was in London, England, which also happened to be my first time abroad."

Keith Lee, one of the first African Americans to appear with American Ballet Theatre, remembers Alvin walking into the ABT studios looking like "a great patriarch." Ailey's choreography for *The River* centered on Lee and Sallie Wilson as the principals of the ballet. Erik Bruhn, Natasha Makarova, Ivan Nagy, Cynthia Gregory, and Dennis Nahat were also in that extraordinary cast.

"Alvin put me up front, where I started the ballet and closed the ballet along with these other, established ballet stars," remembers Lee. "It was the biggest honor of my life! To this day, *The River* was the ballet that made my career." Lee was also in the second piece Ailey choreographed for ABT: *Sea Change,* to the music of Benjamin Britten. Eventually, in the mid-to-late eighties, Lee served as the ballet master of the Ailey company.

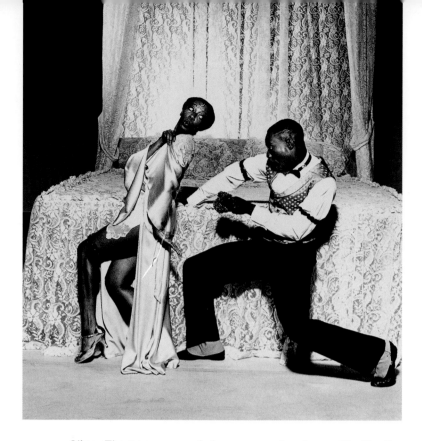

Clive Thompson spent ten years dancing with Martha Graham's company before he joined Ailey in 1970. "One of the great legacies of Alvin Ailey," said Thompson, "was that he created a world, a space, a place, using dance to transcend race, color, class for the masses of the people that we entertained. When I was in Alvin's company, we were dancing for the people."

For Thompson, Alvin created a place to stand; he made it legitimate for any black dancer today to say, "I am a dancer." He credits Judith Jamison with continuing the same creative spirit and imagination. "The Ailey company is thriving today because of Judith Jamison. It is still the most popular dance company in the world."

"I remember going to talk to Alvin about how insecure I felt in his company, being the so-called white guy," says Kenneth Pearl, who joined the company in 1970 for a six-week tour of

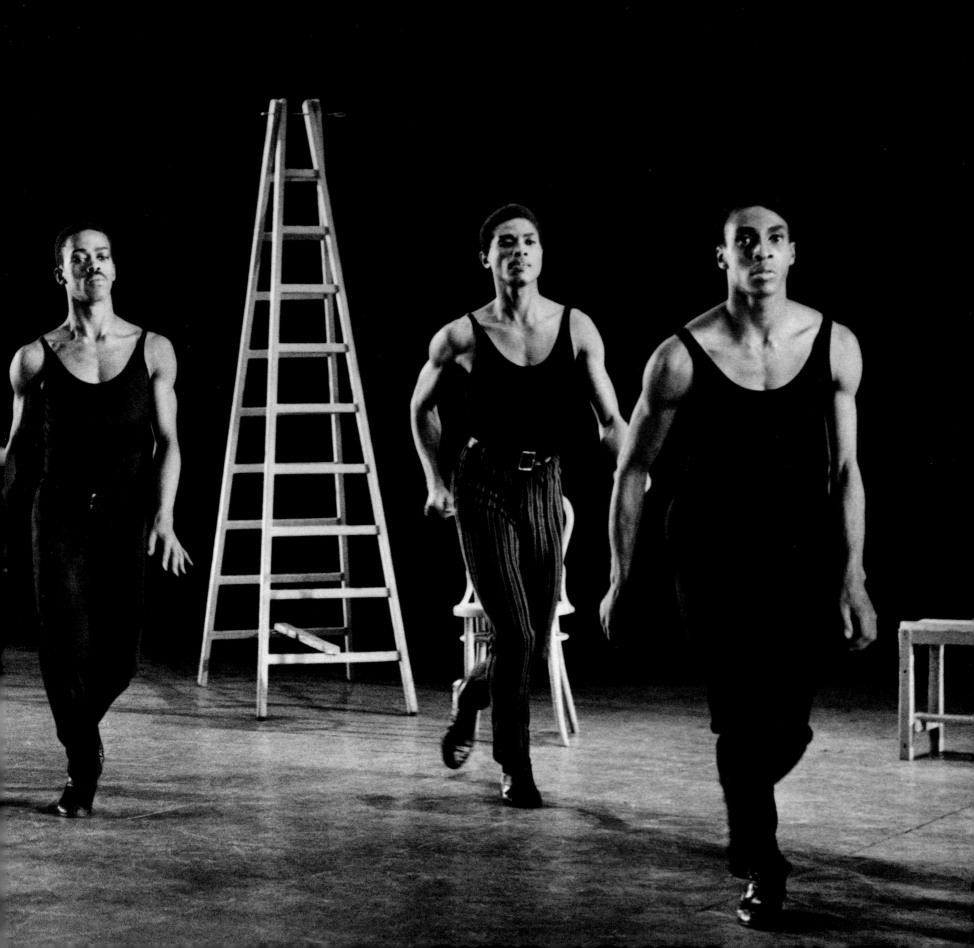

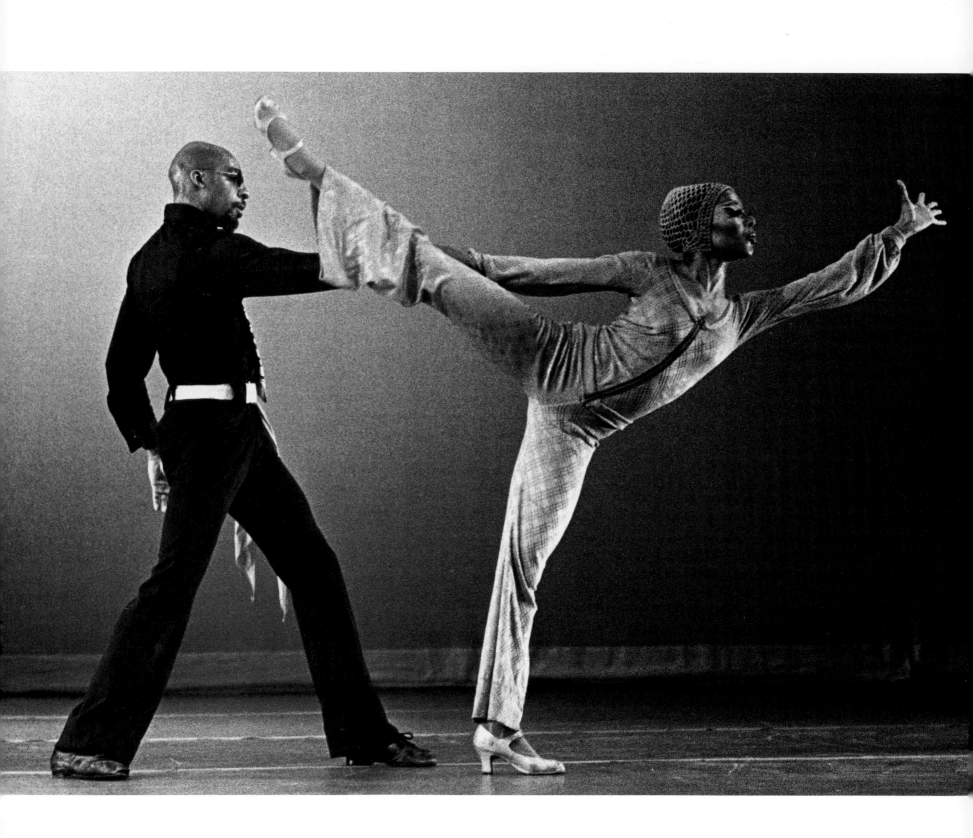

Judith Jamison and
Sara Yarborough could
out-dance ten guys at once.
Hector Mercado.

Russia. "Most of the dances we performed, like *Blues Suite* or *Rainbow Round My Shoulder*, were American themes through the black tradition in modern dance. I said to Alvin, 'I feel out of place because I am not African American.' Alvin said, 'For me it is not the color of your skin. It is how you feel inside and what you show the audience.' It was the most unforgettable comment Alvin said to me in the whole time I danced for his company. It was such a relief. I said to myself, 'Now I can be here with Ailey!'"

That year, at the enormous audition Ailey held in preparation for the Russian tour, one young man who tried out was Hector Mercado. "I just sailed through the audition," Mercado recalls. I was fresh out of the Harkness School, and I had all of my positions ready; all my i's were dotted and my t's crossed. When it came to the pirouettes, I did four and landed after executing a double tour to the knee. I nailed it!"

He was giving them a performance, and the fact that he wasn't really interested in joining the company gave him an added feeling of ease. That changed when he heard they were going to Scandinavia and Russia; when Alvin offered him a contract, Mercado grabbed it. "I wanted it only because they were going to Russia and I had never been out of the country," he says. "I was just turning twenty-one!" The tour was a triumph. Mercado went on to become a star of the Ailey company. One writer compared him to Valentino, Nureyev, Belafonte, and even Lena Horne.

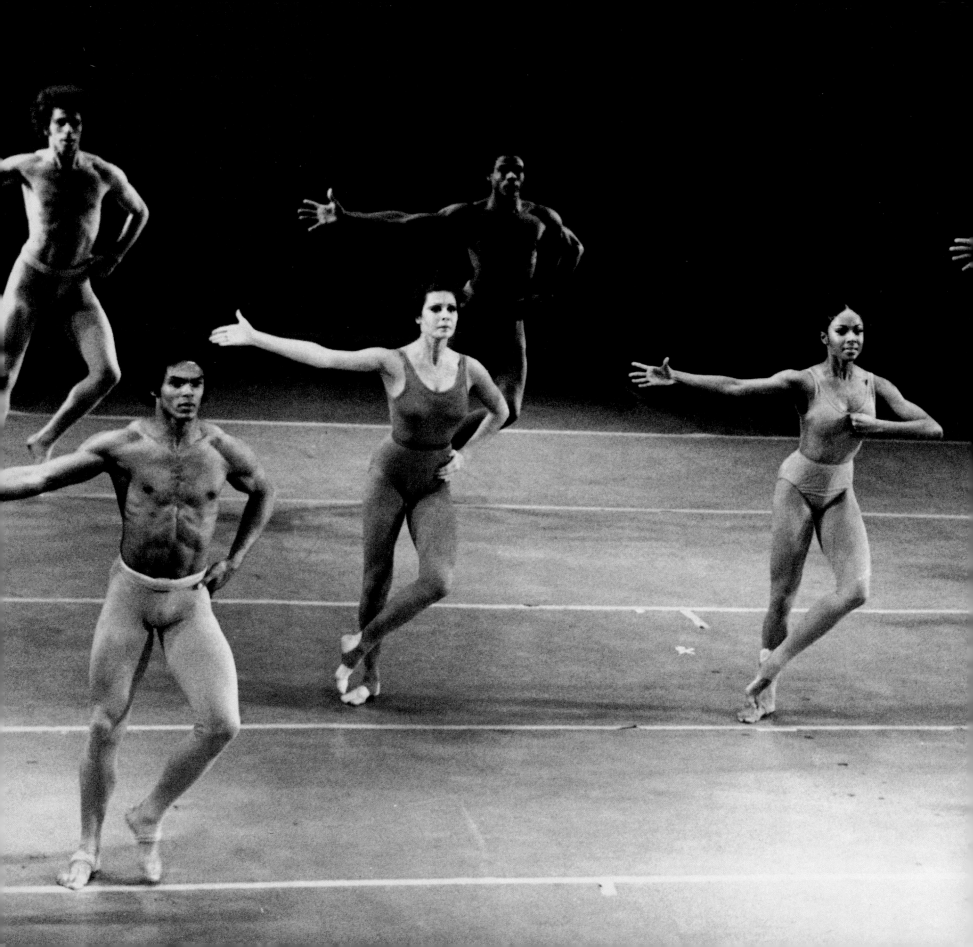

Alvin brought three tall men into his company as partners for Donna Wood: Elbert Watson, Warren Spears, and Peter Woodin.

"Alvin never had a problem putting me in to dance 'Fix Me, Jesus' or 'I Wanna Be Ready,'" Woodin remembers. "The only section I never danced was 'Wade in the Water,' and I don't think a white boy will ever dance that piece." Principally, Woodin danced with Wood in *Portrait of Billie*, *Rainbow Round My Shoulder*, *The Lark Ascending*, "Fix Me, Jesus," and Eleo Pomare's *Blood Burning Moon*.

"I found myself as a performer by dancing with Alvin," Carl Paris recalls. "There were moments on stage, dancing in Alvin's repertoire, that were absolute bliss." Paris found traveling through the world with Alvin Ailey to be a great education. Dancing in the company was also extremely demanding because the members had to learn and perform so many styles of movement. Paris credits his early experiences with Ailey for making him an eclectic choreographer: "I can't get it out of me!"

Mel Tomlinson, who also performed with Dance Theater of Harlem and the New York City Ballet, joined Ailey later in the seventies.

"When I got into the Ailey company, I loved the dancing of Dudley Williams and Ulysses Dove, who also choreographed. I was so impressed that Ulysses could do multiple turns on a bare foot. I loved how he worked," says Tomlinson.

Streams, one of Ailey's five water-themed ballets; (left to right) Kenneth Pearl, Hector Mercado, Christa Muller, Clover Mathis, Sara Yarborough, Clive Thompson, and Dudley Williams.
Photographer: Fred Fehl

I always felt hidden until Alvin got ahold of me.
Mel Tomlinson

Tomlinson admired Ailey for being so secure as an artist that he could invite other choreographers to create for his company, thus giving his dancers the opportunity to work with some of the other giants of the dance world.

Miguel Godreau joined the company in 1965. A self-described "hillbilly from Puerto Rico," he moved to New York City at the age of five. Nicknamed "the black Nureyev," he partnered Marjorie Tallchief in Ailey's *El Amor Brujo,* choreographed for the Harkness Ballet in 1966.

"Alvin gave me a chance to do things no one else had ever let me do," he once recalled. "I said to Alvin, 'let me have a moment when I can point my foot and do something lyrical and soft. So he put me into *Knoxville, Summer of 1915.*"

"Once you start making dances on your own body, it's hard to know when to stop," Alvin Ailey said in 1969. "Soon you are competing with the kids in your own company, and that can be a dangerous thing. I want to nurture my dancers, I want to see them experiment, I want to watch them grow." Ailey, who had no children of his own, concluded, "Maybe I just want to be a father figure."

"In Paris, Alvin took me out to dinner and we discussed what I had performed that evening in *For Bird—With Love,*"

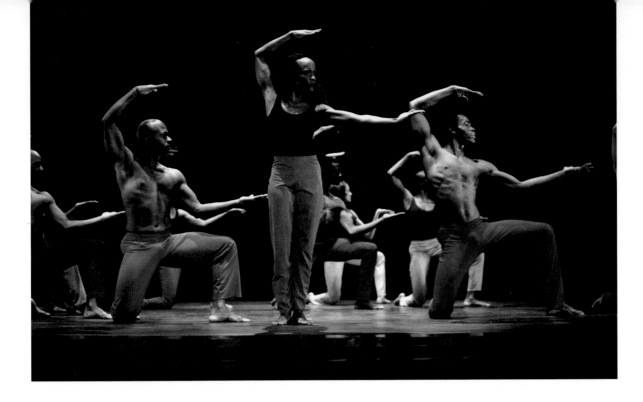

recalls Debora Chase. "Alvin would let you experiment and then say, "No, that didn't work, Chaseova." Everyone in Alvin's company was either a "skia" or an "ova." His intimacy made his dancers feel good and that was his way of getting the best out of his concert dancers."

Renee Robinson spent ten years under the guidance of Ailey; she joined his workshop company in the early eighties and danced in his *Memoria.* Says Robinson, "When Ms. Jamison took over as artistic director, my thoughts were, she is a new director. Even though she had worked under Alvin as both his muse and star, I had the sense that she would be her own person. I was sure she would carry on a lot of the aspects of the company that Alvin had set into place. I also had a strong feeling about her because she is a woman. And look what she has accomplished!"

OPPOSITE: *The Time Before the Time After (After the Time Before)* by Lar Lubovitch, one of the first of five dances Lubovitch re-choreographed for Ailey; Sara Yarborough and Mel Tomlinson.
Photographer: Jack Vartoogian

ABOVE: *Hymn,* Judith Jamison's tribute to her mentor Alvin Ailey; Glenn A. Sims, Renee Robinson, and Jamar Roberts, 2003.
Photographer: Paul Kolnik

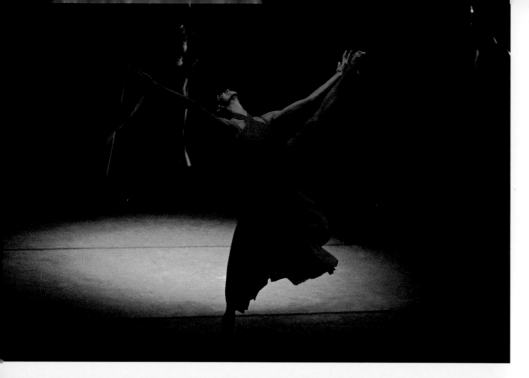

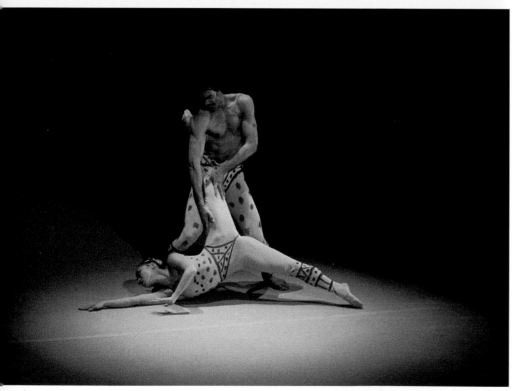

ABOVE LEFT: *Liberian Suite*, Horton's jazz piece set to music by Duke Ellington; Donna Wood, 1976

Photographer: Jack Vartoogian

BELOW LEFT: Clive Thompson and Tina Yuan in "Of Love," the second part of *Hidden Rites,* in 1973.

Photographer: Jack Vartoogian

OPPOSITE: *Cry*, first danced by Judith Jamison. Ailey's dedication: "For all black women, everywhere—especially our mothers," in 1971.

Photographer: Jack Mitchell

Since 1989, under the artistic direction of Judith Jamison, the company has become a home for a new generation of extraordinary talents. Among the current dancers, Bahiyah Sayyed-Gaines—who is extremely well versed in ballet, both the Horton and Graham modern dance techniques, jazz, and ethnic dancing—has a fierce dramatic sense that puts her squarely in the Ailey tradition of dancer-actresses. She has been compared to the 1940s film diva Joan Crawford. Dwana Adiaha Smallwood, who joined the company in 1995, inherited the Ailey solo *Cry*, originally created for Judith Jamison. A commanding presence, regal and even austere, Smallwood reinvents for a new generation the quintessential Ailey woman.

Matthew Rushing, Glenn Sims, and Amos Machanic, along with Clifton Brown, Samuel Deschauteurs, and Dion Wilson, are dancers of stunning grace and power. They and other young dancers yet unknown will carry the Ailey legacy the next step in the journey.

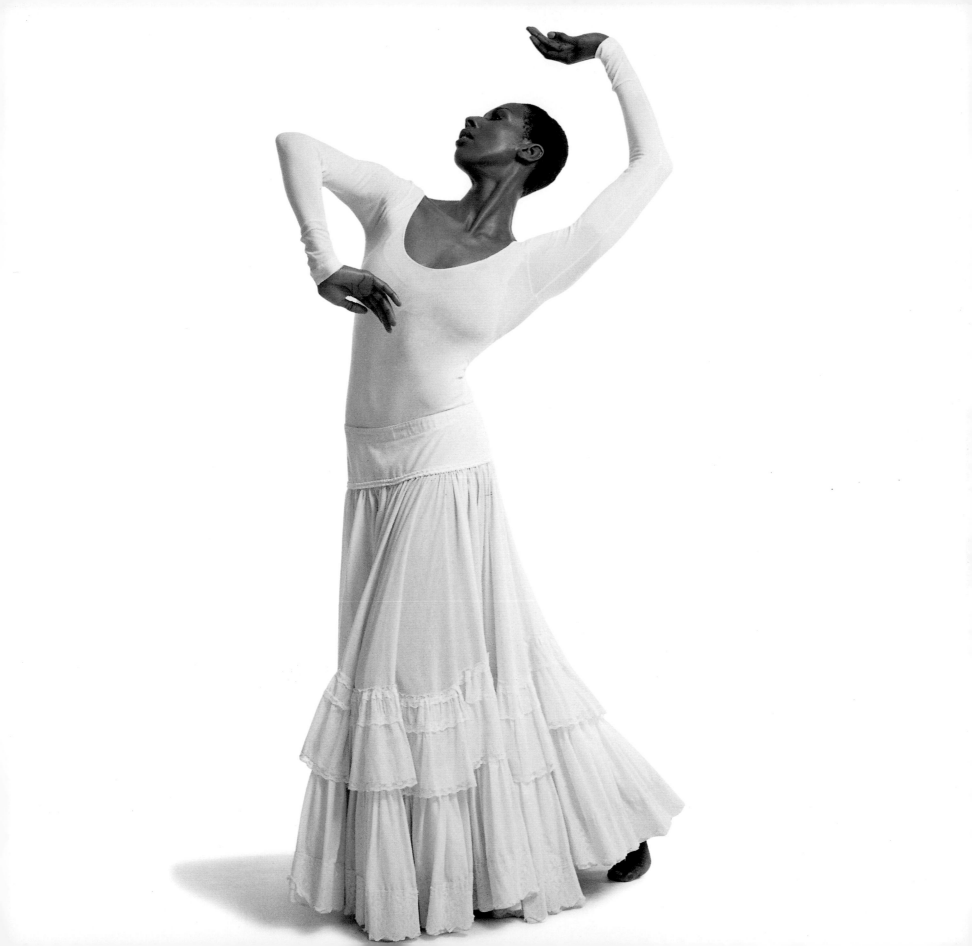

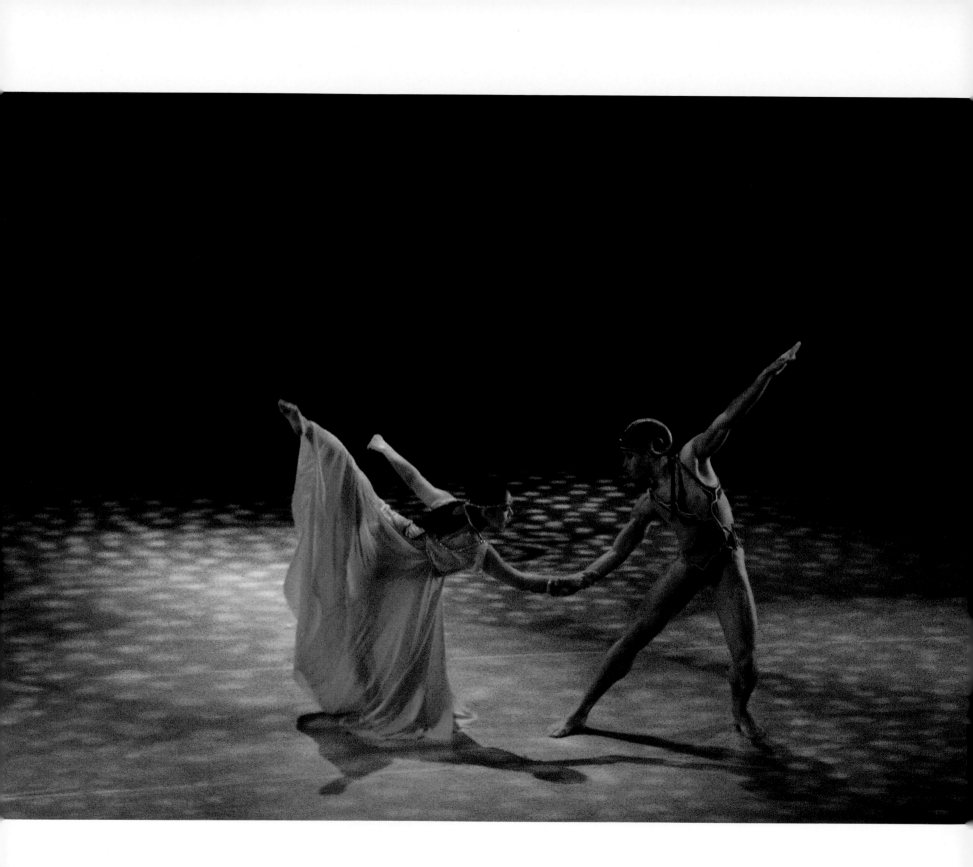

It wasn't just musical dancing; it wasn't just modern dancing; it wasn't classical dancing. It was absolutely everything!

Lynn Seymour

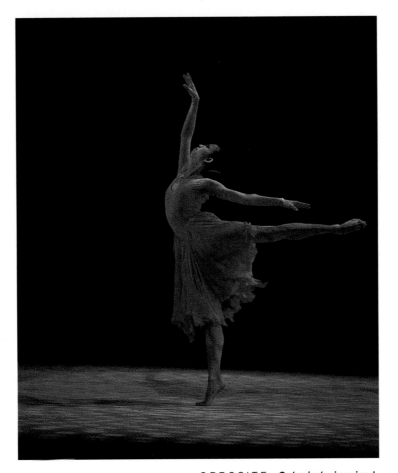

OPPOSITE: *Satyriade*, inspired by the stories of satyrs and nymphs of ancient Greece; Mari Kajiwara and Keith McDaniels in 1983.

Photographer: Jack Vartoogian

ABOVE: *The Lark Ascending*, to the music of Ralph Vaughan Williams; with Elizabeth Roxas in 1986.

Photographer: Jack Vartoogian

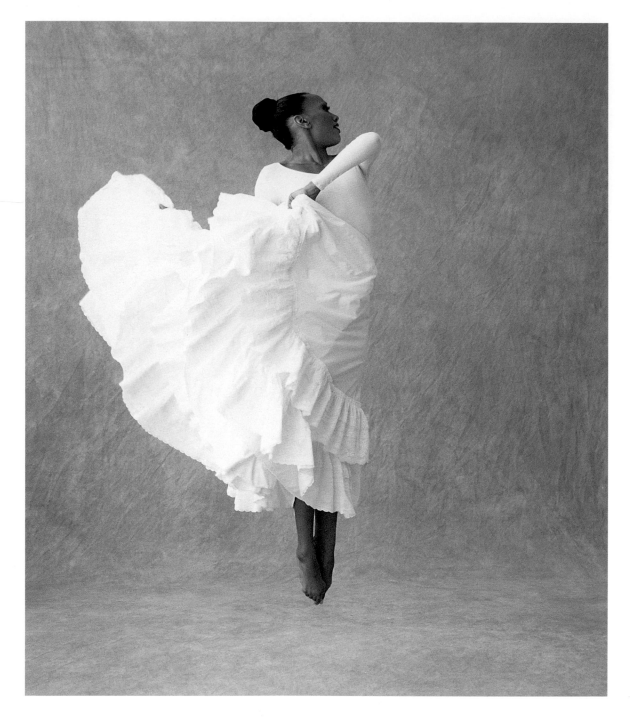

LEFT: *Cry,* with Linda-Denise Fisher-Harrell.

Photographer: Andrew Eccles

OPPOSITE: Judith Jamison's *Double Exposure*, with Mathew Rushing.

Photographer: Paul Kolnik

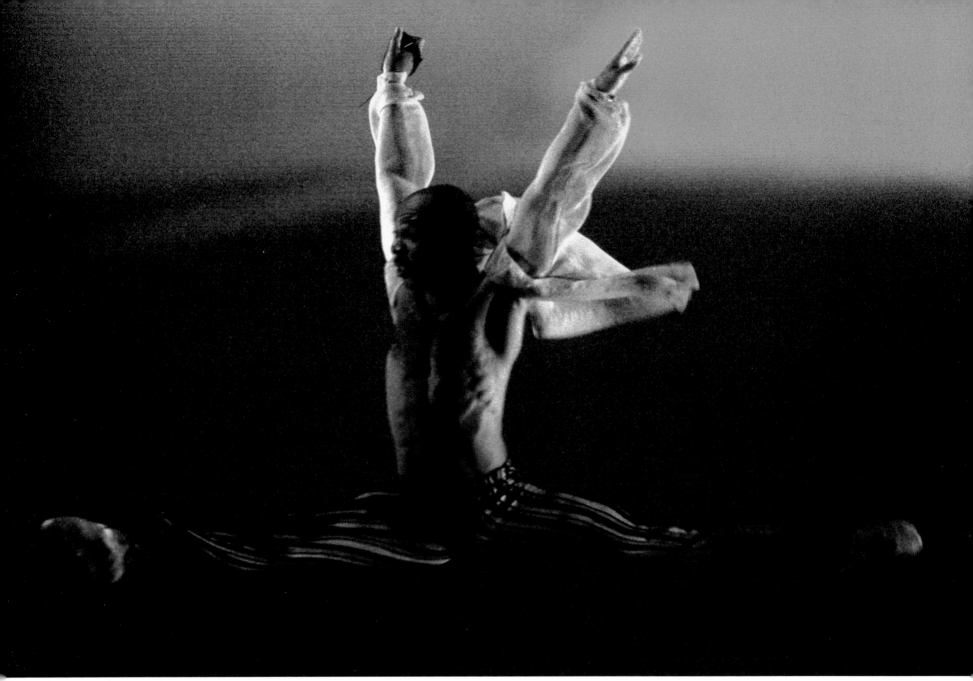

Dancing can be man raised to his highest. It's using the physical presence to strive for perfection. For the dancer, in that moment on stage, the audience is like the eye of God. You want to be perfect. *Alvin Ailey*

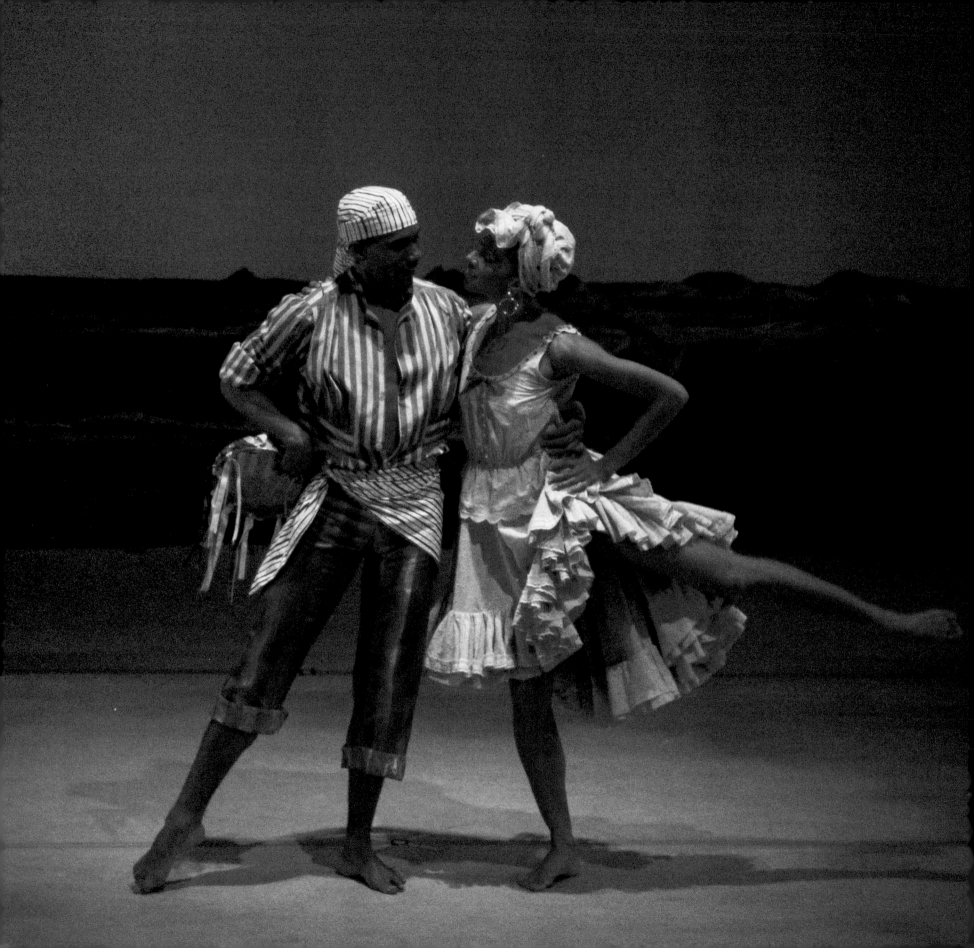

My dancers must be able to do anything, and I don't care if they're black or white or purple or green. *Alvin Ailey*

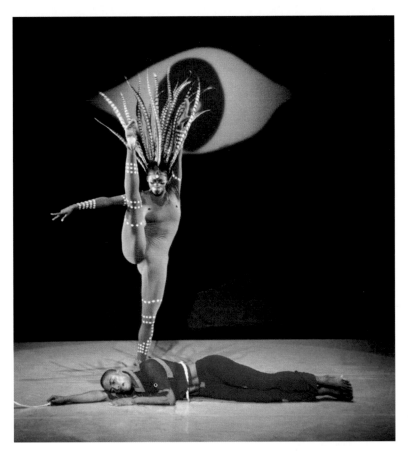

OPPOSITE: **From Katherine Dunham's** *L'Ag'ya*, **with April Berry and Rodney Nugent in 1987.**

Photographer: Beatriz Schiller

ABOVE: **Geoffrey Holder's revised** *The Prodigal Prince*, **starring Dwana Adiaha Smallwood and Jeffrey Gerodias in 1999.**

Photographer: Paul Kolnik

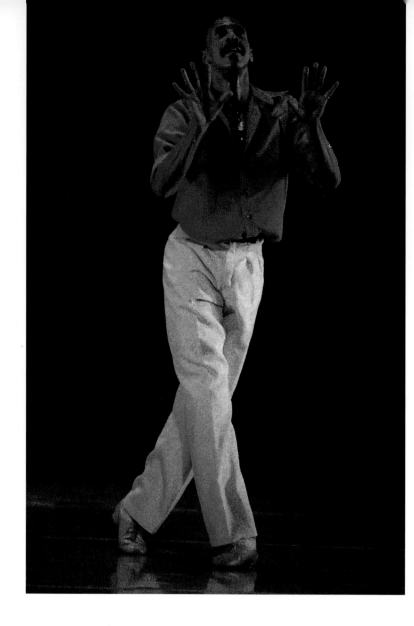

LEFT: **Dudley Williams in** *Mingus Dances*, 1979.

Photographer: Johan Elbers

OPPOSITE: **The company in the 1970s—(back row to front row) Melvin Jones, Keith McDaniel, Beth Shorter, Ronni Favors, Steve Mones, Jodi Moccia, Peter Woodin, Mari Kajiwara, Marilyn Banks, Carl Bailey, Sarita Allen, Ulysses Dove, Charles Adams, Nikki Harrison, Alvin Ailey, Judith Jamison, Alistair Butler, Milton Myers, Michihiko Oka, Mary Barnett, Maxine Sherman, Dudley Williams, Clive Thompson, Masazumi Chaya, Estelle Spurlock, Donna Wood.**

Photographer: Jack Mitchell

We are on a spiritual journey together, and we have become what Alvin called "citizens of the world." *Tina Monica Williams*

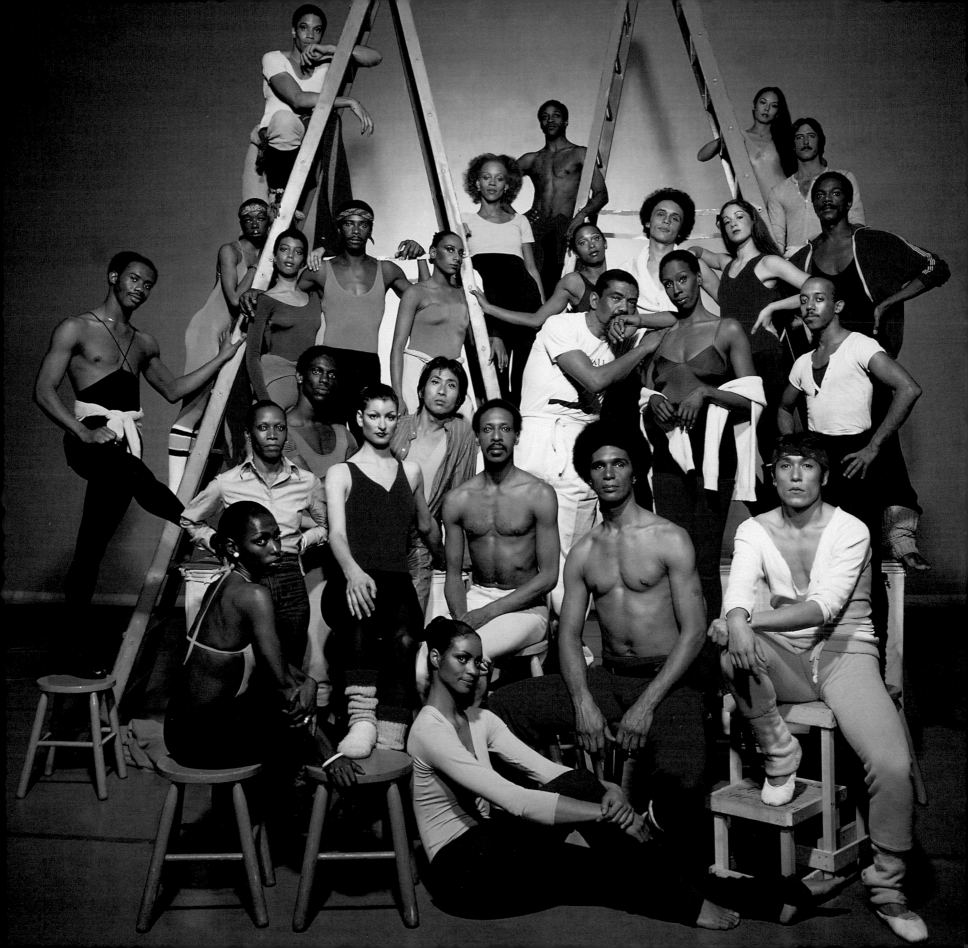

Muses

Dancers are often a choreographer's inspirational spark. For Alvin Ailey, the individual qualities of Carmen de Lavallade, Gary DeLoatch, Judith Jamison, Dudley Williams, and Donna Wood inspired some of the most poetic choreography within the Ailey idiom.

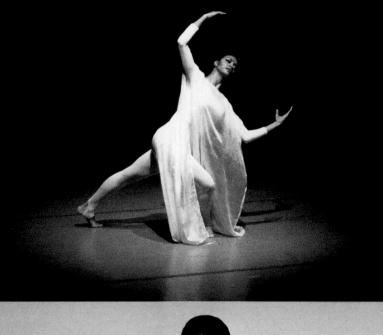

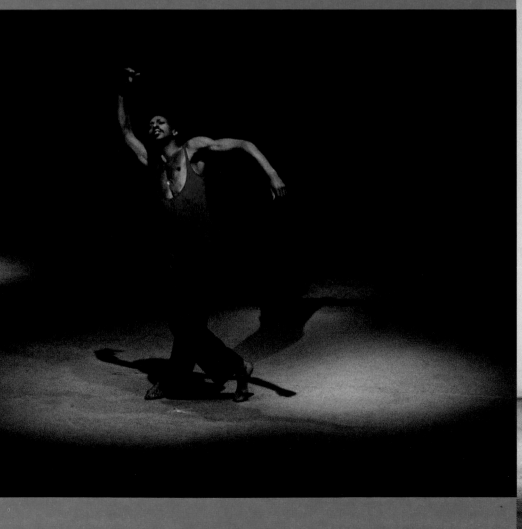

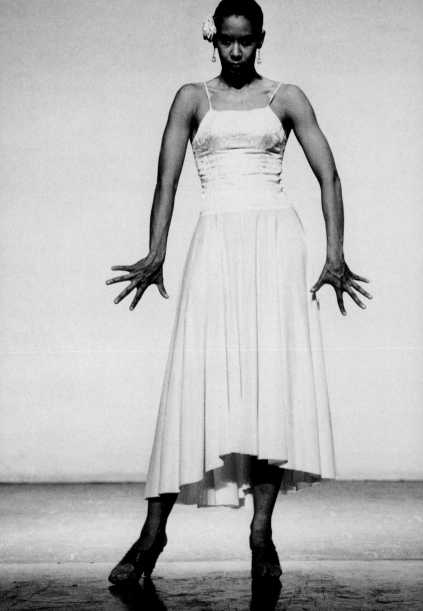

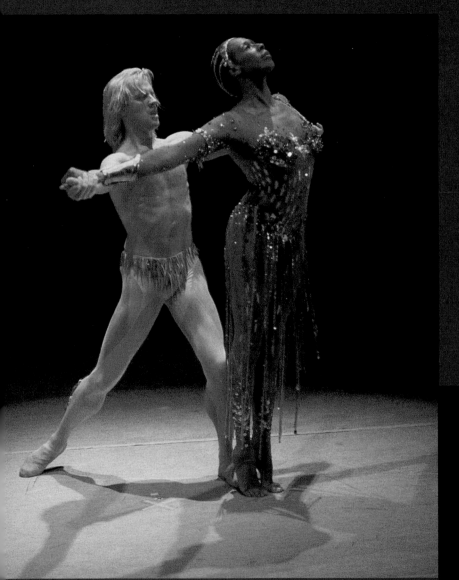

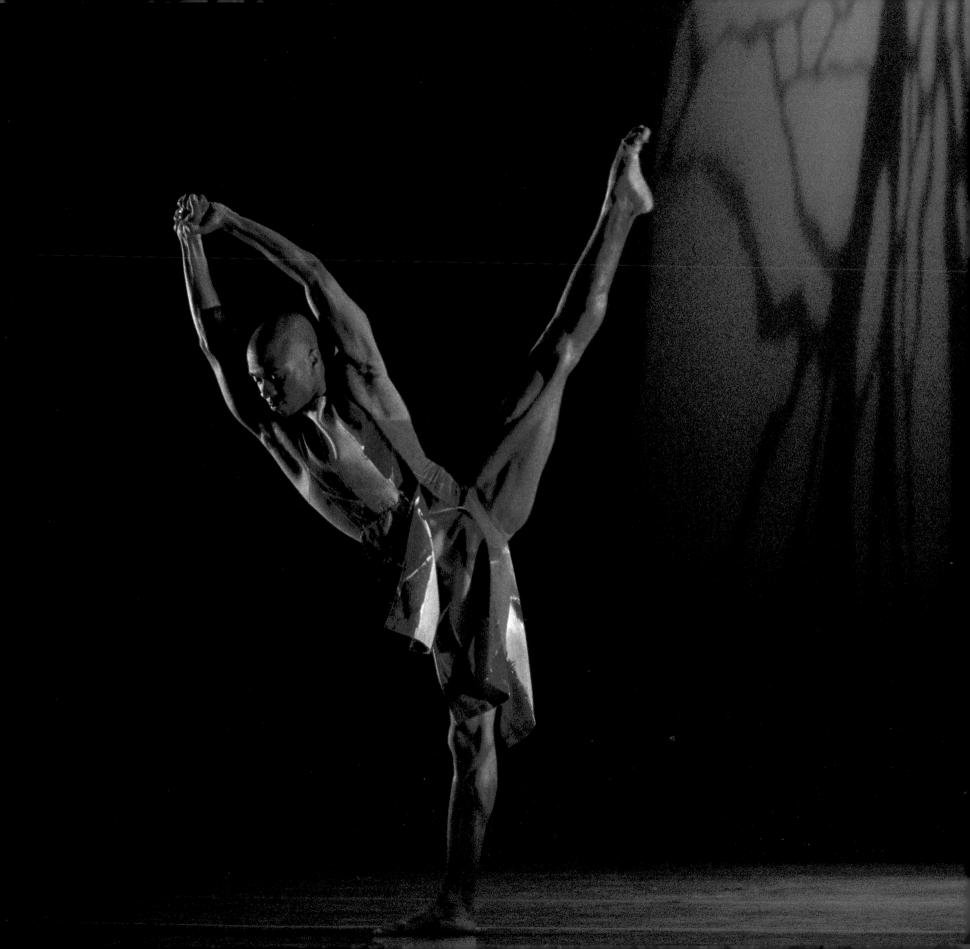

Developing a Repertory

HAVING ESTABLISHED HIS COMPANY, ALVIN AILEY SET OUT TO BUILD A REPERTORY OF NEW works and old treasures. From the beginning he had been strongly influenced by his mentor Lester Horton. "I was tremendously impressed by him," said Ailey in 1975. "There were all kinds of people around him, all kinds of ideas, all kinds of music, painting, sculpture. Lester was the genius of all of this." At Horton's, Ailey not only studied dance and experimented with choreography, but he mopped the stage and changed the gels; he worked in the costume shop; he painted scenery. To earn money, he worked in a nearby restaurant. "And I was happy," remembers Ailey. "Lester let us know that we were all beautiful. There were Japanese and Mexicans and blacks, whites, greens, and pinks. And it was great! I was very happy being in the milieu of dancers." Eventually Ailey would include five ballets by Horton in his company's repertory.

John Butler was one of the contemporary choreographers Ailey met when he first arrived in New York City. Butler came out of the generation of choreographers who created dance-drama, such as Martha Graham, Agnes de Mille, and Antony Tudor. When the young Ailey troupe toured the Far East, Horton, Butler, and Glen Tetley contributed one dance each to the company's program of ten pieces. Geoffrey Holder said that Butler was the "mother of us all because he would confirm what we were all choreographing." By 1983 there were seven Butler dances in the repertory of the Ailey company, and another seven by Talley Beatty.

"Take a work like Talley Beatty's *The Road of the Phoebe Snow* or his *Congo Tango Palace*," said Ailey in 1965. "I have wanted to keep fine dances like these alive, which sometimes means programming them once or twice a week on an overloaded tour just to keep them running in the repertory. Beatty created his own special way of moving in these dances and a whole picture of a black social milieu. It's imperative for the dancers to know this way of moving."

> One has to be versed in all dance techniques and at the same time have some sense of theatricality. Particularly in Alvin's work, you have to be mature enough to bring something to it, because he gives you a lot of room as an individual artist. *Dwight Rhoden*

Donald McKayle, a close friend of Ailey's, would create eight ballets for him. Back when Alvin was dancing in McKayle's company, they would talk about their choreographic ideas and visions. "I enjoyed communicating with Alvin," says McKayle, "although Alvin was terribly critical of himself as a choreographer. It was vitally important for him to develop this repertory, and he has done a great service to the world." Three of McKayle's monumental works—*Games*, *Rainbow Round My Shoulder*, and *District Storyville*—were presented in a full evening's performance in 1990.

Geoffrey Holder believes it was extremely astute of Ailey to create a modern dance repertory company. Ailey wasn't like Graham or Merce Cunningham or Paul Taylor, who only presented their own works in a single program. "It gave the audience time to breathe," explains Holder. "I believe that is why Balanchine took on Jerry Robbins, so one could have a fresh perspective between the various ballets." Holder's two works for Ailey were *The Prodigal Prince* (1968 and 1999) and *Adagio for a Dead Soldier* (1970). *The Prodigal Prince* was inspired by the young Puerto Rican dancer Miguel Godreau, who, Holder says, "was like an imperial Latin, a brave bullfighter." Holder created *Adagio for a Dead Soldier* for the "tall, beautiful, powerful" Judith Jamison. Holder choreographed the piece during the Vietnam War and dedicated it to "all of the war dead on both sides in this incredible tragedy."

One of the first African Americans to study at Balanchine's School of American Ballet, Louis Johnson began choreographing while still a student. In 1964 Ailey saw his *Lament*, choreographed in 1953, and wanted his dancers to perform it, especially Georgia Collins, Hope Clarke, and later Judith Jamison. Johnson had set the piece to the music of Hector Villa-Lobos and combined the techniques of jazz, modern, and ballet. "It was very exciting for that time," remembers Johnson. "In 1981 Alvin asked

PAGE 62: Judith Jamison's *Divining*,
with Matthew Rushing, in 1999.
Photographer: Jack Vartoogian

me to create anything I wanted for the company, so I choreographed *Fontessa and Friends* for Donna Wood. When we revived it, April Berry danced as the lead woman."

In assembling his repertory, Ailey believed that dance fans should be educated as well as entertained. "It takes a lot of tenacity to keep the old stuff in the repertory," said Ailey in 1985. "Some of the works are dated, and all of them are hard to reconstruct because you have to have somebody who knows the dance to come in and work with the company, and it is getting harder and harder to find people who remember those pieces. Still, I think we have to try."

"Through dedicated effort," Ailey continued, "we have been able to keep alive some of the black ballets by Pearl Primus and Katherine Dunham, for instance, that nobody would have seen otherwise." Works by Janet Collins, Anna Sokolow, Joyce Trisler, May O'Donnell, Pauline Koner, José Limón, Louis Falco, Ted Shawn, Lucas Hoving, Diane McIntyre, Lar Lubovitch, Billy Wilson, Elisa Monte, Hans van Manen, and Eleo Pomare have also been preserved in the eclectic Ailey repertory.

Jennifer Muller, an alumna of José Limón, first choreographed for Ailey in 1977 with *Crossword* and returned in 1987 with *Speeds*. Both were set to the music of her longtime collaborator, Burt Alacantara. In 2003 Judith Jamison commissioned Muller to choreograph a new piece titled *Footprints*. "I loved Alvin," says Muller, "and Judy [Jamison] and Chaya [Associate Artistic Director Masazumi Chaya] and I go way back. In fact, both Chaya and Renee danced in my earlier pieces for Ailey. "The current dancers are wonderful to work with. They have a tremendous energy, generosity,

and spirit. *Footprints* was an opportunity to discover new things in new people."

Kathryn Posin first created for the Ailey company in 1980 with *Later That Day*, choreographed to Philip Glass's music from *Einstein on the Beach*. Posin was the first choreographer to use minimalist music within the Ailey canon. *Later That Day* was a hit with the company for three years. "I created a minimalist floor plan and had ten men dancing in a line," she remembers. "Only two of those men are still alive: Chaya and Milton Myers."

Alvin Ailey provided avant-garde choreographer Bill T. Jones with his first major commission, *Fever Swamp*, choreographed for the Ailey company in 1983. Ailey then included the dance in the program for the PBS television special *Dance in America*, bringing Jones's work to mainstream America. In the program notes, Jones described *Fever Swamp* as "a dance created for the male members of Ailey noted for their strength, accessibility, and robust ensemble work." In the Ailey company of the eighties, said Jones, "I was concerned with combining formalism with athleticism while depicting my solid commitment to blend high and low art. I had never worked with six black men before, and my agenda was to portray a masculine ritual. *Fever Swamp* was a huge success, and I was young and thought I would live forever."

Sixteen years later the work was revived for the company under Judith Jamison. Although he describes the earlier version as a cliché, "a posturing piece for the dancers," Jones reworked *Fever Swamp*, making it "more difficult, faster, more complicated, and technically more challenging in terms of the classical vocabulary and partnering the dancers must execute." In 1999 I wanted to include a woman to show that their energies match the men's. Ultimately all of the dancers give a kick-ass, tour-de-force performance to Peter Gordon's driven locomotive score." As Jones observed, the work delivered to the performers and the viewers "a curious adrenaline rush."

Under the direction of Judith Jamison, The Ailey has continued to introduce fresh work by choreographers seeking to take American dance in new directions. Jawole Willa Jo Zollar, the artistic director of Urban Bush Women, was asked by Jamison to stage her outstanding dance about the homeless, *Shelter*, for the company in 1992. She had an all-female cast, an all-male cast, and a mixed cast perform this extraordinary social statement. In 1999 Jamison commissioned Zollar to create another new work, *C# Street-Bb Avenue*. Jazz was always a big part of her life. "I grew up listening to Sarah Vaughn, Ella Fitzgerald, and Charlie 'Bird' Parker," says Zollar. "I love their music. I also loved the music of my youth, which was doo-wop and R & B." She was entranced by Alvin Ailey's two ballets about Kansas City jazz, *For Bird—With Love* and *Opus McShann*.

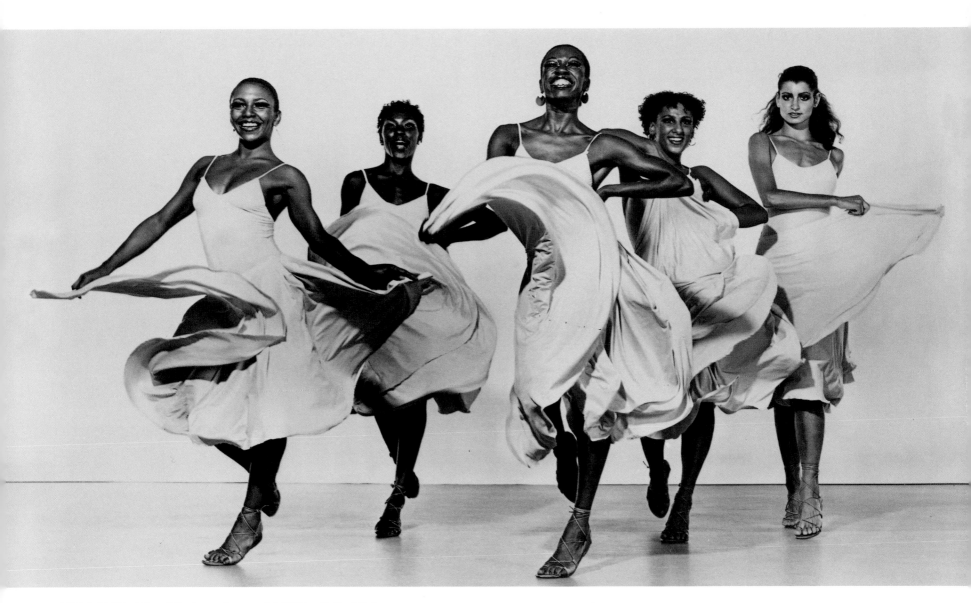

OPPOSITE: Miguel Godreau, in Geoffrey Holder's *The Prodigal Prince,* in 1967.

Photographer: Jack Mitchell

ABOVE: *Suite Otis* by George Faison; Linda Spriggs, Estelle Spurlock, Marilyn Banks, Sarita Allen, Maxine Sherman, in 1979.

Photographer: Jack Mitchell

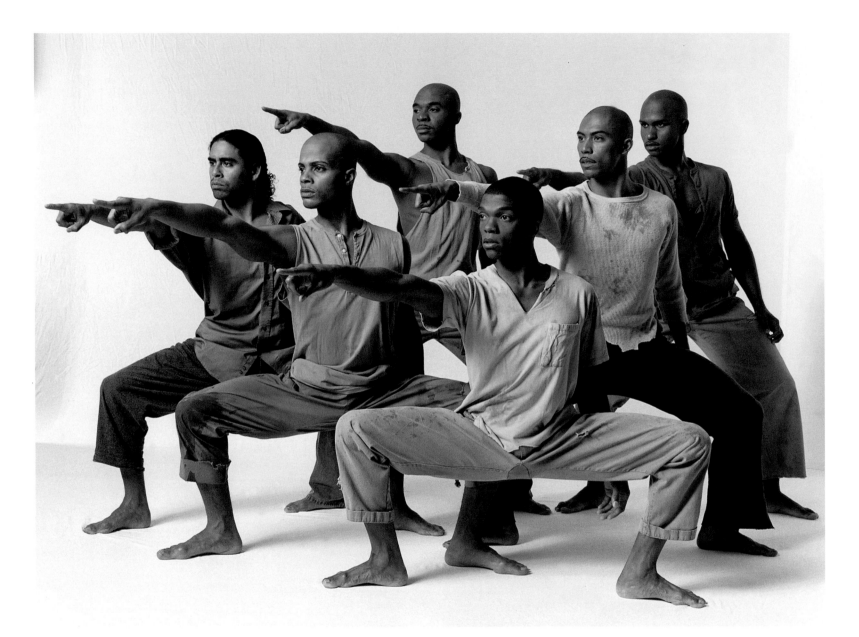

ABOVE: *Shelter* by Jawole Willa Jo Zollar; Guillermo Asca, Vernard Gilmore, Matthew Rushing, Kevin Boseman, Jeffrey Gerodias, Glen A. Sims

Photographer: Andrew Eccles

OPPOSITE: choreographer Bill T. Jones in 1983 rehearsing *Fever Swamp*, Jones's "masculine ritual," with (left to right) Ron Brown, Rodney Nugent, Kevin Brown, Keith McDaniel, Daniel Clark, and Gregory Stewart.

Photographer: Jack Mitchell

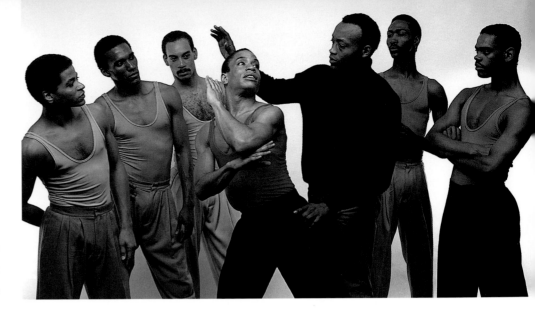

According to Joe Nash, the African American dance historian, "Alvin's goal from the very beginning was for his dancers to be able to move from one style to another, with ease, grace, passion, and conviction." Ailey also wanted his dancers to experience the process of choreographing. Exceptional members of his company, like George Faison, Hope Clarke, Kelvin Rotardier, Loretta Abbott, Michele Murray, Joan Peters, John Parks, Milton Myers, Gary DeLoatch, Ulysses Dove, and Mary Barnett, as well as Dwight Rhoden and Troy Powell have all contributed dances for the Ailey repertory. Most of the earlier dancers created solos for Jamison. Choreographing for her "was quite a challenge," Jamison recalls, because she was typecast "as goddess, earth mother, a bold, strong, forceful woman. Those specific, choreographic dancers knew me very well and were able to go past that."

Kelvin Rotardier began working with Ailey in 1963. By 1970 Rotardier had two dances that he had choreographed in the Ailey repertory.

"With *The Cageling* I created a solo for John Parks. The jazz score by Nat Adderly was very militant. I was influenced by reading about the Black Panthers."

Child of the Earth, to the music of Hugh Masekela, was a duet he created for Consuelo Atlas and Clive Thompson. "I also performed it with Connie when Clive didn't dance it. Connie and I worked very well together." Rotardier choreographed *Tell It Like It Is* to the music of Terry Callier in 1988.

In 1970 John Parks choreographed *Black Unionism*, to the music of John Coltrane. "I was in my revolutionary phase, so I created a solo for Judith titled *Nubian Lady* in 1972," he says. "It was amazing to watch Judith go out of her comfort zone to attain what I had given her to perform. Judy had a magic, a charisma that was just incredible to share and behold."

"I want you to think about choreographing a work on Ailey II," Alvin Ailey said to Milton Myers in 1974. "Would you be interested in doing a work for the Ellington Festival?" Alvin then gave him Ellington's book, *Music Is My Mistress*, and told him to do his homework. "I think at that point Alvin saw something in me that he liked as a choreographer," states Myers. "Alvin watched my classes, and he enjoyed the way I was putting movement together." Myers created *Echoes in Blue* for Alvin's Ellington Festival in 1975, and in 1977, he choreographed a solo for Jamison titled *The Wait*, to the music of Antonio Vivaldi.

"Alvin's interpretation of the African American experience was liberating and full of self-esteem," recalls George Faison, who danced briefly with the company. "In that sense I began to think of other things to say in dance." In all, five Faison ballets were performed by the Ailey company: *Gazelle*, *Suite Otis*, *Tilt*, and *Slaves* had all been choreographed originally for the George Faison Universal Dance Experience.

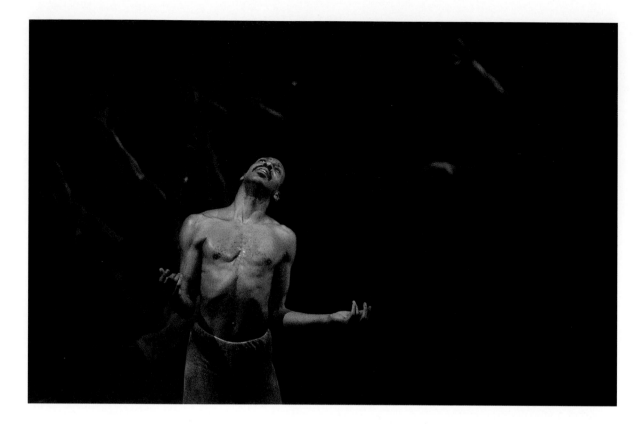

OPPOSITE: *Rift*, by Judith Jamison, in 1991; with Dwight Rhoden and Antonio Carlos Scott facing Daniel Clark, Renee Robinson, Danielle Gee, Lydia Roberts, Don Bellamy, and Raquell Chavis.

Photographer: Beatriz Schiller

ABOVE: Dudley Williams in *Rainbow Round My Shoulder*, Donald McKayle's powerful work about chain gangs.

Photographer: Johan Elbers

"Alvin would see these ballets with my company and then ask me to set or re-create them for Ailey. My ballets had their own notoriety. Alvin wanted me to give his dancers elements that would challenge them as performing artists."

Judith Jamison herself has created ten ballets for the Ailey company. *Tease* was choreographed for Ailey II in 1988, and *Forgotten Time*, originally produced by the Jamison Project, was brought into the Ailey repertory in 1989. Since that time, Jamison's works created for the Ailey have included the Emmy Award-winner *Rift; Divining; Hymn,* her moving tribute to Alvin Ailey; *Riverside; Echo: Far from Home;* and *Double Exposure*. On *Sweet Release* in 1996 and again on *HERE . . . NOW* in 2001, Jamison collaborated with the celebrated trumpeter and composer Wynton Marsalis.

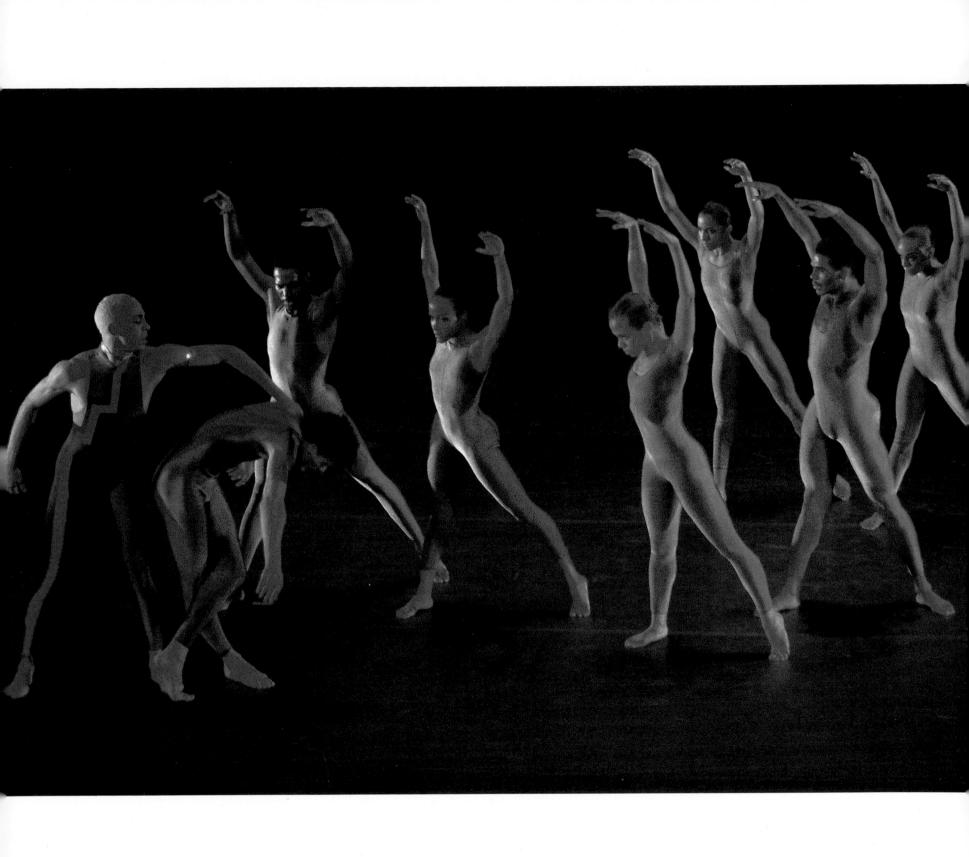

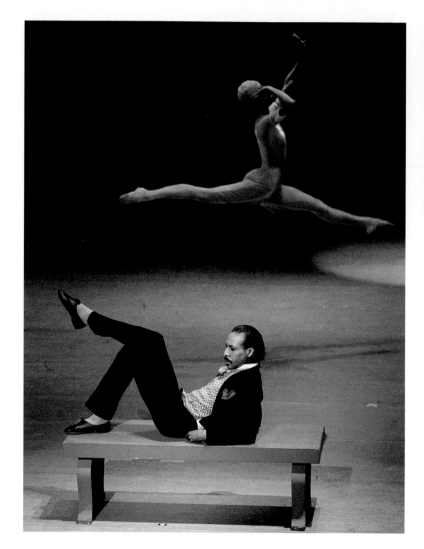

ABOVE: *Later That Day* by
Kathryn Posin; with Maxine
Sherman and Dudley Williams
in 1980.

Photographer: Jack Vartoogian

RIGHT: Judith Jamison in
Facets, a solo by John Butler,
in 1978.

Photographer: Jack Vartoogian

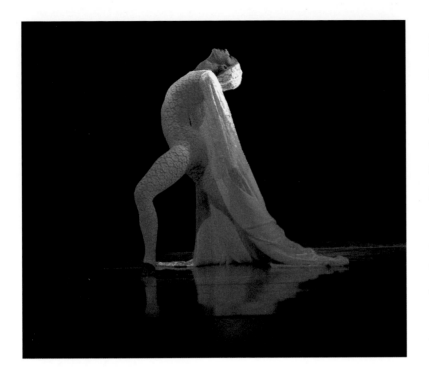

April Berry in *Collage* by Donald McKayle, 1984. The forces of nature inspired this work, according to the choreographer.

Photographer: Jack Vartoogian

Troy Powell was encouraged by Judith Jamison to create his first piece, *Ascension*, to the music of Michael Wemberly, while he was a dancer with the Ailey company. "As far as being a choreographer, and being a black man in dance, I've always identified with Alvin," says Powell. "It is what Alvin started out doing and what Judy is continuing: opening the doors up for a lot of people. She has done a wonderful job of keeping Alvin alive, true, and honest—Aileyfied."

"Beyond Alvin's spirituality, dancers are attracted to the Ailey repertory because it is so diverse," says Dwight Rhoden, who directs the Ailey-inspired company Complexions with former Ailey dancer Desmond Richardson.

Jamison commissioned Rhoden's *Frames* while he was dancing with the company in 1992. He has choreographed two more pieces, *Chocolate Sessions* in 2000 and *Bounty Verses* in 2003. Rhoden thinks Jamison's eclecticism is different from Ailey's but still within the same spirit of diversity and adventure in terms of taking chances.

"Judy is sharp and intelligent when selecting choreographers," says Rhoden. "She is not taking the secure route, and that is part of the appeal of the company. The reality is, people who come to see the Ailey company perform will, in one way or another, be entertained and provoked beyond the edge."

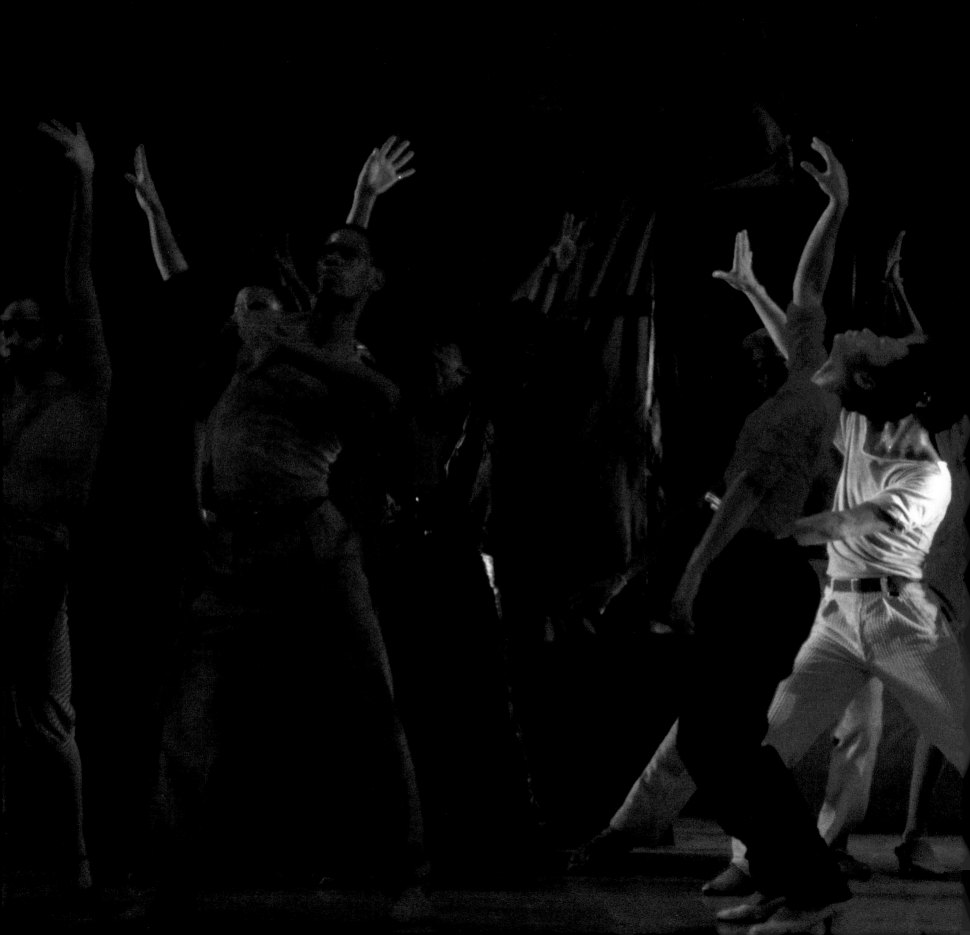

Talley created an entirely wonderful way of telling a story that incorporated bits of Graham but also jazz, combining that and classical ballet, and then moving it at 250 miles an hour. *Judith Jamison*

The company performing the
sensational and jazzy *Blueshift,*
by Talley Beatty, in 1983.
Photographer: Jack Vartoogian

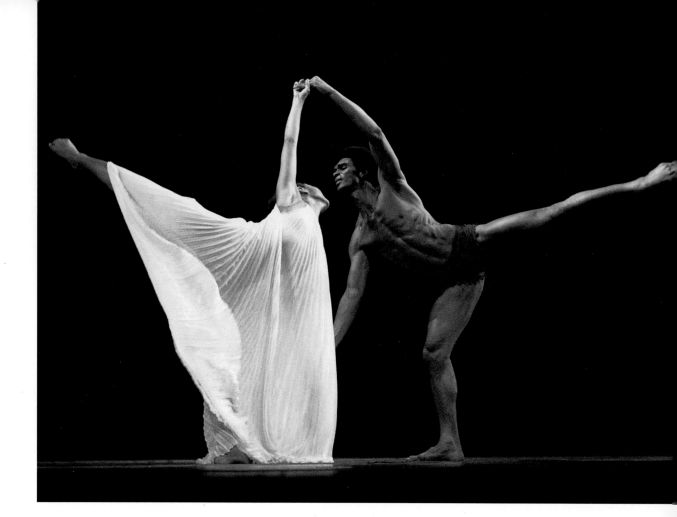

Carmina Burana, John Butler's love duet inspired by medieval poetry, performed by Tina Yuan and Clive Thompson in 1975.
Photographer: Johan Elbers

Everything in dancing is style, allusion, the essence of many thoughts and feelings, the abstraction of many moments. Each movement is the sum total of moments and experiences.

Alvin Ailey

Clive Thompson is Perseus and
Judith Jamison is the Gorgon in
Margo Sappington's *Medusa*,
1978.

Photographer: Jack Vartoogian

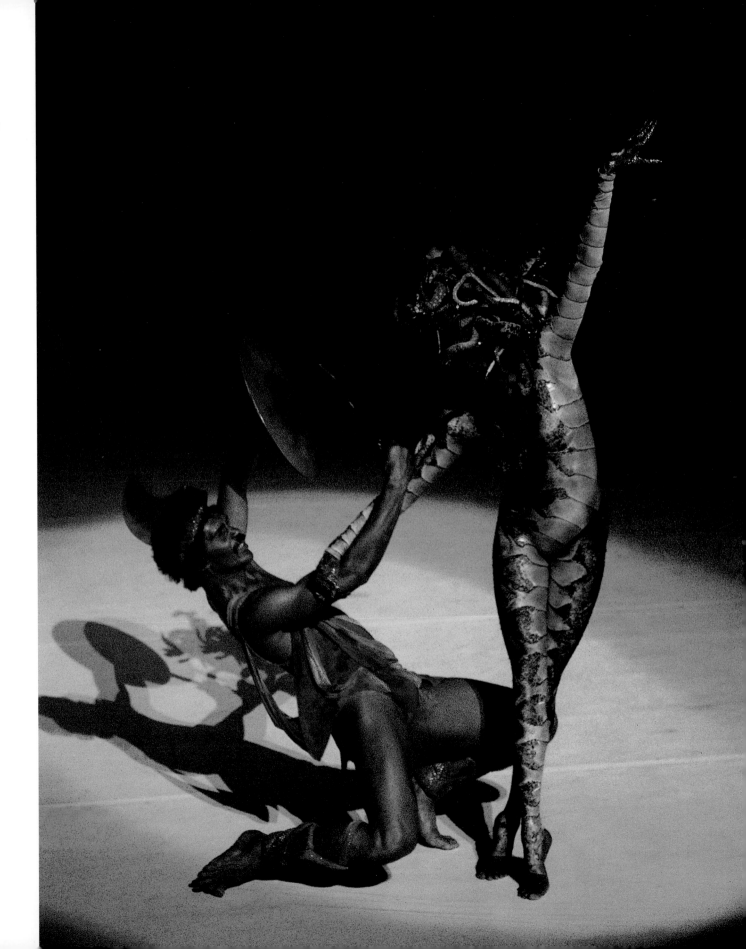

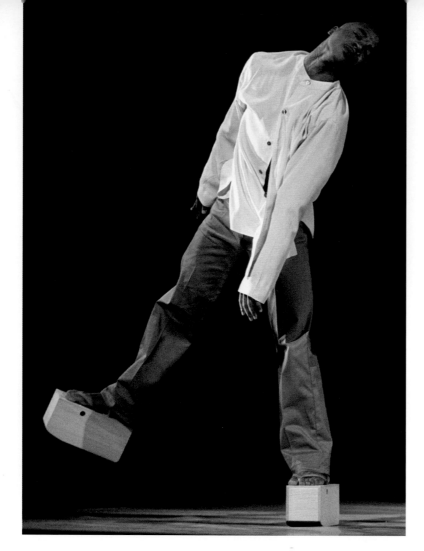

Even as a choreographer and dancer I see in terms of theater. I've never liked to see dancers on stage, but people. I always tell my dancers: don't look like a dancer; be a vessel for human emotions, try to look like a human being. Only when I achieve this do I feel that both the public and I are satisfied.

Alvin Ailey

ABOVE: Mathew Rushing in *Caravan* by Louis Falco, originally choreographed for Ailey's 1976 Duke Ellington festival.

Photographer: Paul Kolnik

OPPOSITE: *The Stackup* by Talley Beatty; Rodney Nugent, Sharrell Mesh, and the company in 1984.

Photographer: Jack Vartoogian

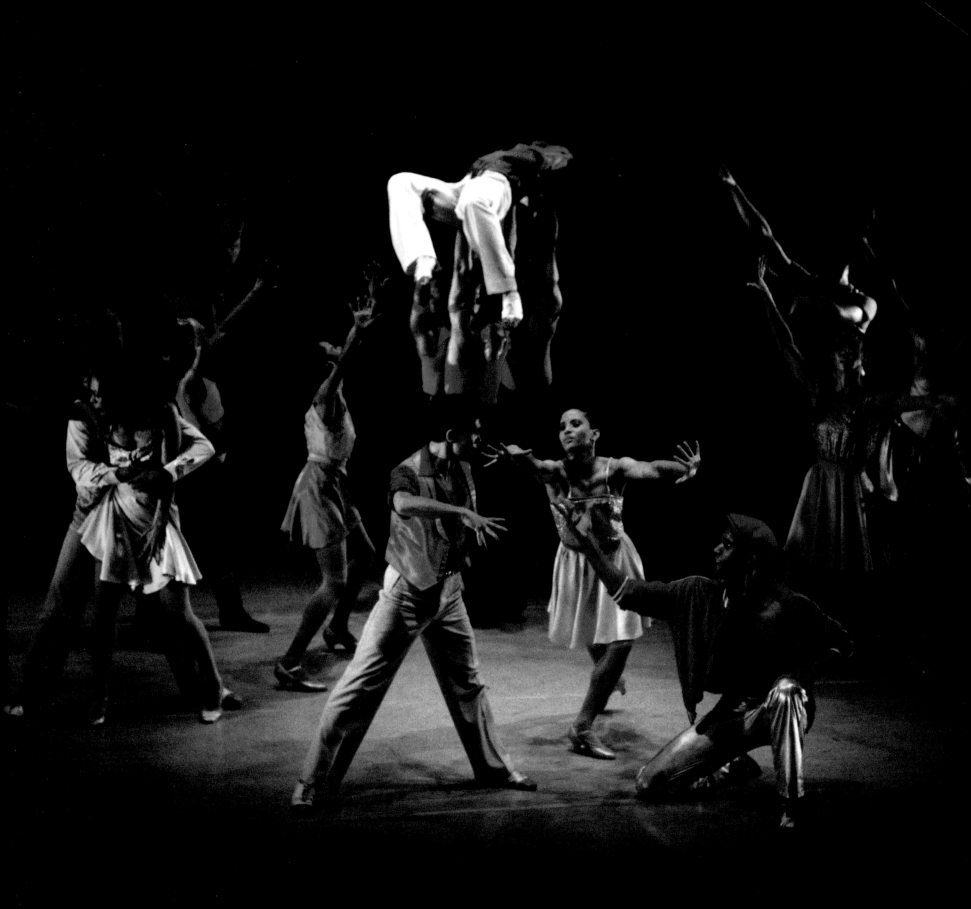

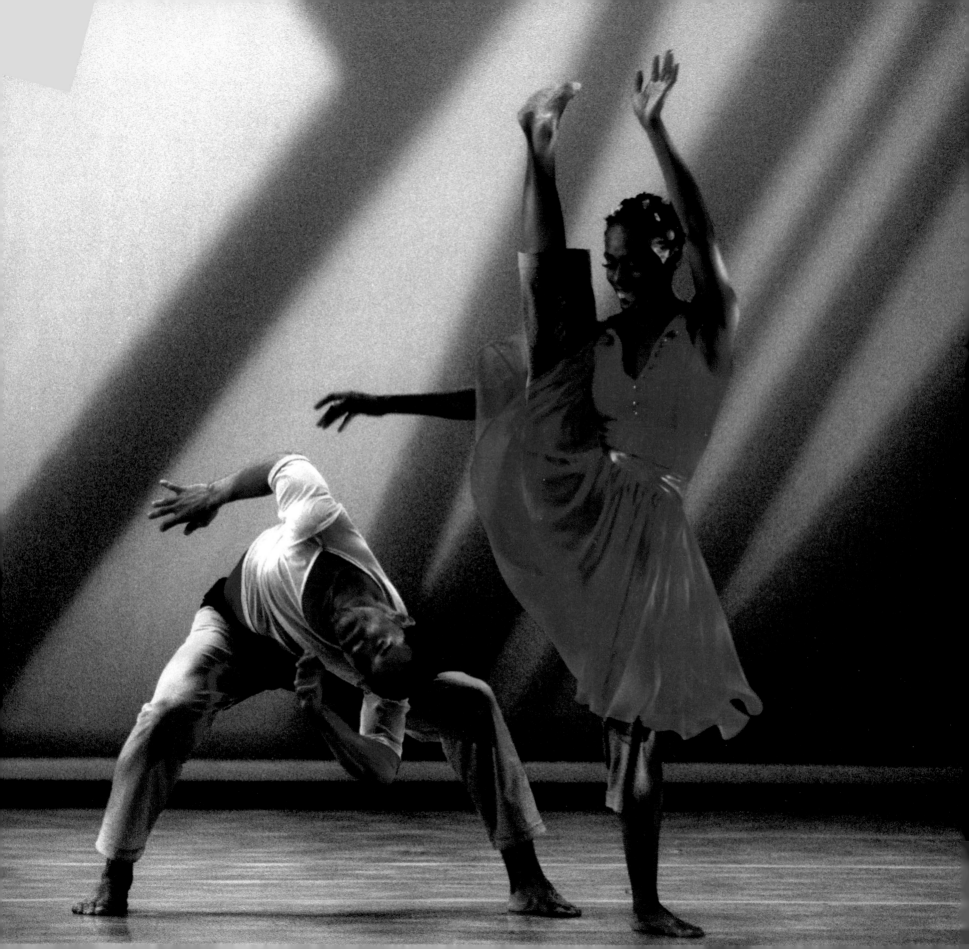

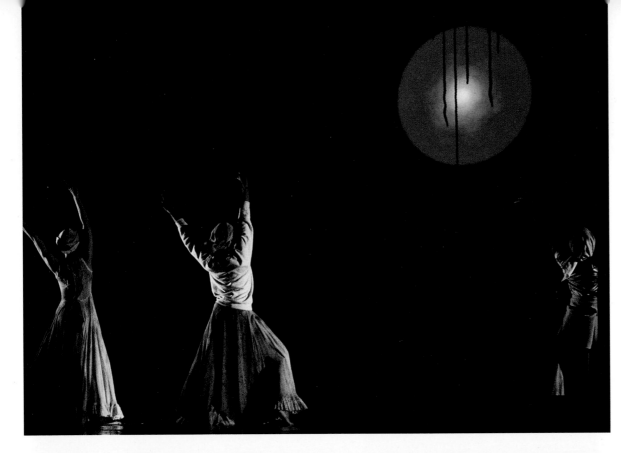

OPPOSITE: *C# Street-B^b Avenue* by Jawole Willa Jo Zollar; Dwana Adiaha Smallwood and Richard Witter in 1999.

Photographer: Paul Kolnik

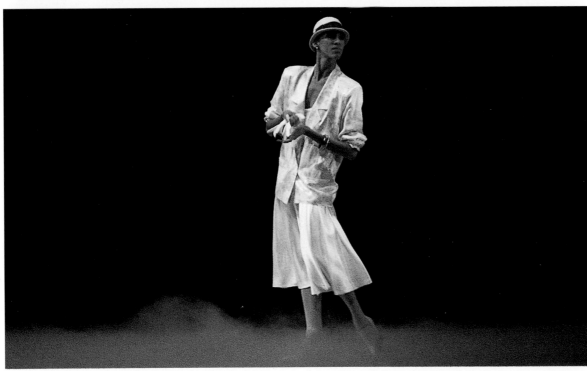

ABOVE: *Blood Burning Moon* by Eleo Pomare, 1977.

Photographer: Beatriz Schiller

BELOW: April Berry in *Lament* by Louis Johnson.

Photographer: Jack Vartoogian

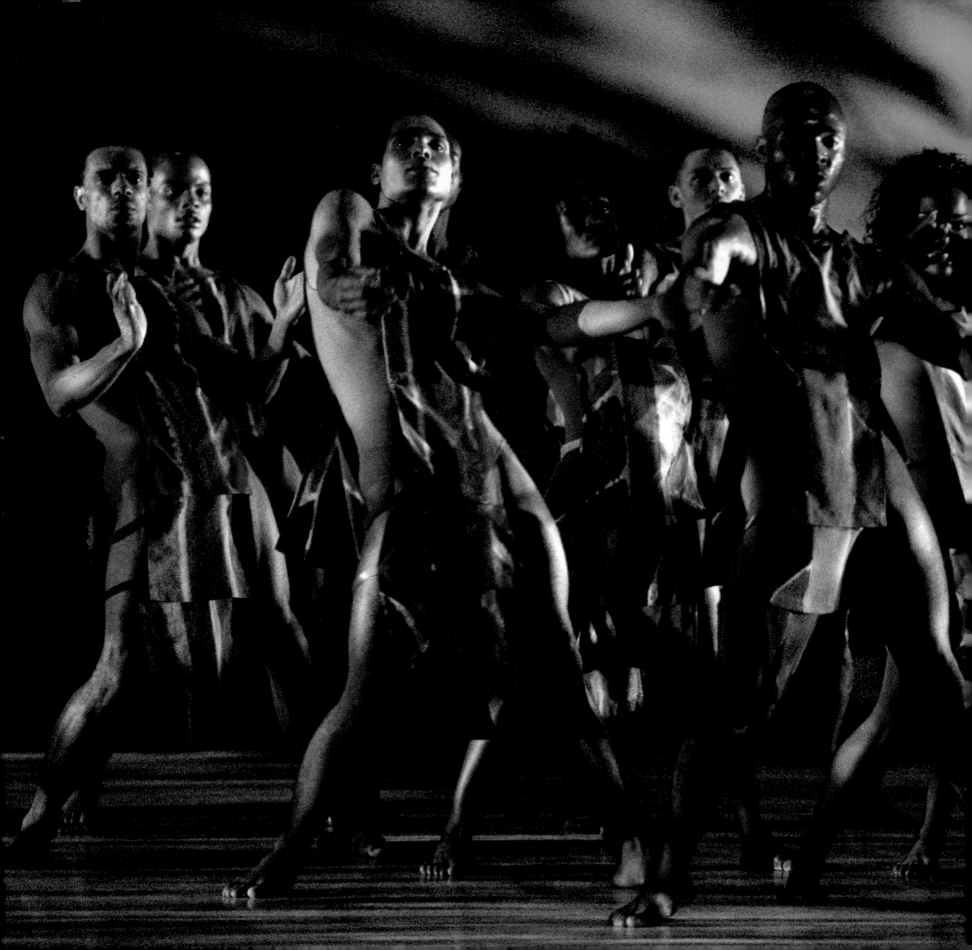

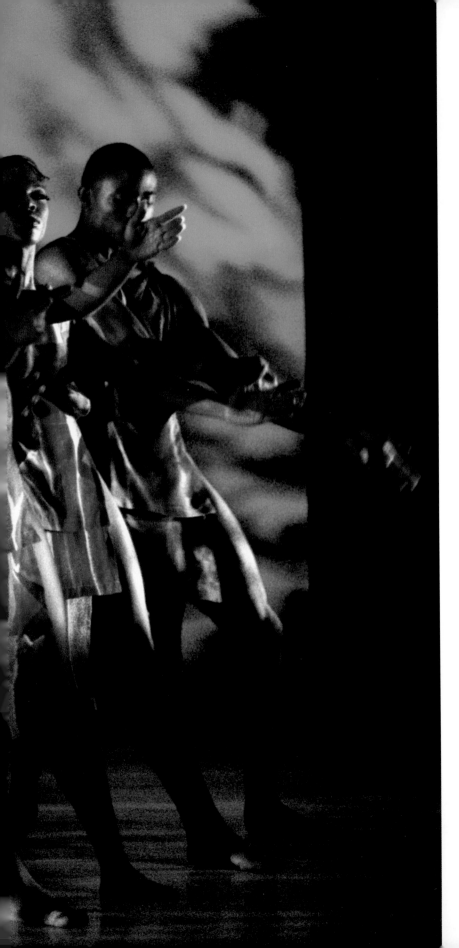

As a dancer, I don't ever remember being eager to choreograph. Alvin pulled me out of the Connecticut woods to create my first piece, *Divining*, for the company in 1984.

Judith Jamison

The company, led by Mathew Rushing, in Judith Jamison's *Divining*.

Photographer: Paul Kolnik

The revised *Fever Swamp* by Bill T. Jones was "More difficult, faster, more complicated, and technically more challenging in terms of the classical vocabulary and partnering the dancers must execute" and included a woman.

Performing here (left to right): Richard Witter, Guillermo Asca, Dwana Adiaha Smallwood, Matthew Rushing, and Kevin Boseman.
Photographer: Paul Kolnik

The company's not just about the African American experience. It's about the culture and the modern dance tradition.

Judith Jamison

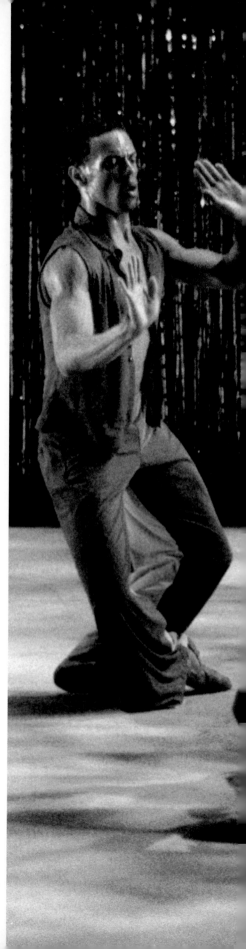

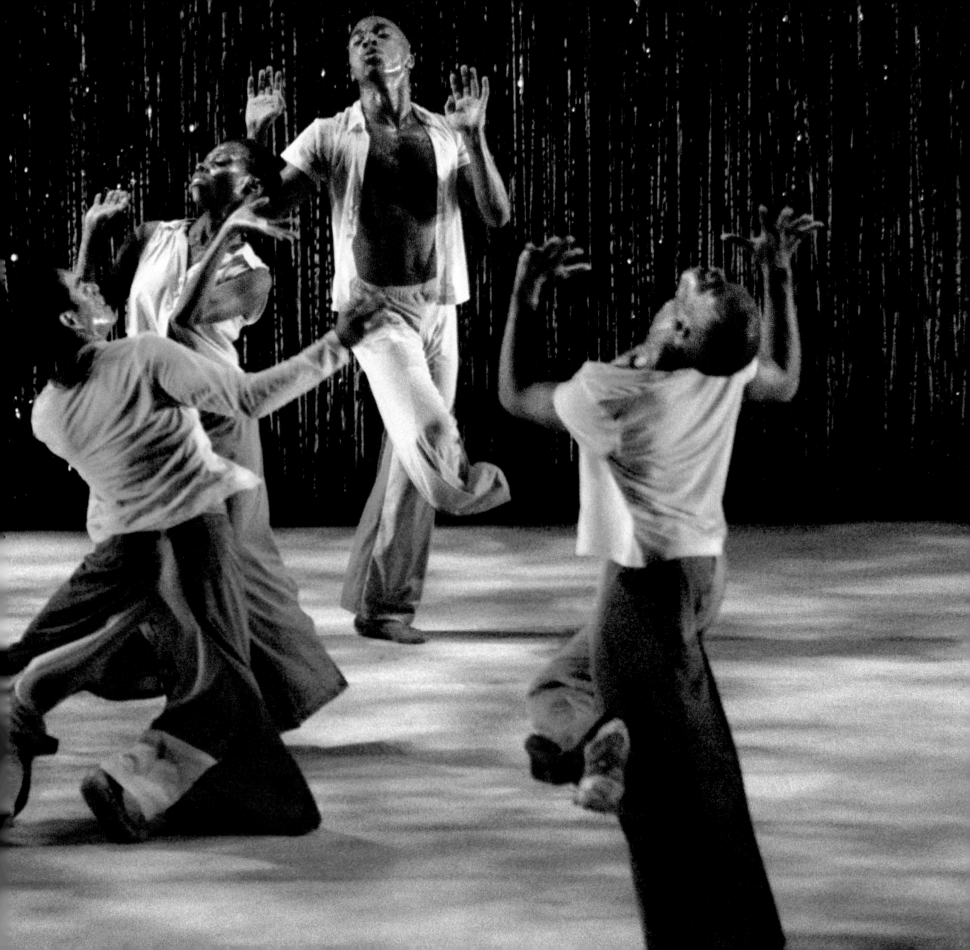

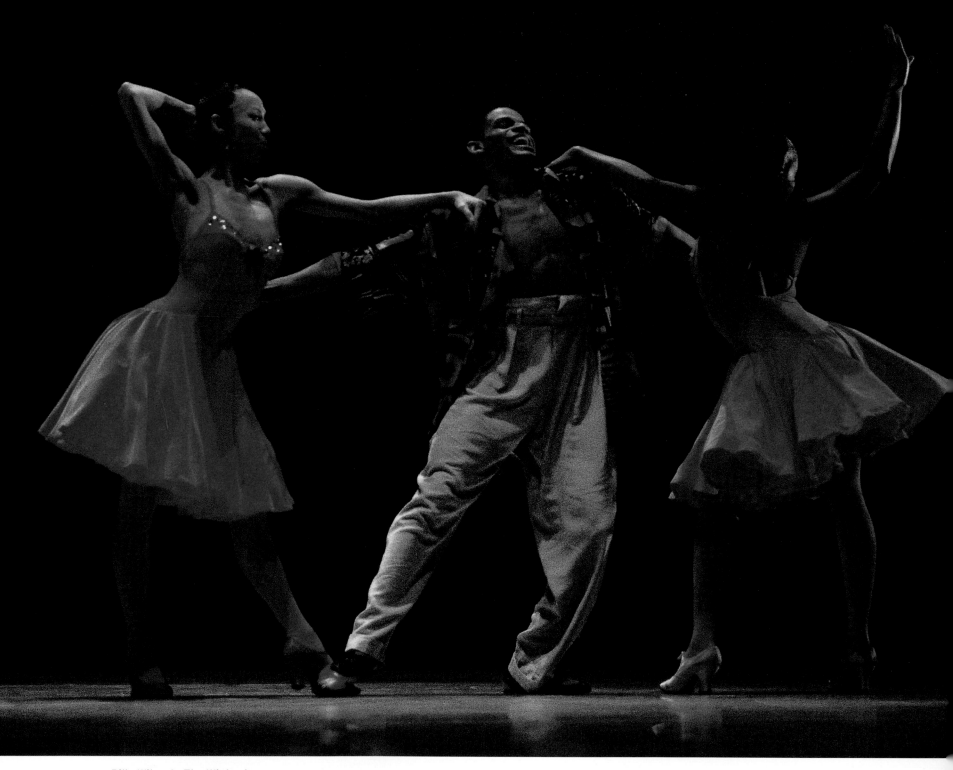

Billy Wilson's *The Winter in
Lisbon*; with Michael Thomas,
Elisabeth Roxas (left), and
Deborah Manning (right) in 1992.
Photographer: Jack Vartoogian

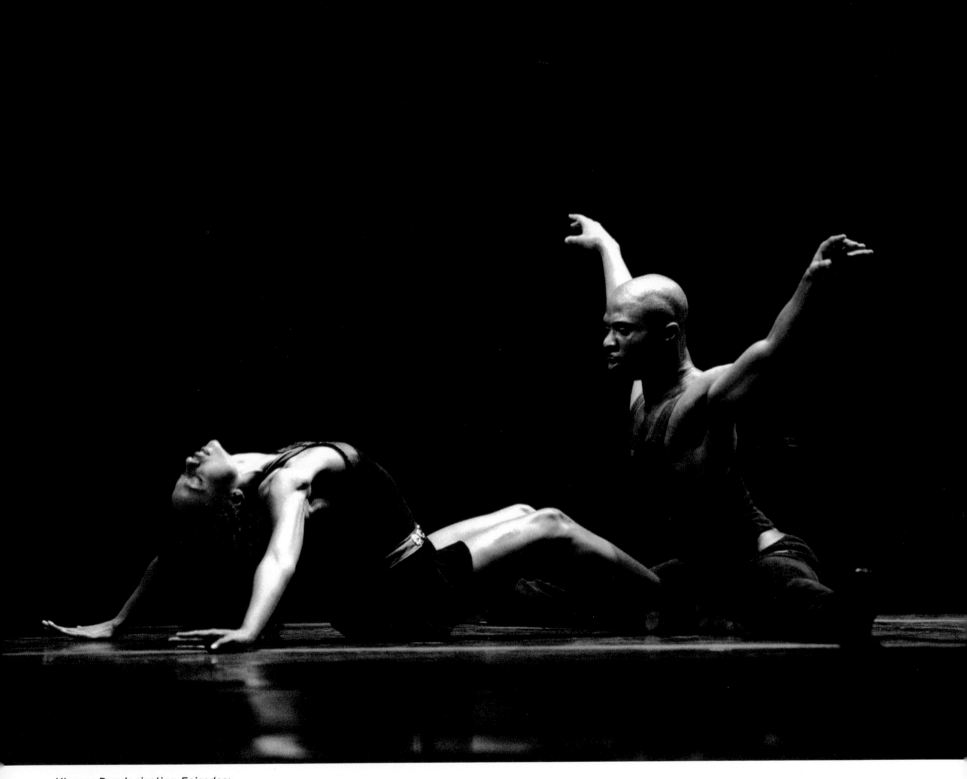

Ulysses Dove's riveting *Episodes;*
with Linda Celeste Sims and
Matthew Rushing.

Photographer: Paul Kolnik

Ulysses Dove

The explosive dancer Ulysses Dove was one of the most impor-
tant choreographers to come from within the company. A protégé
of Alvin Ailey, he was influenced by Balanchine and Cunningham
as well, and would contribute his own version of a revolutionary
dance theater through almost twenty works that were performed
around the world.

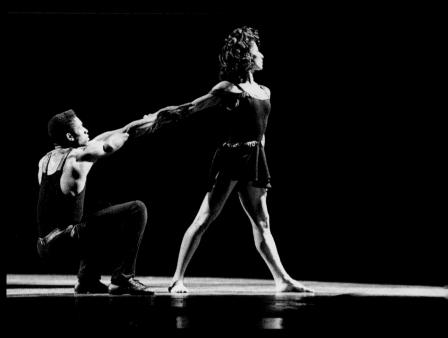

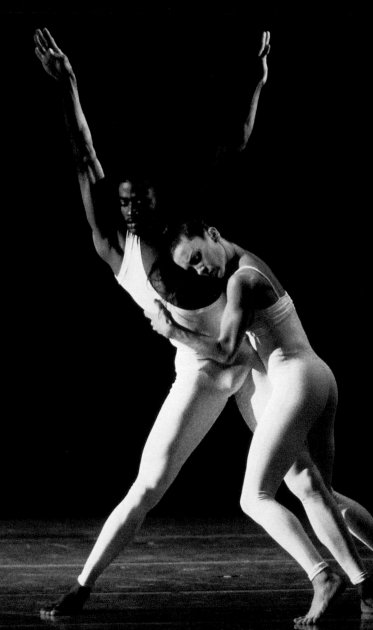

OPPOSITE, FAR LEFT:
Bad Blood, with Amos Mechanic
and Lynn Barre
Photographer: Gert Krautbauer

OPPOSITE RIGHT, ABOVE:
Episodes, with Desmond
Richardson and Neisha Folkes.
Photographer: Jack Vartoogian

OPPOSITE RIGHT, BELOW:
Inside, 1980; his first solo for
Judith Jamison.
Photographer: Jack Vartoogian

ABOVE: The ritualized *Vespers*,
with Barbara Pouncie,
Deborah Manning, Neisha Folkes,
Renee Robinson, Debora Chase,
Sharrell Mesh.
Photographer: Jack Vartoogian

RIGHT, ABOVE: The
theatrical *Night Shade*, with
Marey Griffith, in 1984
Photographer: Johan Elbers

RIGHT, BELOW: Modern
realism in Urban Folk Dance, with
Linda-Denise Fisher-Harrell and
Bernard Gaddis.
Photographer: Gert Krautbauer

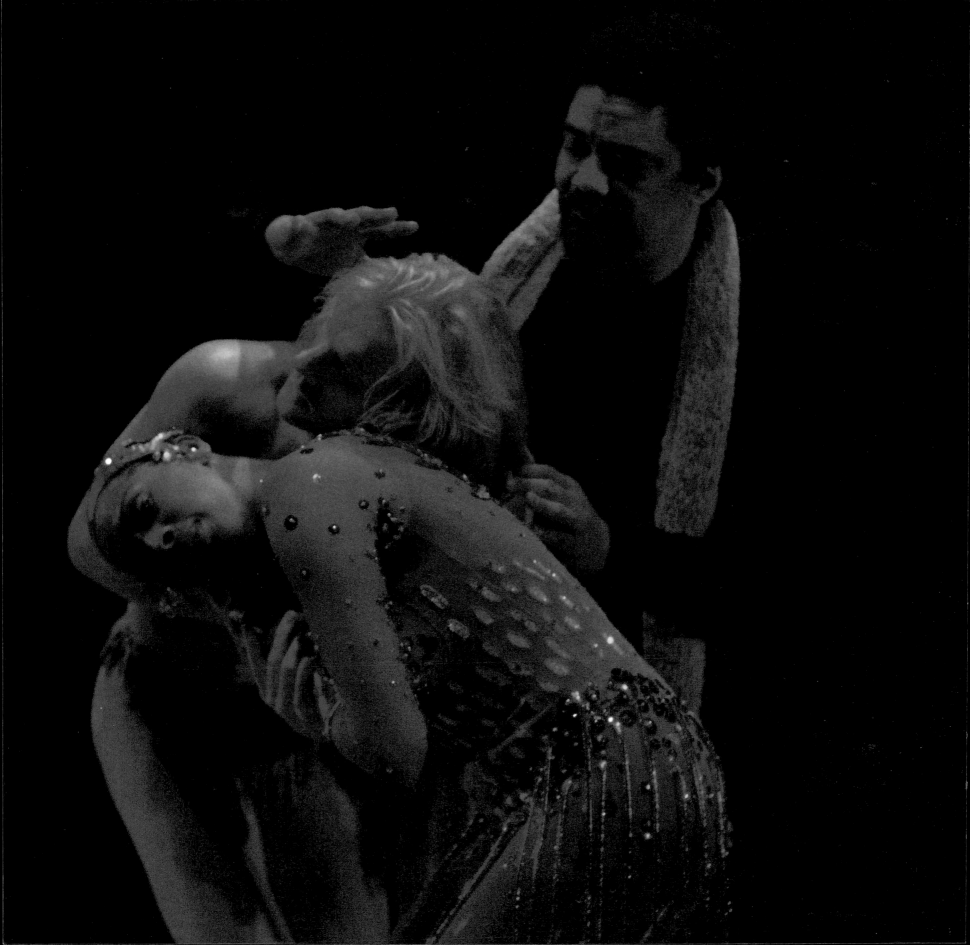

ALL CHOREOGRAPHERS HAVE THEIR OWN PARTICULAR WAY OF CREATING THEIR DANCES. Ailey wanted his dancers to be versatile and strong in a variety of techniques so they would be able to adapt to the wishes and demands of visiting choreographers. As the strengths and abilities of young dancers reach new levels, it seems they can execute any movement that is humanly possible.

"I'm in there indicating to the kids these steps in my new dance," recalled Alvin Ailey, "and every now and then they say, 'Well, show me!' I go to a gym with all those machines. But that doesn't prepare you for dancing. Dancing is definitely a young man's sport."

Rehearsal and Development

Ailey used to say that he was a Capricorn; a goat, a climber. He would keep trying, never give up, never say die. Of course, he added, that's the nature of this dancing business.

"This is such a terribly frustrating profession. It's a high-anxiety business. Dancing is either right or wrong, there's no in between, so we're constantly living with the anxiety of trying to keep our standards up. The goal always seems to be just beyond us because we're always trying for the perfect statement." The path to that perfect statement was often beset with obstacles; there were the inevitable injuries, conflicts, time pressures. Kenneth Pearl remembers being called on to sub in *Blues Suite* while the company was touring Russia. "Judith and Mari [Kajiwara] taught me segments in a hotel lobby before I had to go onstage to perform."

"It was like that story you hear so often: You go on tour, learn all of the ballets, dancers get injured and you get thrown in at the last minute while your shoe falls off in performance, but you complete the show."

Donna Wood recalls the time that Alvin asked her to learn *Cry*. "The problem was Judy was leaving for Hamburg, Germany. The only way I could learn *Cry* was to go down to Judy's apartment and push all the furniture aside in the living room. I learned it in four days. I think Judy got to watch it one day in rehearsal, but we didn't have time to have for a teaching rehearsal." Later, when Jamison returned, she would help Wood from the wings.

"*Cry* is a killer solo," said Wood. "I don't know how I got through it. At the very end, when you are dying and you still have to keep going with that turn, turn, turn, turn to the upstage corner, Judy was always in that wing for me. Judy got me on track to finish the dance, and I will always appreciate that she did it for me."

Alvin Ailey was never content to repeat himself; instead he challenged himself and his company to keep learning and growing. As a choreographer Ailey used his Horton and Cole backgrounds to formulate most of his ideas. In the early seventies, however, he began to add some of the classical vocabulary into his dancing designs as well. Behind the eclecticism was a common thread of purpose, the desire to dig deeper and to connect with an audience in the most direct and meaningful way. He even said, "I'm constantly shouting at rehearsals, 'You're boring everyone to death, dear. You're dancing about dance, not about life!' Don't go out there and be a ballerina; reveal yourself."

Even though Ailey was always committed to the struggle of the black people, he didn't want to create dances only to black music. "I didn't want to encourage the prejudice that the Negro dancer can only do Negro things," he explained in 1969. "I want to show him in the mainstream of dance. "Not that I don't want to do an evening of Ellington the way Balanchine does Stravinsky," he added. "If I can find the time, there are hundreds of ballets that I want to do. I'd like to do a full-length ballet on Malcolm X with a Charlie Mingus score and décor by Larry Rivers. And a ballet about Charlie 'Bird' Parker and works to Bach and Prokofiev. And a ballet on Hart Crane and Bessie Smith . . . "

Between the years 1974 and 1976, following Duke Ellington's death in 1972, Ailey choreographed nine ballets to Ellington's music and mounted his festival "Ailey Celebrates Ellington." He had begun working with Ellington's music in 1962, with his solo to *Reflections in D*, and in all he would create a total of fifteen dances to the maestro's music.

At the time Ailey wrote, "Ellington was the first authentic genius I ever met. He collected around him a group of superbly gifted men—musicians—who were his Stradivarius. I want to speak in this celebration to his uniqueness, his daring, his beauty, his wit, his enormous spirit. And I want to say something about this great man who through his music, through his personality, and through his love of humanity healed some of the wounds of this century.

PAGE 90: Alvin Ailey rehearsing *Spell* with Judith Jamison and Alexander Godunov in 1981.
Photographer: Johan Elbers

"To me, Duke was a man who spoke to all mankind, a poet, a voice crying out against darkness and negativism. He was a man whom the black community revered; a man who was to us a god. I think we are going to find that much of Mr. Ellington's music is going to rank with the better known classical composers of this century."

One of the highlights of the Ellington festival, besides *Night Creature*, was a pas de deux for Judith Jamison and Mikhail Baryshnikov titled *Pas de Duke*. Baryshnikov had seen the Ailey company perform in Leningrad in one of his first glimpses of Western dance. He specifically remembered the works *Cry* and *Revelations*, and the dancers Judith Jamison and Miguel Godreau. Of course, he had heard the music of Ellington in Russia, which made him even more excited to participate in the festival. He was twenty-eight years old and at the height of his fame and career. "Alvin said, 'Follow me,' and I did," he recalls. "Alvin came from the street in his socks and shoes and went right to work creating and rehearsing the ballet. Alvin choreographed the piece very quickly."

"There was a sort of Grahamesque contraction that Alvin used, and there were a few moments that I couldn't get right," recalls Baryshnikov. "During one of my jumps Alvin wanted an extra curve in my chest. I realized later that it was Martha's influence on Ailey. Within the rest of the piece Alvin encouraged me to use my natural line and elevation."

Pas de Duke was Ailey's modern-dance translation of a classical pas de deux honoring two of the most renowned dancers in the world. It not only captured the exuberance of the star dancers' qualities and techniques but highlighted a range of Ellington's music.

By the late seventies, two decades of intense creativity and the unceasing demands of running the company were starting to take their toll. In 1979 Ailey was faced with the death of Joyce Trisler, his good friend from the Horton days. He choreographed *Memoria* for her, to the music of Keith Jarrett. That ballet sent Ailey into a personal and psychological meltdown.

> I want to help show my people how beautiful they are. I want to hold up the mirror to my audience that says this is the way people can be, this is how open people can be. *Alvin Ailey*

"Joyce let the stresses and the pulls and the anxieties of doing ballets and keeping a company really get to her, and she tried to do it all by herself," said Ailey in 1980. "The lesson I learned was, give something up. Do less. Concentrate on what's really important, and not all of the errata, all the little things that would drive one—if you'll excuse the expression—crazy!"

Ailey was away for six months. When he did return, he thought at first he would never be able to choreograph again. But in 1980 he created his astonishing jazz dance *Phases*. "It'll be something affirmative," Ailey predicted while the work was still in development. "Something about life and beauty and making something where there was nothing before. It'll be a celebration of the life force." Ailey went on to choreograph fifteen dances during the last ten years of his life.

In 1993 Judith Jamison created *Hymn*, her tribute to her mentor, in collaboration with the theater artist and playwright Anna Deavere Smith, who wrote the libretto. The work uses the classical, modern (both Horton and Graham), jazz, and African-

Judy would be putting my arms in the right places during the duet as we went along. Judy would say, "If you look here, then it really will be more amusing. Or try this or that." *Mikhail Baryshnikov*

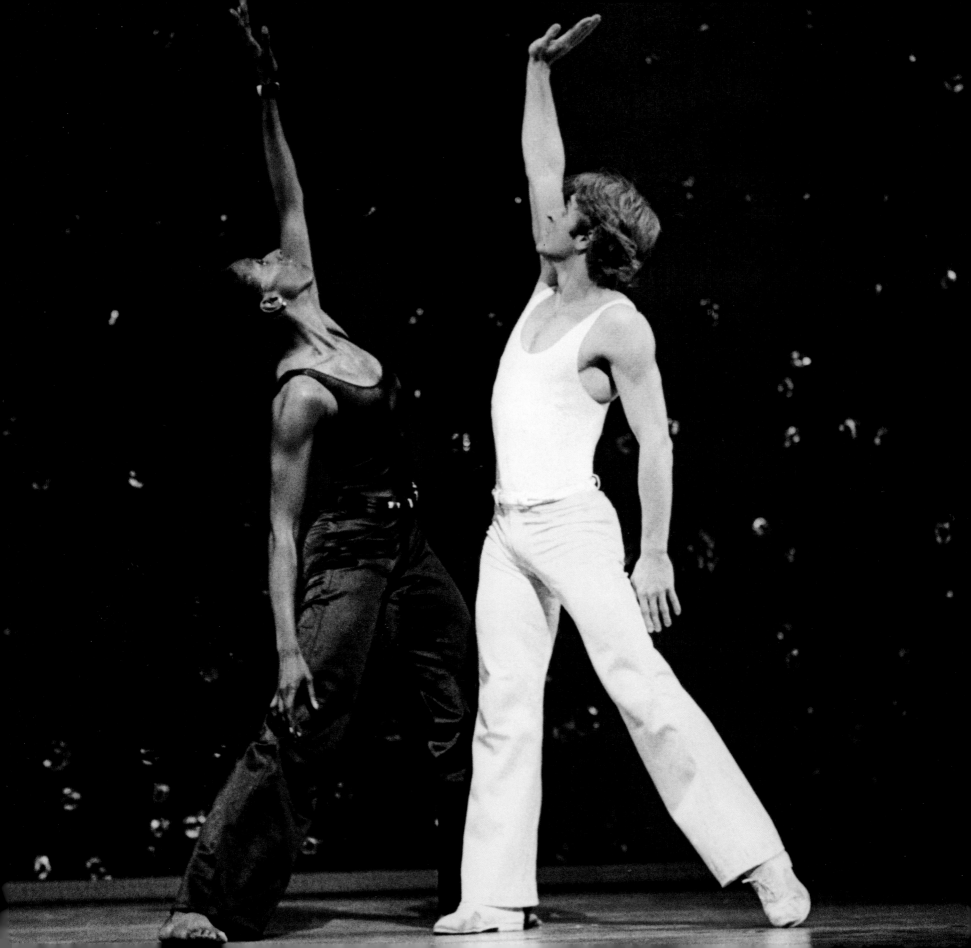

influenced idioms, as well as the vernacular movements that Ailey used in his own choreographic vocabulary. Smith based the libretto on interviews she conducted with the company's individual dancers; their words are interspersed with an original score by Robert Ruggieri. "It's not just about 'pulling off' a bunch of steps," explains Jamison. "The words are about people, their relationships to each other and particularly to one man."

Hymn was restaged for the company's 2003 season. "When you create a dance on specific people, it's very difficult to then address the same circumstances ten years later," said Jamison. "For example, Troy Powell's section will be danced by Clifton Brown, but those are Troy's words Clifton is dancing to. In the piece, Troy says, 'We don't have a war but we have AIDS.' Well, we still have AIDS, but now we also have a war."

"Each generation and every dancer I teach this to, in a way, has to find their own meaning from within. They have to listen to the musicality, the cadence of the spoken word. When I ask a new company member to perform a part, he or she cannot just repeat what the original dancer did."

Alvin Ailey came out of his personal crisis spiritually whole. However, he did not minimize the mental and emotional cost of creating and choreographing new ballets for twenty-five years. Choreography, he said, was "the most difficult thing that I have ever tried to do in my life. It doesn't just flow, although as a craftsman I can take a piece of music and make up steps to it very easily. But to get to the core of what it's about and to get to the inner line and to give it some form and some feeling of dynamics and theatricality—it's always difficult."

The artists I have now are extraordinary. They have the ability to understand a role and reinvent it for themselves in a way that is vibrant and honest.
Judith Jamison

Hymn, Judith Jamison's tribute to her mentor, Alvin Ailey; with Danielle Gee, Andre Tyson, Desmond Richardson, Lydia Roberts, Leonard Meek, and Michael Thomas in 1993.
Photographer: Beatriz Schiller

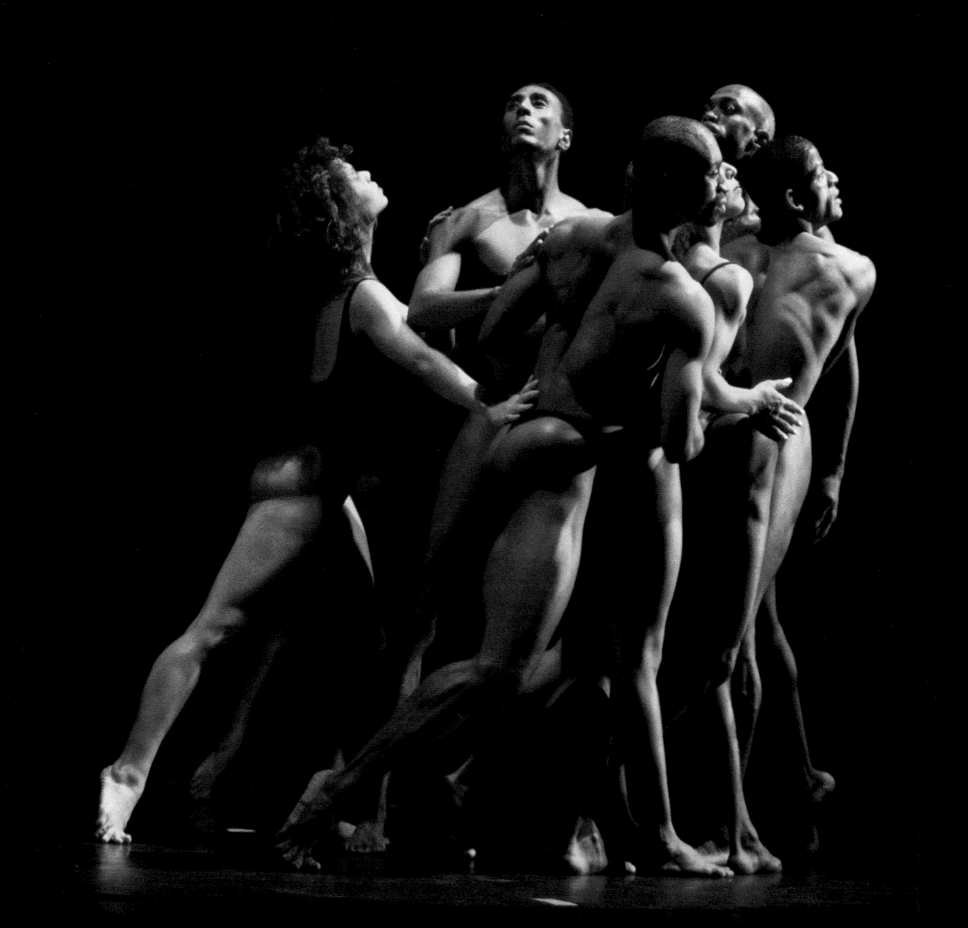

Dancers' bodies are capable of doing even more than they were ten years ago, which of course only enhances their beauty. An Ailey dancer understands the spirit of dance, the communication of dance, and the passion and depth of movement. It's not something superficial. Dance isn't a cloak you put on; it's a revealer, as opposed to a concealment.

Judith Jamison

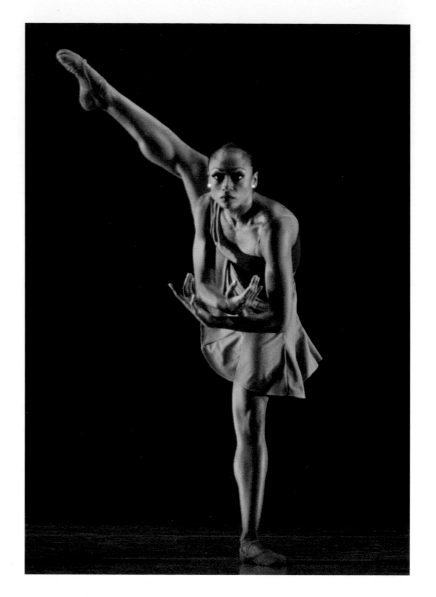

Linda Celeste Sims in Dwight Rhoden's *Bounty Verses,* 2003.

Photographer: Paul Kolnik

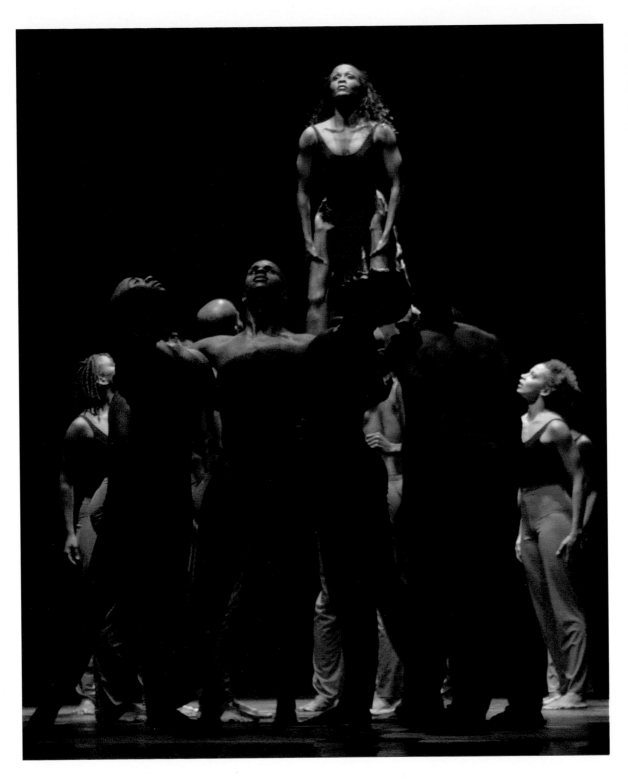

Hymn, 2003: In front are Matthew Rushing, Glen A. Sims, and Benoit-Swan Pouffer. On the right is Tina Monica Williams. Renee Robinson is aloft.

Photographer: Janet P. Levitt

All my life I've been fascinated by the precipice in all of us. When you come to it, you either choose to fall or you don't. *Alvin Ailey*

LEFT: *The River*, Ailey's collaboration with Duke Ellington; with Linda-Denise Fisher-Harrell and Bernard Gaddis.

Photographer: Jack Vartoogian

OPPOSITE: A new *Pas de Duke*, 1991, with Lydia Roberts and Desmond Richardson.

Photographer: Johan Elbers

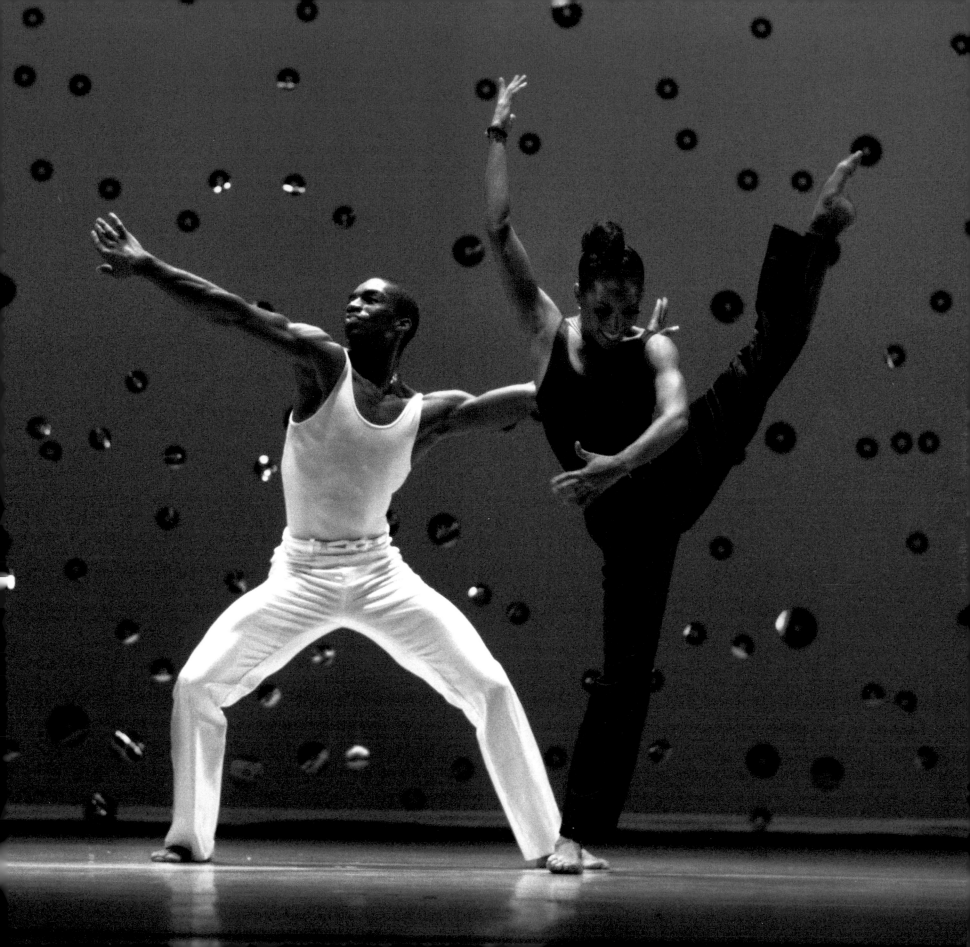

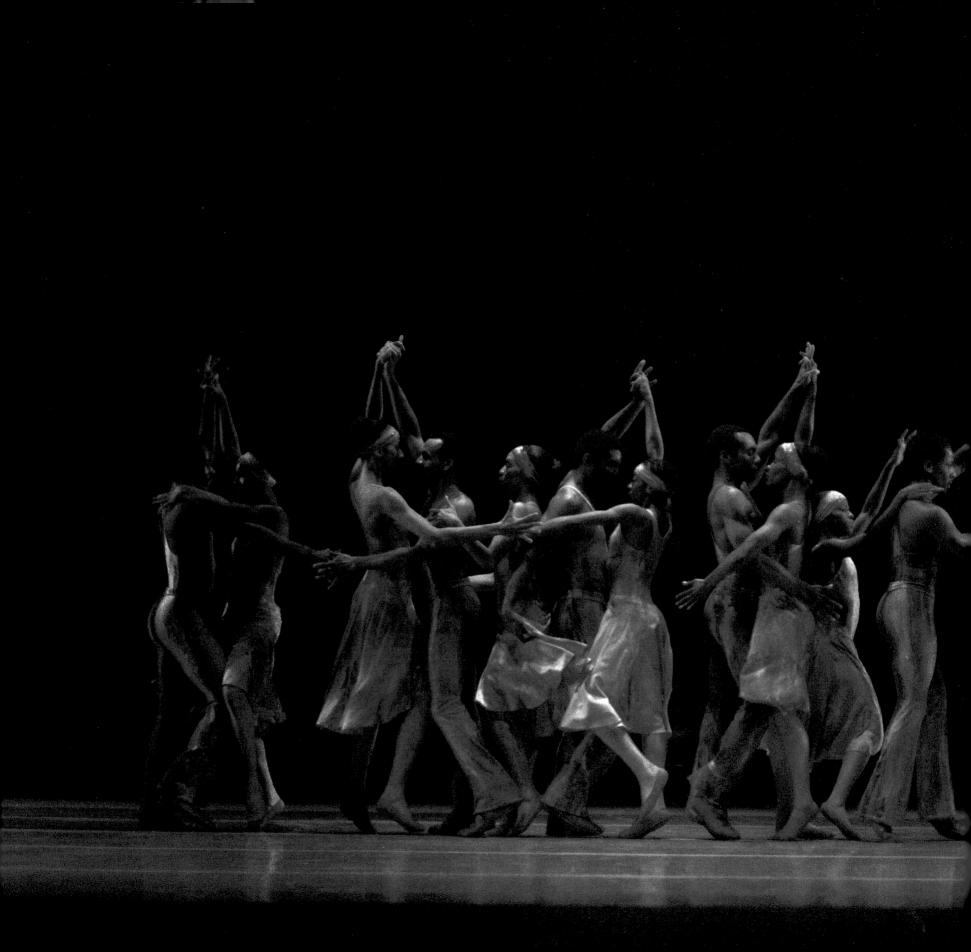

People lose themselves in the dance.
I hope they fantasize about it. It's
rhythmical and it's honest. Beautiful,
and beautiful people do it. Physical,
expressive, spacious An idealization
of our dream. *Alvin Ailey*

Night Creature; the company
in 1984.

Photographer: Johan Elbers

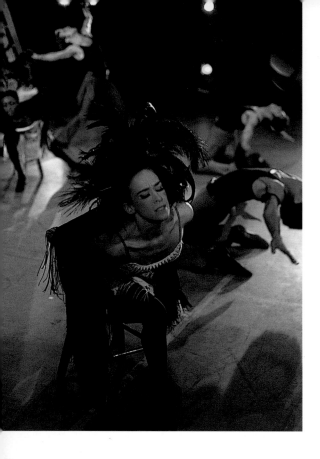

LEFT: Linda Kent in *Blues Suite,* in 1971.
Photographer: Jack Mitchell

RIGHT: *Masakela Langage* by Alvin Ailey; (left to right) Solange Sandy Groves, Renee Robinson, Troy Powell, Lisa Johnson, Dwana Adiaha Smallwood, and Linda-Denise Fisher-Harrell.
Photographer: Jack Vartoogian

I'm in there indicating to the kids these steps in my new dance. And every now and then they say, "Well, show me!" I go to a gym with all those machines. But that doesn't prepare you for dancing. Dancing is definitely a young man's sport. *Alvin Ailey*

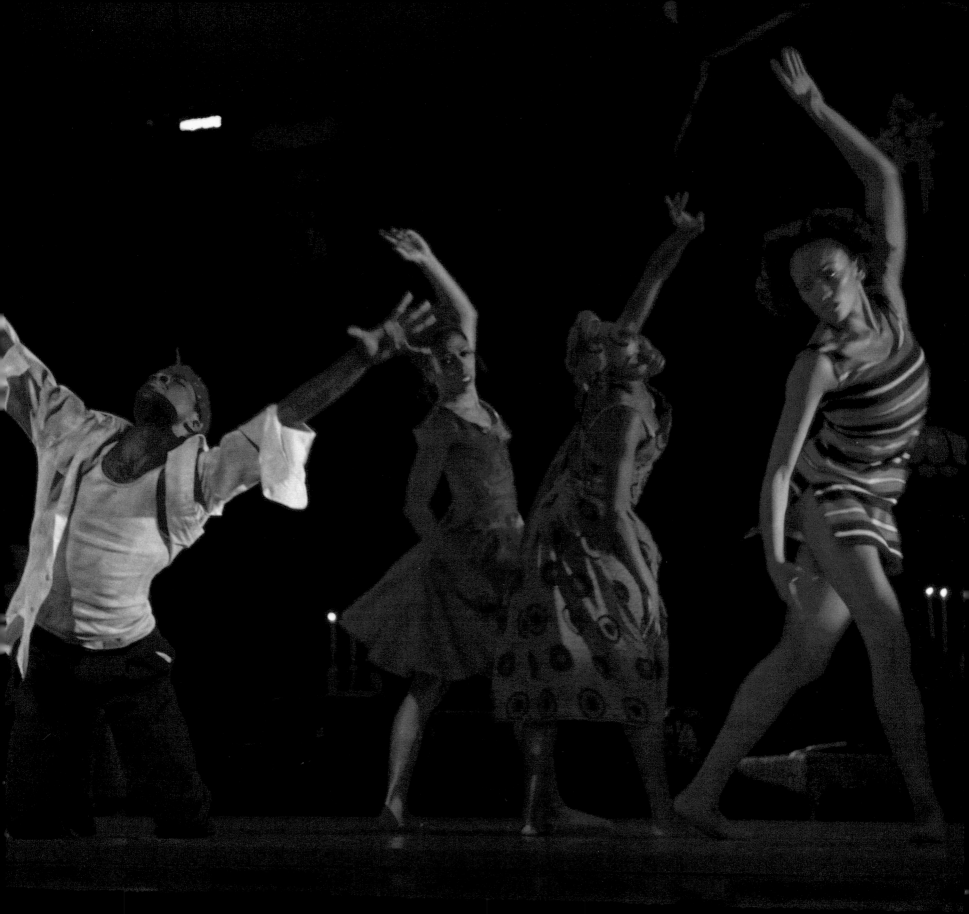

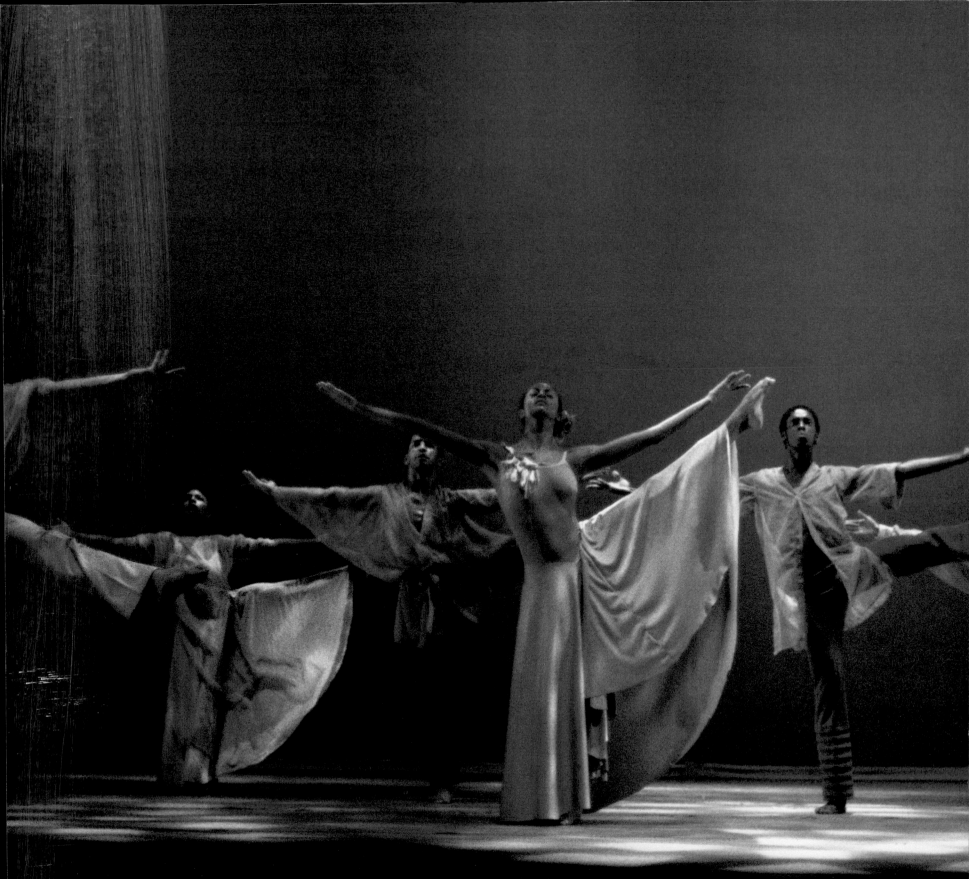

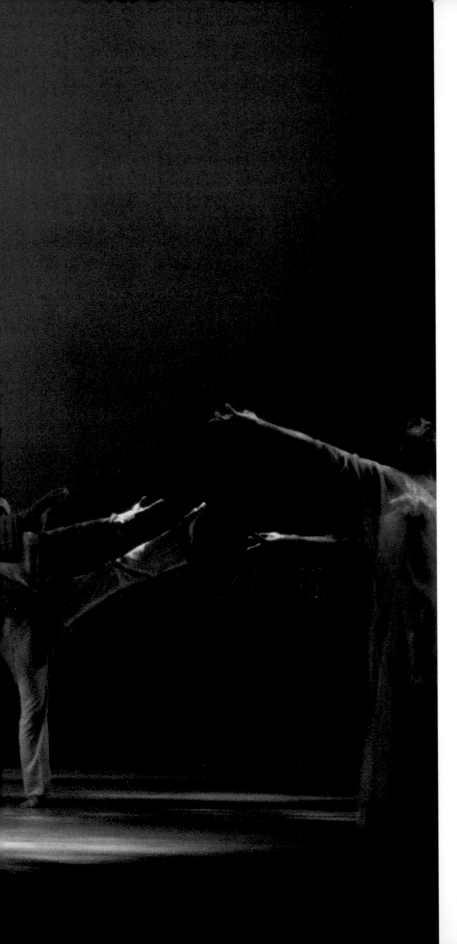

Memoria, Ailey's tribute to Joyce
Trisler; with Donna Wood in 1979.

Photographer: Johan Elbers

Creating the Dance

An array of eclectic choreographers allowed the Ailey dancers to participate in a world of expressive movement. Through word and gesture, their choreographic process expanded the individuals' dance vocabulary, strengthening them as performing artists.

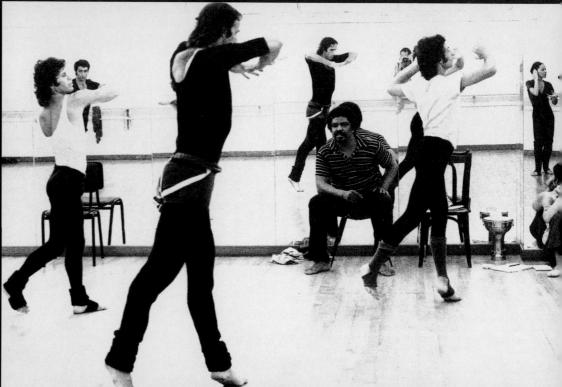

ABOVE: Alvin Ailey working with the Harkness Ballet, ca. 1967.

FAR LEFT, ABOVE: Alonzo King discussing *Follow the Subtle Current Upstream.*
Photographer: Paul Kolnik

ABOVE: Donald Byrd at dress rehearsal of *Dance at the Gym* with Matthew Rushing.
Photographer: Paul Kolnik

LEFT: Dwight Rhoden at rehearsal of *Chocolate Sessions.*
Photographer: Paul Kolnik

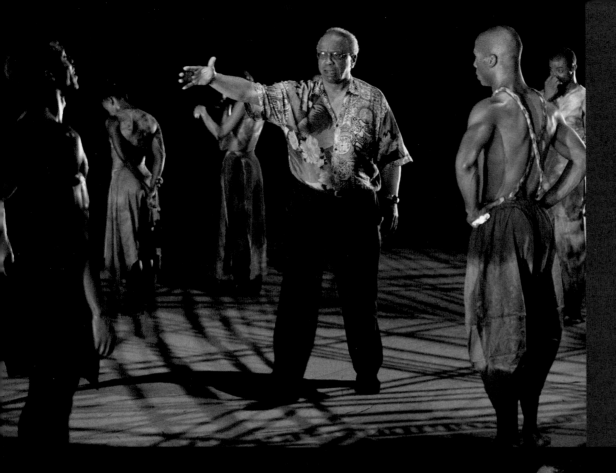

LEFT, ABOVE: Donald McKayle
rehearsing *Danger Run*, 1999.
Photographer: Paul Kolnik

LEFT, BELOW: Bill T. Jones
demonstrating *Fever Swamp*, 1999,
as Kristopher Storey looks on.
Photographer: Paul Kolnik

BELOW, RIGHT: Judith Jamison
performing in her ballet, *Hymn*.
Photographer: Gert Krautbauer

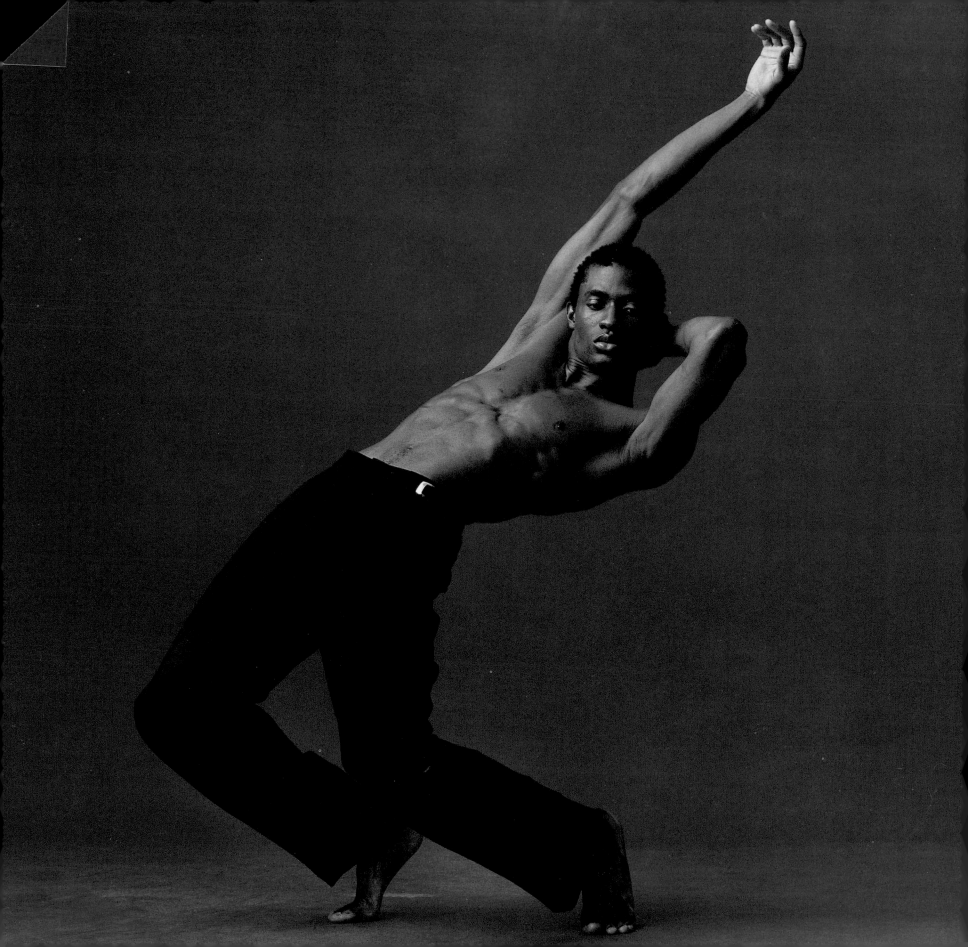

IN THE EARLY SEVENTIES ALVIN AILEY WAS ALREADY SECURING THE AILEY LEGACY BY building a second company and creating outreach programs for inner-city youth that would eventually serve most of America's large urban centers. Determined to establish a foundation for the next generation of dancers and audiences, Alvin would most often have one of his former female dancers take charge in implementing these programs.

Sylvia Waters had recently returned to dance with the company after a maternity leave when Ailey asked her to direct a second company. He needed an ensemble on which he could create new works; the first company was too busy traveling and performing around the world. The second company, called the Alvin Ailey Repertory Ensemble, was officially renamed Ailey II in 1999. Waters has been its artistic director for the past thirty years.

As a dancer Waters had performed many Ailey creations: *Quintet, Masekela Language, Streams, Choral Dances, Mary Lou's Mass, Archipelago, Mass, The Lark Ascending,* and *Hidden Rites.* She was then able to re-stage these works on Ailey II in order to keep Alvin's works alive today. "I think with something like *Quintet* you really got a chance to see Alvin's work developing," said Waters.

"*Quintet* was like an extension of *Blues Suite.* You were encouraged to dig deep, way down into your guts and psyche. Alvin portrayed five women who came from different places, and he explored how they adapted—or didn't—to the performance circus in the music industry.

Waters loved participating in Alvin's choreographic processes, in ballets that later became classics of twentieth-century modern dance.

"I have been committed to the idea of discovering talent in dancers, choreographers, composers, lighting, set, and costume designers. I want to accurately retain what Alvin has left us and generously propagate the life and spirit that Alvin has given to so many audiences and artists."

The Next Generation

Most of the great Ailey dancers performed with Ailey II before they were able to join the first company. The transition was not always easy: Desmond Richardson and Aubrey Lynch both had to audition three times. "I went into the main company via the second company," says Desmond. "Once I got there, Alvin said, 'Yes, these are the steps, and you learned the dance in the second company and performed it all over the United States, but now I need you to put something else into it, and this is why I choreographed it that way.' The minute he gave me that image, I was like, 'OK, I got it!'"

Aubrey Lynch had finished the eighteen-month certificate program at the Ailey School and was about to start studying there on scholarship. On his first day as a scholarship student he was chosen to dance in the second company. "I was probably happier at that moment than even when I got into the first company," says Lynch.

"I had sacrificed everything, including my ego and my father's approval and opinion of me, which at the time, were zero. I remember after the meeting with Sylvia, I was jumping up and down in the bathroom yelling, 'Yes, yes, yes!' Then the work started."

"I auditioned three times for Alvin and I still didn't make it on the third try," says André Tyson. "But he knew my dancing from Ailey II. Then one day in 1985 I got a call from Alvin, who said, in his deep, charismatic voice, 'Ahn-dre, I've been thinking about you; do you want to come and dance with me?'" André was so high, he recalls, "I was literally on the ceiling."

Very few dancers went directly into the company. Don Bellamy was one of the last men Ailey took into the company before he passed away. After seeing Bellamy dance *The River* at the Capitol Ballet in Washington, D.C. Alvin told him, "I would like to offer you a job. I have a second company, which is a building block for the first company, where you will learn my style, you'll learn my repertory." Because of formalities, he made Bellamy audition among other dancers auditioning for both companies. In the middle of the audition Alvin turned to Sylvia and said, "Don will not be coming into the second company because he will be coming into the first company directly."

Under the direction of Sylvia Waters, Ailey II today fulfills much of the outreach mission that Alvin Ailey always envisioned. From the beginning it was a principle with Ailey that dance should be accessible, economically as well as artistically. Peter Woodin remembers a particular engagement in Rio:

"Alvin found out that the bottom ticket price was unaffordable to the person in the street. He went to the management and threatened to pull the company from the engagement if they didn't make a section of the theater and a block of tickets available at a low price for the common person. Alvin felt so strongly about that. Always at City Center dance students could get into the show for almost nothing."

PAGE 110: Company member Amos Machanic, a 2003 portrait.

Photographer: Andrew Eccles

As Judith Jamison recalls, "Alvin was always adamant about creating outreach programs with master classes, lecture-demonstrations, and mini-performances. Ailey II and Ailey teaching artists do the nuts and bolts of our outreach programs because the first company performs so much that they don't have the time." And, of course, Jamison observes, you can go places with twelve dancers that you can't go with thirty. Ailey II performs in hospitals, prisons, nursing homes, and schools, bringing dance to where the people are.

The Ailey organization has continued to foster new work as well. In 1987 Ulysses Dove created an explosive choreographic masterpiece, *Episodes*, for the London Festival Ballet. The company danced the ballet in bare feet. In 1988 Dove re-choreographed the dance en pointe for Patrick Dupond's Ballet Français de Nancy. In 1989 Ailey took *Episodes* into his company's repertory, allowing his audiences a glimpse of what dance would look like in the next century. Like his mentor Ailey, who was always exploring the battle of the sexes in his choreography, Dove in *Episodes* sharply exposed the eternal dilemma of men and women—drawn together and driven apart. *Episodes* was created to a provocative score by Robert Ruggieri, Dove's longtime collabora-

tor. As early as 1979, Dove choreographed *I See the Moon and the Moon Sees Me* for Ailey II. In 1992 Dove told the dancer and critic Gus Solomons Jr., "Since the first piece I did, Alvin believed in my work."

"He would take time to argue with me because he knew I would not accept anything unless I really believed it. Even though we fought, we were always truthful with each other. The crazier my stuff got, the more I found my own voice and the more Alvin liked it. Alvin taught me about humanity. His heart beat once for him and once for the rest of the world."

The company presented seven ballets by Dove in their repertory from 1979 to 1995. Ailey and Jamison wanted the dancers to experience the brilliance of Dove's iconoclastic process in creating dances for the next generation of performers. Under Jamison, his work remains in the repertory.

> Making dances is an act of progress; it is an act of growth, an act of music, an act of teaching, an act of celebration, an act of joy.
> *Alvin Ailey*

Ronald K. Brown's choreographic masterpiece *Grace* premiered with the Ailey company in 1999. He would become the preeminent choreographer for the next generation of Ailey dancers. A protégé of Judith Jamison's when she choreographed *Into the Life* for Jennifer Muller's company in 1987, Brown had already established his own company, Evidence, back in 1985. His connection to Ailey, however, dates from one of his earliest memories: Brown recalls that he saw *Revelations* when he was in second grade, and its impact on him as a young child was unforgettable. In fact, he says, to this day, "Duke's jazz brings to my mind Alvin Ailey."

"With Duke's 'Come Sunday' for my ballet *Grace* —well, it gave me the spiritual grounding that the dance needed. All of my work has a connection to the dances I have choreographed before; at the same time, I'm continuing to move forward. If a dance connects with the energy of the folks watching and participating, that is definitely the bottom line, because then it will lift one's spirit and stir one's soul."

Brown returned to the company in 2001 to choreograph a second piece, *Serving Nia*, to the music of Dizzy Gillespie, among others.

Juba, choreographed by Robert Battle to a commissioned score by John Mackey, premiered during Ailey's 2003 season. It is a modern-day *Rite of Spring*: no longer the pagan Russian ritual imagined by Stravinsky and Nijinsky back in 1913, but a contemporary story set in an urban ghetto. Battle started out with Ailey II, where he had previously created another thrilling, ritualistic dance entitled *The Hunt*.

Ailey always wanted to reach as wide an audience as possible. "It doesn't bother me to be called popular, in the good sense of the word, or commercial, in the good sense of that word. First get the people into the theater; then you can show them anything you want. But you can't show them anything at all if they're still standing outside."

> I see dance as a ritual, a tradition that connects to Ailey's modern tradition, expressed through the unique qualities of these dancers. What is created is always a total surprise to me.
> *Robert Battle*

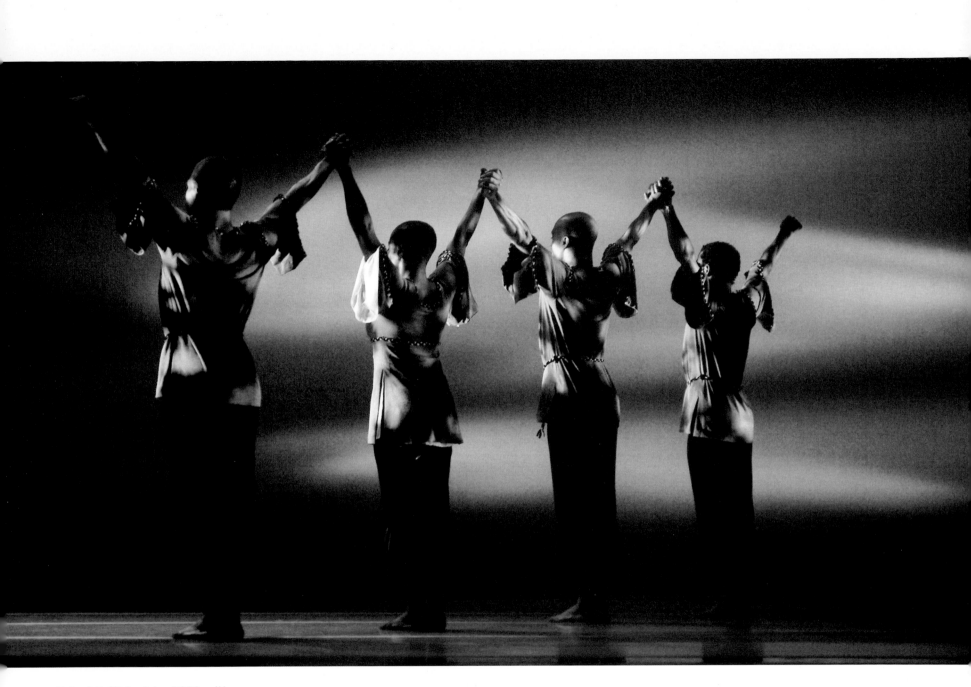

Robert Battle's *Juba,* 2003, with
(left to right) Abdur-Rahim
Jackson, Hope Boykin, Matthew
Rushing, and Samuel
Deshauteurs.
Photographer: Nan Melville

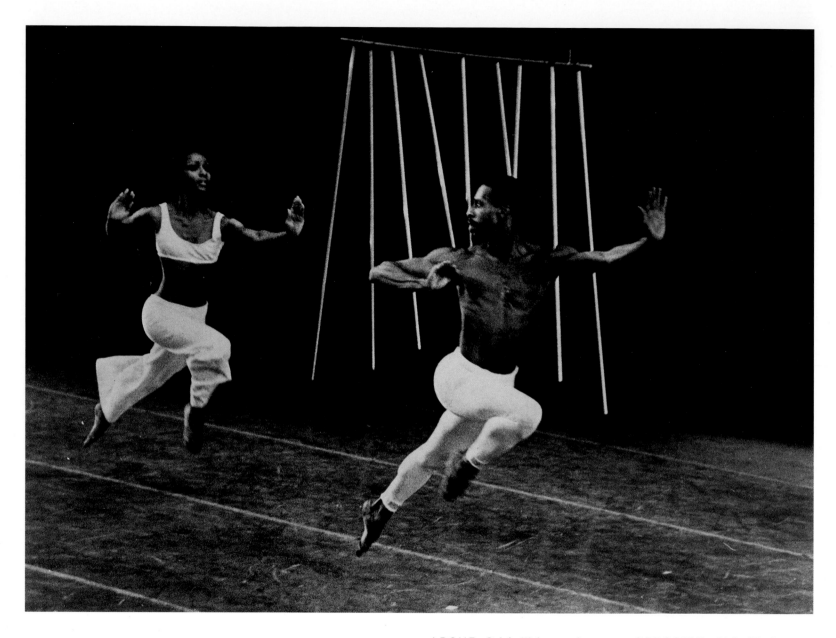

ABOVE: Sylvia Waters and
Dudley Williams in Paul
Sanasardo's *Metallics*.

Photographer: Fred Fehl

OPPOSITE: Alvin Ailey's
Quintet with Ailey II dancers.

Photographer: Tamesha Eley

The strength, tenacity, beauty, and intelligence of the women of Ailey were always honored even if the story was tragic. Alvin had a deep sensitivity about the angst and struggles of women. *Sylvia Waters*

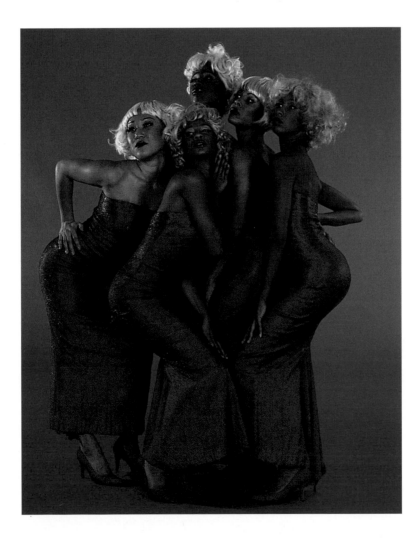

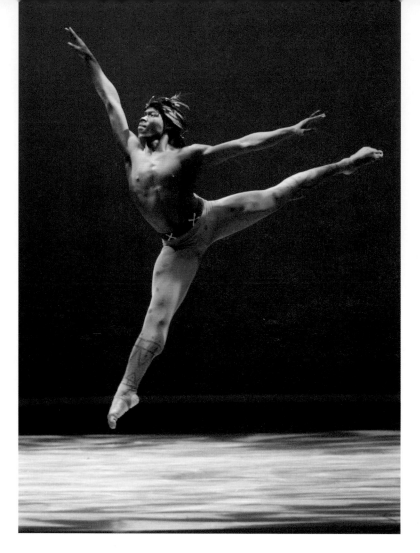

LEFT: Alvin Ailey's *Hidden Rites,* with Prince Credell, for Ailey II.

Photographer: Jack Vartoogian

BELOW: *Aspects of a Vibe*, choreographed by Darrell Grand Moultrie, with Hanifa Jackson and Kevin Goodwine, for Ailey II.

Photographer: Jack Vartoogian

OPPOSITE: *Prayer in Discord* by Nathan Trice; with Leyland Simmons. Courtney Brené Corbin, and Kirven J. Boyd, for Ailey II.

Photographer: Roy Volkmann

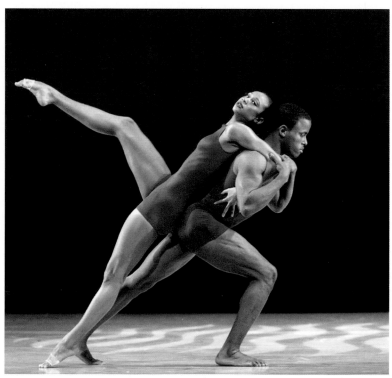

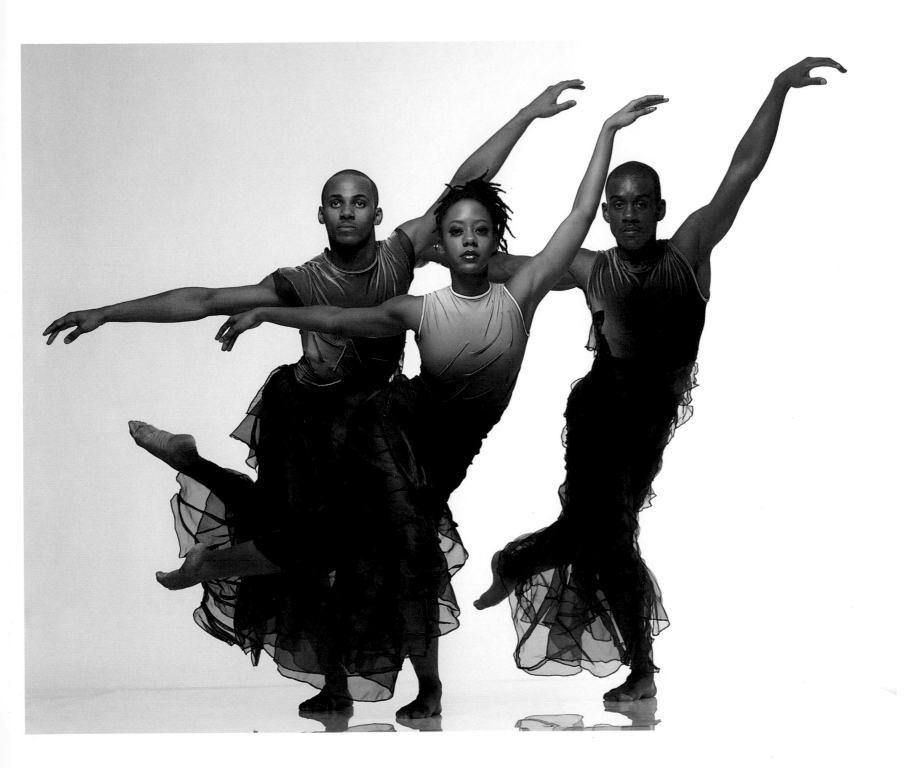

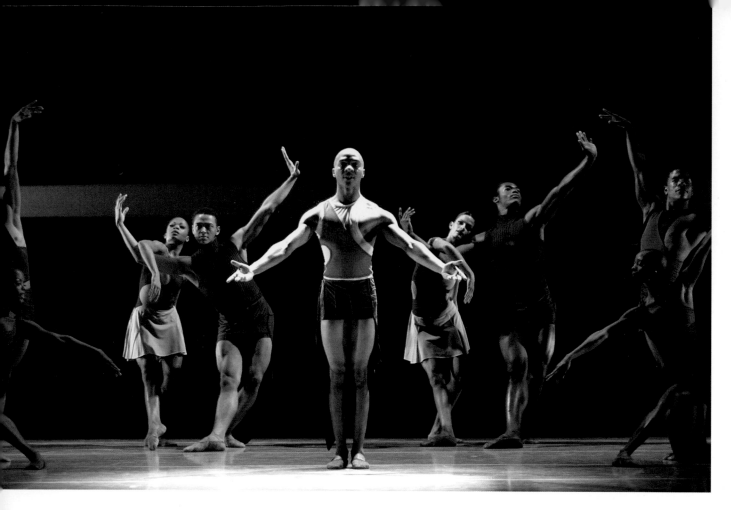

LEFT: Dwight Rhoden's *Bounty Verses;* with (left to right) Bahiyah Sayyed-Gaines, Clifton Brown, Matthew Rushing, Wendy White Sasser, Jamar Roberts, Abdur-Rahim Jackson, and Dwana Adiaha Smallwood.
Photographer: Paul Kolnik

OPPOSITE: *Footprints* by Jennifer Muller; with Guillermo Asca and Jeffrey Gerodias in 2003.
Photographer: Andrew Eccles

Because it's the Ailey Company and because of Mr. Ailey's legacy, I'm being challenged to work in places that I haven't before. *Ronald K. Brown*

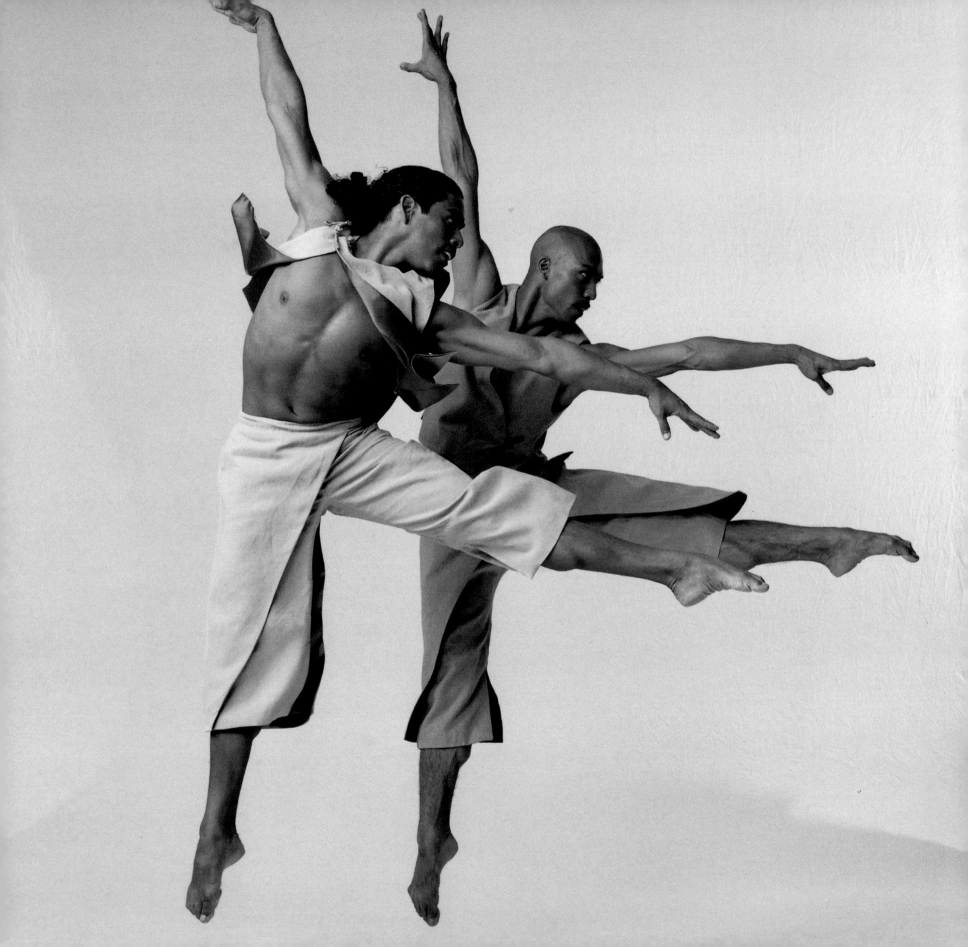

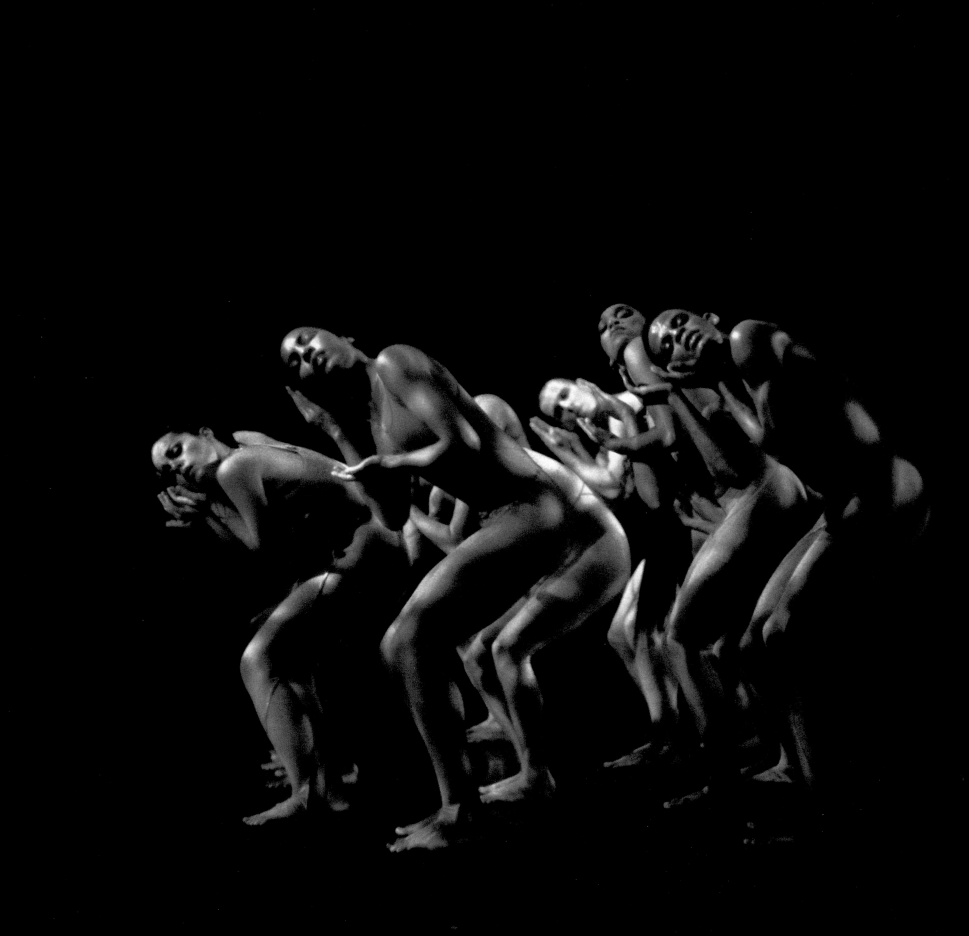

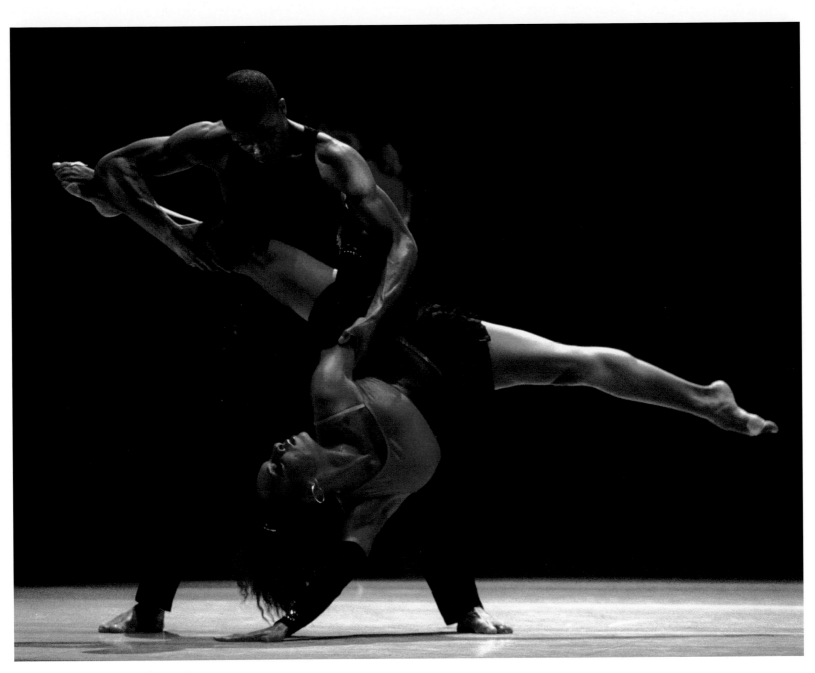

OPPOSITE: The Jamison
Project performing *Forgotten
Time* by Judith Jamison, 1989.

Photographer: Jack Vartoogian

ABOVE: *Dance at the Gym* by
Donald Byrd; with Olivia Bowman
and Kevin Boseman.

Photographer: Paul Kolnik

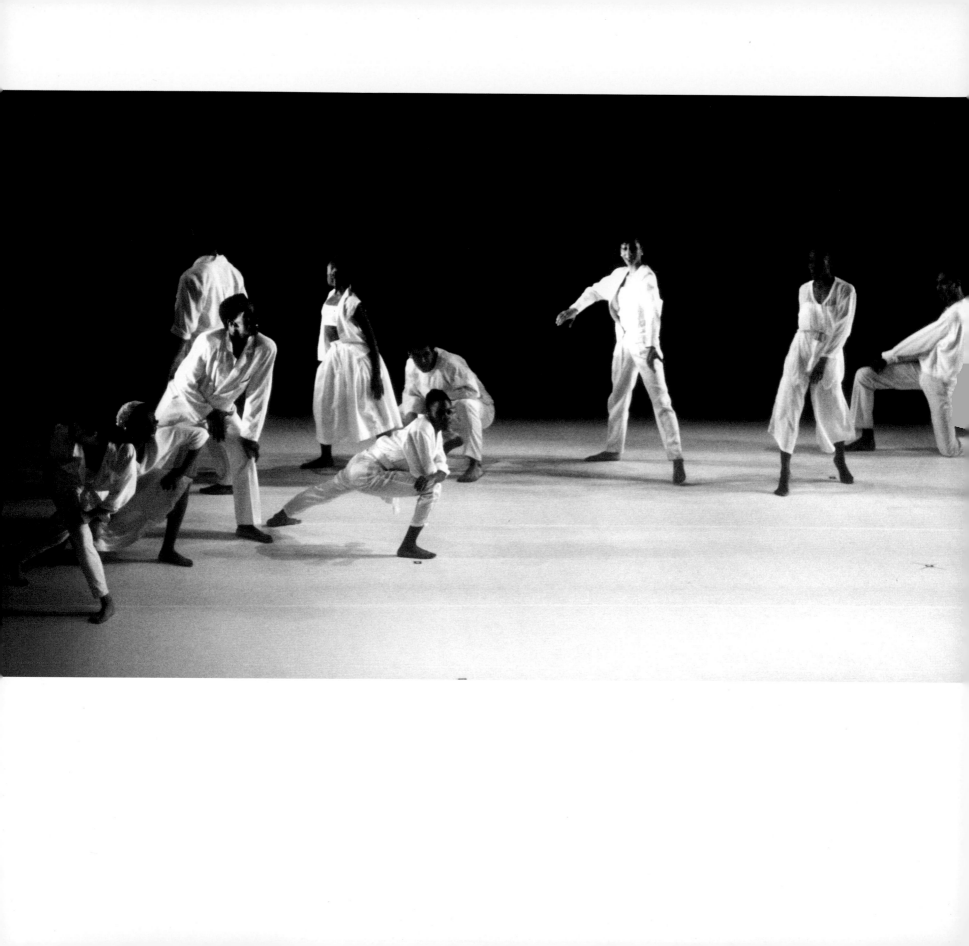

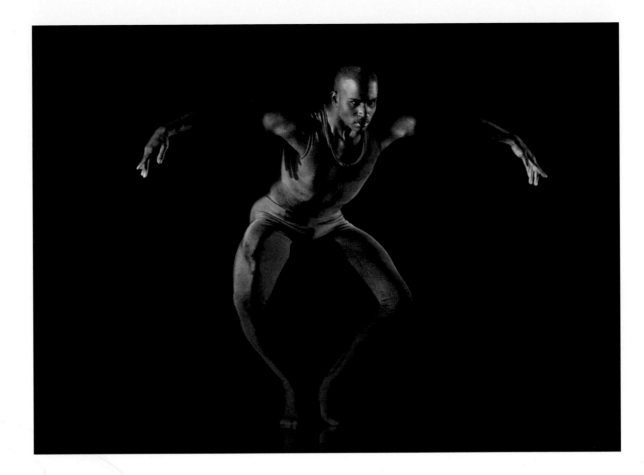

LEFT: Jennifer Muller's *Speeds;*
with (left to right) Elizabeth
Roxas, Marilyn Banks, Ralph
Glenmore, Gary DeLoatch,
Ruthlynn Salomons, Deborah
Manning, Jonathan Riseling,
Neisha Folkes, Renee Robinson,
and Daniel Clark, in 1987.
Photographer: Jack Vartoogian

ABOVE: Glen A. Sims in
Treading by Elisa Monte in 2003.
Photographer: Basil Childers

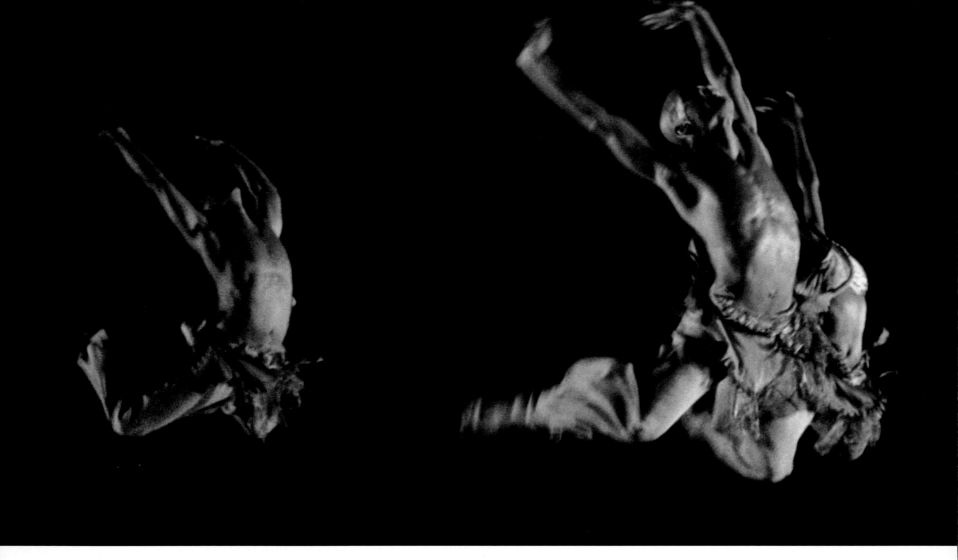

Each generation is distinct in what they bring to the Ailey repertory, and that is what I keep in mind when I am adding ballets to the repertory. I want to expand what's in the dancers' heads and their hearts, to challenge them and also challenge the audience.

Judith Jamison

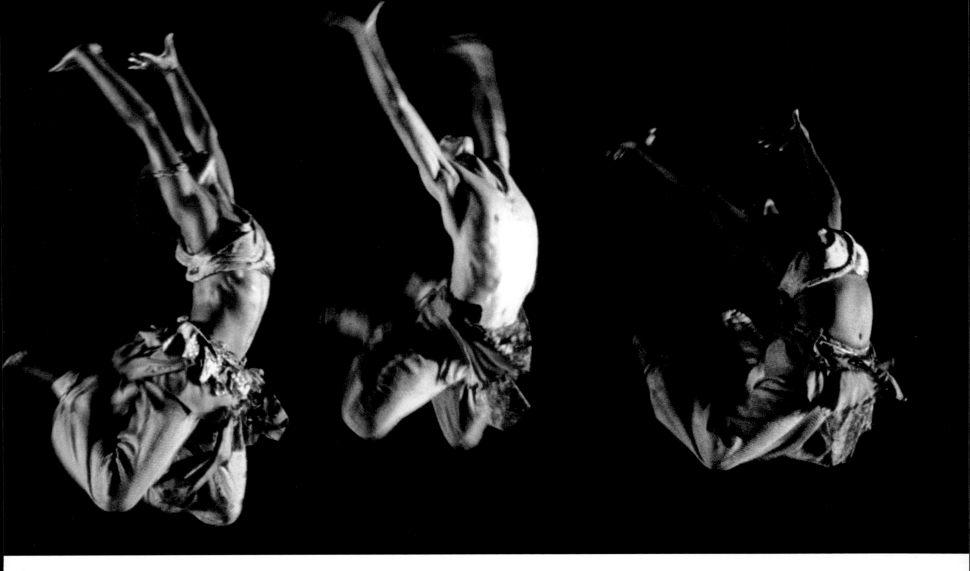

Prayers from the Edge, by Lynne
Taylor-Corbett; with Guillermo
Asca, Vernard Gilmore, Bahiya
Sayyed-Gaines, Juan Antonio
Rodriguez, and, Hope Boykin,
in 2002.

Photographer: Paul Kolnik

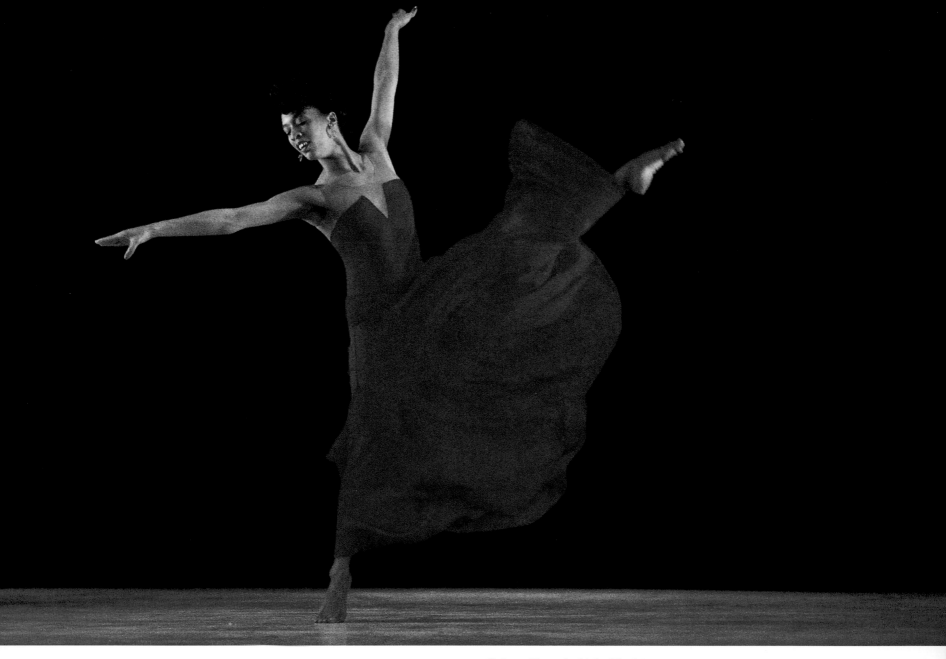

Debora Chase in Alvin Ailey's
For Bird—With Love.
Photographer: Jack Vartoogian

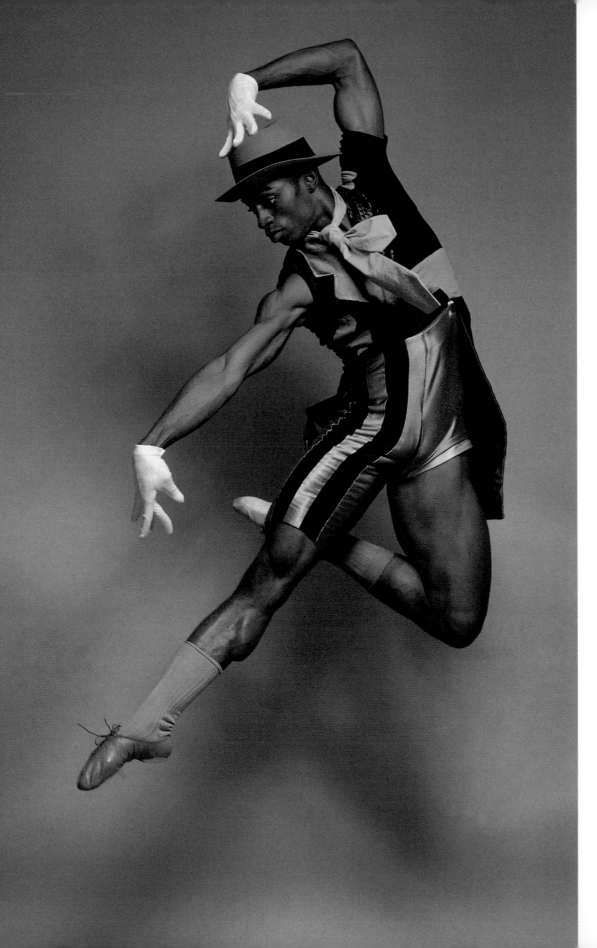

Desmond Richardson in Louis
Johnson's *Fontessa and Friends*,
in 1989.
Photographer: Jack Mitchell

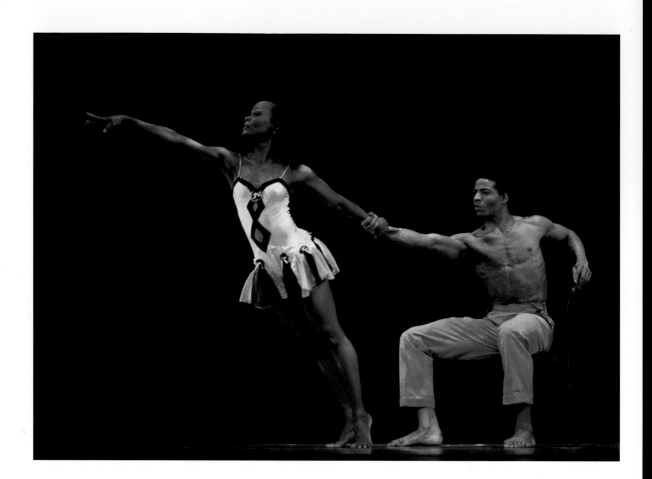

ABOVE: *Opus McShann,* Alvin
Ailey's last love duet; with Renee
Robinson and Edward Franklin
in 1988.

Photographer: Jack Vartoogian

LEFT: Renee Robinson in
Redha's *Lettres d'Amour* in 1998.

Photographer: Paul Kolnik

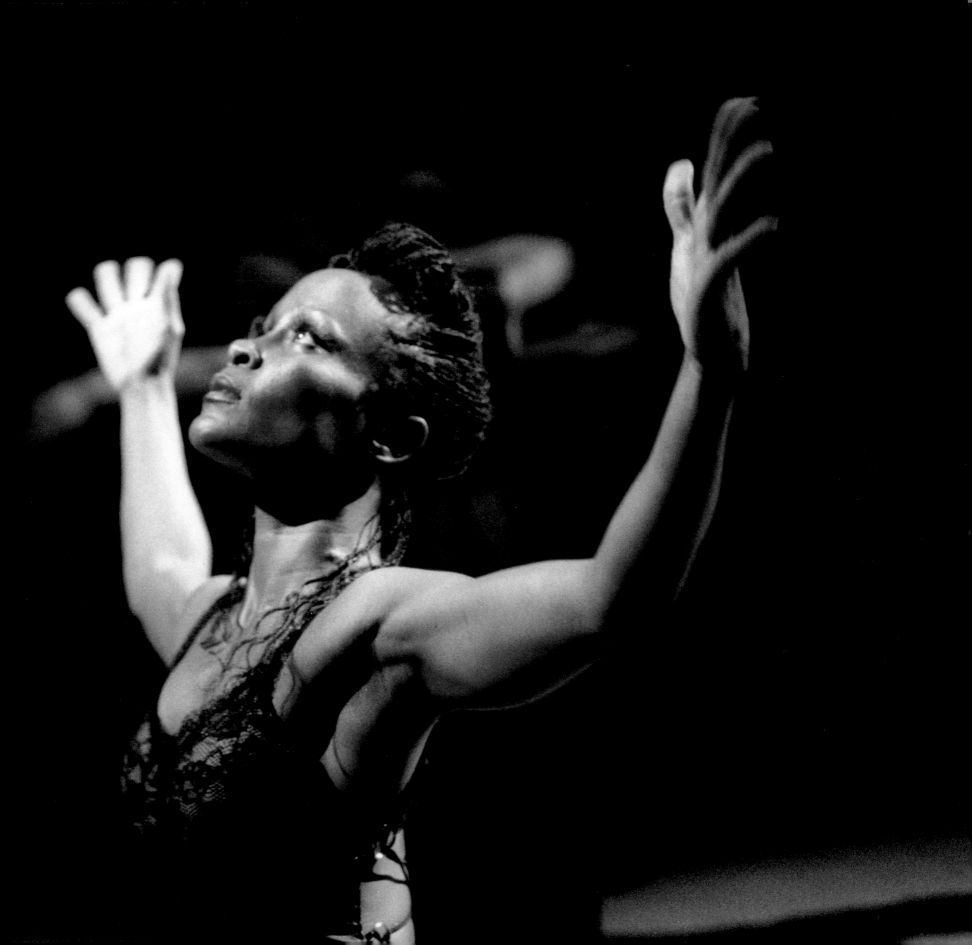

Ronald K. Brown

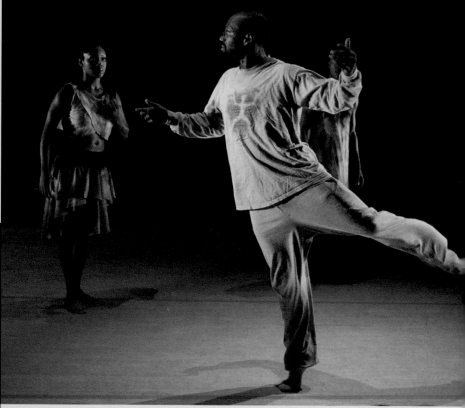

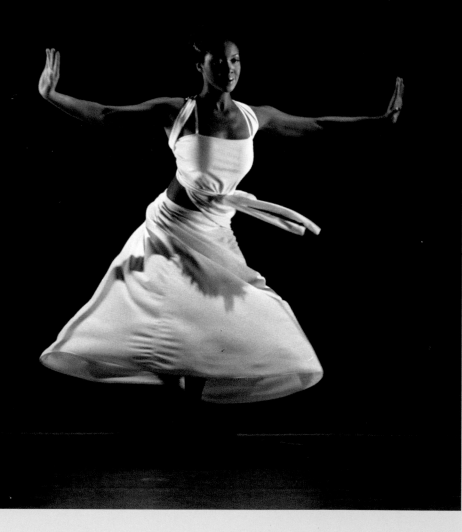

It's Mr. Ailey's traditions and legacy, along with Ms. Jamison's intention, that has allowed me to dream as a choreographer and to become my highest self.

Ronald K. Brown

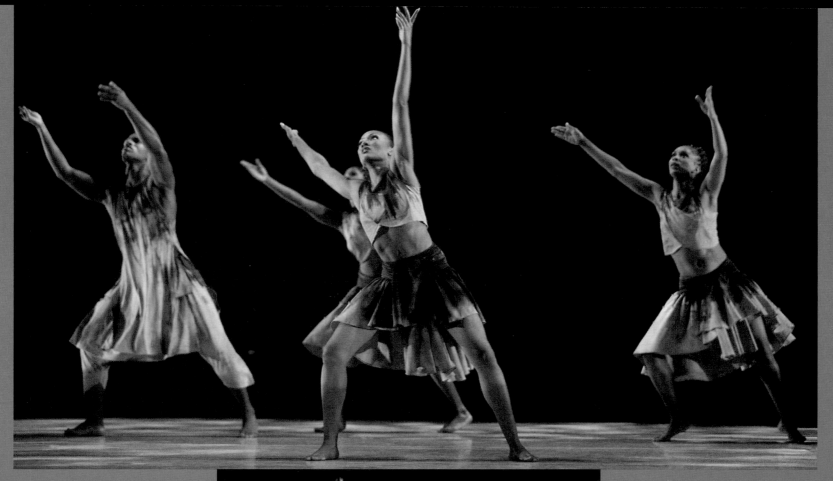

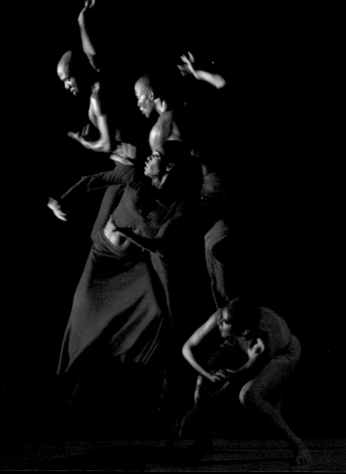

OPPOSITE, RIGHT:
Ronald K. Brown at a dress
rehearsal of *Serving Nia.*
Asha Thomas looks on.
Photographer: Paul Kolnik

OPPOSITE, LEFT:
Asha Thomas in Ronald K.
Brown's *Grace.*
Photographer: Paul Kolnik

ABOVE: Glen A. Sims, Linda
Celeste Sims, and Cheryl Rowley-
Gaskins in *Serving Nia.*
Photographer: Paul Kolnik

BELOW: Briana Reed (center)
in *Grace.*
Photographer: Paul Kolnik

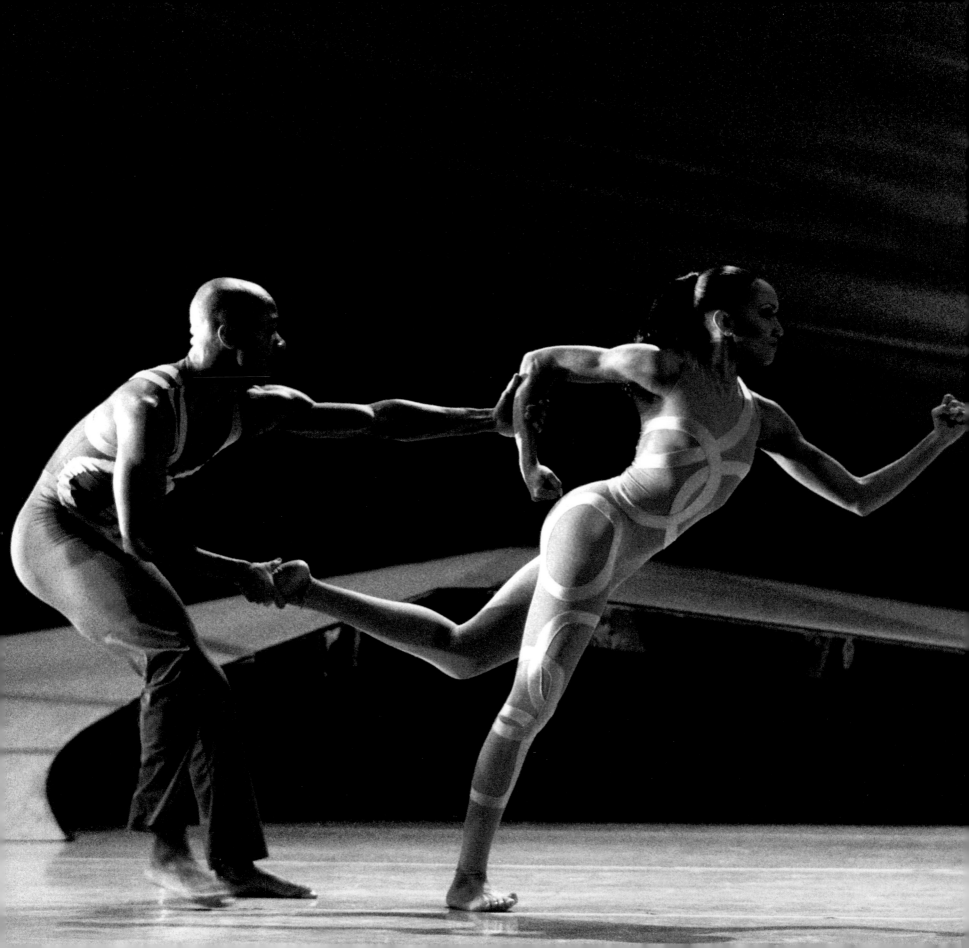

Transitions

WHEN JUDITH JAMISON BECAME ARTISTIC DIRECTOR OF THE ALVIN AILEY AMERICAN DANCE Theater in 1989, the company was critically successful and, although more than a million dollars in debt, on the verge of a huge growth spurt. Fifteen years later she continues to guide a group of arts professionals, choreographers, designers, and unusually versatile dancers as they all think and work together. "When that happens," she says, "the sky is the limit."

One of Jamison's first appointments was Masazumi Chaya as associate artistic director of the company. Chaya has served in the company for over thirty years. He was a dancer, rehearsal director, and eventually Ailey's choreographic assistant.

"I went to all of Alvin's rehearsals and learned every part," says Chaya. "I can remember every step because I have one of those Japanese computer brains."

His brain keeps in top condition the company's enormous repertory—Ailey's ballets as well as the dances of many other choreographers, including Alonzo King, Donald Byrd, Lynne T. Corbett, Earl Mosely, and Garth Fagan.

Jamison's biggest challenge, after Ailey's death, was to continue his artistic legacy while expanding the company's reach. "I want to constantly feed the repertory with artists who are on the cusp, putting their feet into the future."

While preserving the work of the senior choreographers who were Alvin's contemporaries, Jamison knows well that audiences also have to be challenged artistically; each new season demands new ballets and fresh visions. She herself began to choreograph in 1984. Her *Double Exposure*, which premiered in 2000, was her eighth ballet for the Ailey company. "I'm influenced by Martha Graham and material moving around; elegance and color, too. Dancers like Matthew Rushing and Glenn Sims give you an extra stretch of whatever movement you've given them initially."

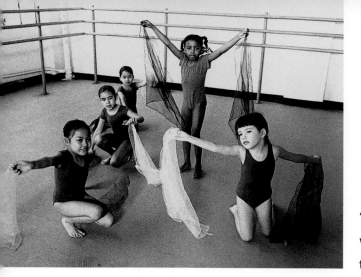

LEFT: The youngest dancers at the Ailey
School, 1998.
Photographer: Marbeth Schnare

BELOW: Warming up before class, 2003.
Photographer: Beatriz Schiller

"I always say when I'm working on a new piece that the dancers' mistakes are sometimes my steps. For instance, they will fall out of something that I have given them to do and it becomes an organic transition into something else. It all boils down to a matter of trust and my belief in what their bodies are naturally doing.

"In one segment of *Double Exposure*," she recalls, "I tripped executing a step. I turned around and saw that the dancers had picked up the trip! All of a sudden the trip became part of the their movement. I love working that way because that is the way Alvin used to work with me. I adore exploring and trusting those dancers to extend themselves in the process of making a dance."

Most of the members of the Ailey company at one time or another studied at the Ailey School, "my real baby," as Alvin described it. Since 1984 Denise Jefferson has directed the school, having joined the faculty in 1974. Under her leadership, the Ailey School has expanded into a leading institution for educating the next generation in dance. "The school was one of the dearest things to Alvin's heart," Peter Woodin says. "If we could ask him today what he was most proud of in all of his accomplishments, the school would be right there at the top of his list."

PAGE 134: Linda-Denise Fisher-Harrell and
Matthew Rushing in Judith Jamison's *HERE. . .
NOW*, 2002.
Photographer: Paul Kolnik

Today the Ailey School welcomes approximately 3,500 students from across the United States and around the world. From its First Steps program for young children to its Professional Division, the school is recognized as an international dance academy whose diverse curriculum includes ballet, with adagio; Horton, Dunham, Graham, Limon, Cunningham, and Taylor modern dance techniques; jazz; West African dance; Spanish and salsa dance; classical Indian dance; tap; yoga; and repertory classes. There are also courses in dance history, particularly the history of the Alvin Ailey American Dance Theater. Guest lecturers, including Joe Nash, Carmen de Lavallade, Gus Solomons, Jr., Sarita Allen, Hinton Battle, Brenda Dixon-Gottschild, Dudley Williams, Eleo

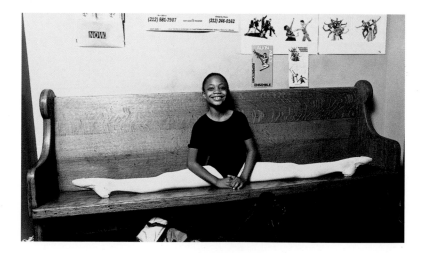

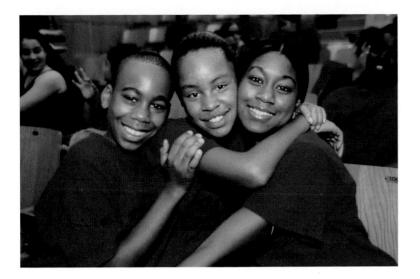

LEFT: AileyCampers, 2003.
Photographer: Ellen Crane

BELOW: Ailey School senior students.
Photographer: Beatriz Schiller

Pomare, Joselli Deans, Abdel Salaam, and Kate Ramsey, frequently conduct the classes. Graduates of the school have gone on to join prominent dance companies all over the world.

With the AileyCamps the company has further extended its mission, while the Ailey Arts-in-Education programs continue to bring concert dance to audiences that might otherwise never be exposed to it. Nasha Thomas-Schmitt, another of Ailey's former dancers, oversees both facets of the organization's education/outreach programs. She danced with the Ailey company from 1986 to 1998, learning *Cry* from Judith Jamison herself. The AileyCamps, currently operating in seven cities nationwide, provide dance instruction, tuition-free, and a nurturing environment for young students that is safe and fun.

The New York City AileyCamp's director is Keith Anthony Lewis, who forfeited his scholarship at Cornell University after one year in order to train at the Ailey School in 1986. Today Lewis is a

choreographer himself. His work *Crazy in Love*, to the hip-hop music of Beyoncé and Jay-Z, had the parents in the audience dancing in their seats as they watched their children in the annual AileyCamp performances.

Back in the seventies Ailey himself recognized that the company needed its own building, but the demands of fundraising were too distracting. "I find that calling people on the phone and going to meetings and parties is too much," he said in 1977. "Man, that is like seven hours of rehearsal. I could have made a new dance in that time."

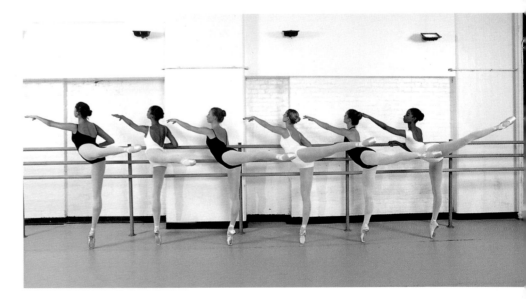

Soon after Judith Jamison assumed the director's role, the Ailey School grew so rapidly that the need for a space became even more acute. She realized early on that a new building was not a luxury, but a necessity.

"I do attend the board meetings. I do raise money. I am a good salesperson because I love the people I am trying to raise money for."

Thanks to Jamison's foresight, the Ailey organization now has its own new building at Fifty-fifth Street and Ninth Avenue in Manhattan. The Joan Weill Center for Dance is named for the chairman of the board of trustees. It includes twelve dance studios and a 295-seat, black-box theater, along with a permanent archive that will serve the entire dance community. In addition, it provides a home for the Ailey School. The nation's largest building devoted to dance, it is, coincidentally, located on the site of the television studio where Alvin filmed *Revelations* for broadcast back in 1961. Both Joan Weill and Executive Director Sharon Gersten Luckman have supported Jamison's initiatives toward this new milestone on the Ailey journey.

Jamison's vision, always true to her mentor's legacy, has allowed the Ailey spirit to set its feet firmly in a new century of American dance.

We are objects of Alvin's creations but he allowed us to show who we are as human beings and artists within his choreographic process. I was lucky enough to meet and work for Alvin in order to find out my own identity.
Masazumi Chaya

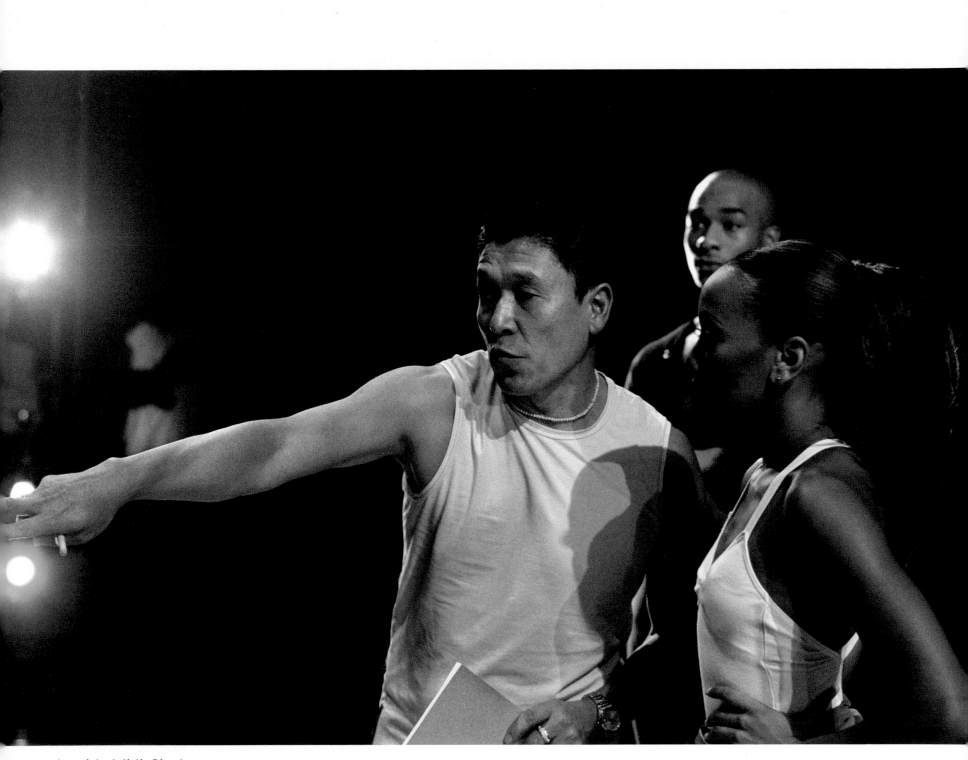

Associate Artistic Director
Masazumi Chaya backstage with
Linda-Denise Fisher-Harrell and
Anthony Burnell.

Photographer: Paul Kolnik

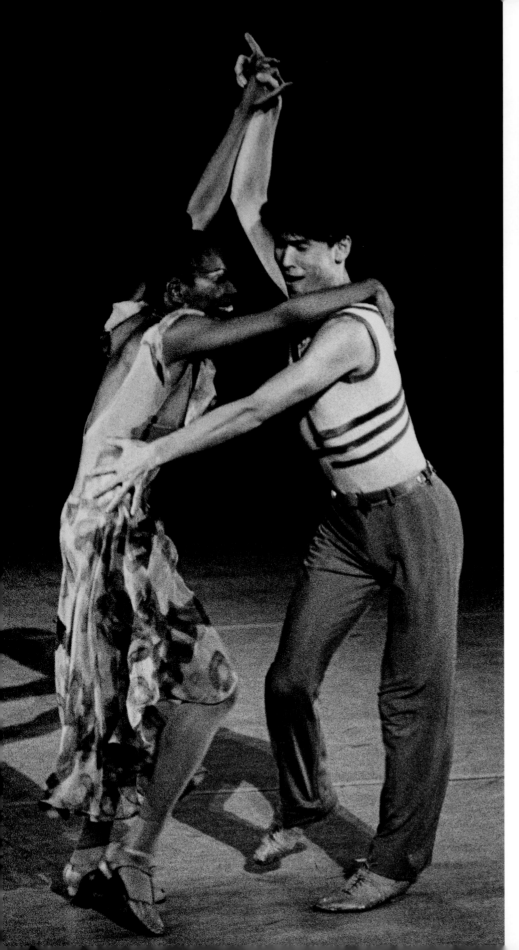

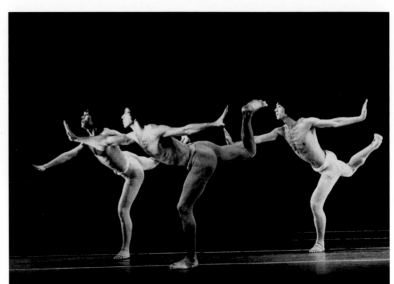

LEFT: Marilyn Banks and
Masazumi Chaya in Alvin Ailey's
Phases, "A celebration of the life
force," in 1980.
Photographer: Jack Vartoogian

ABOVE: Michihiko Oka, Kenneth
Pearl, and Masazumi Chaya in
Alvin Ailey's *Streams*.
Photographer: Fred Fehl

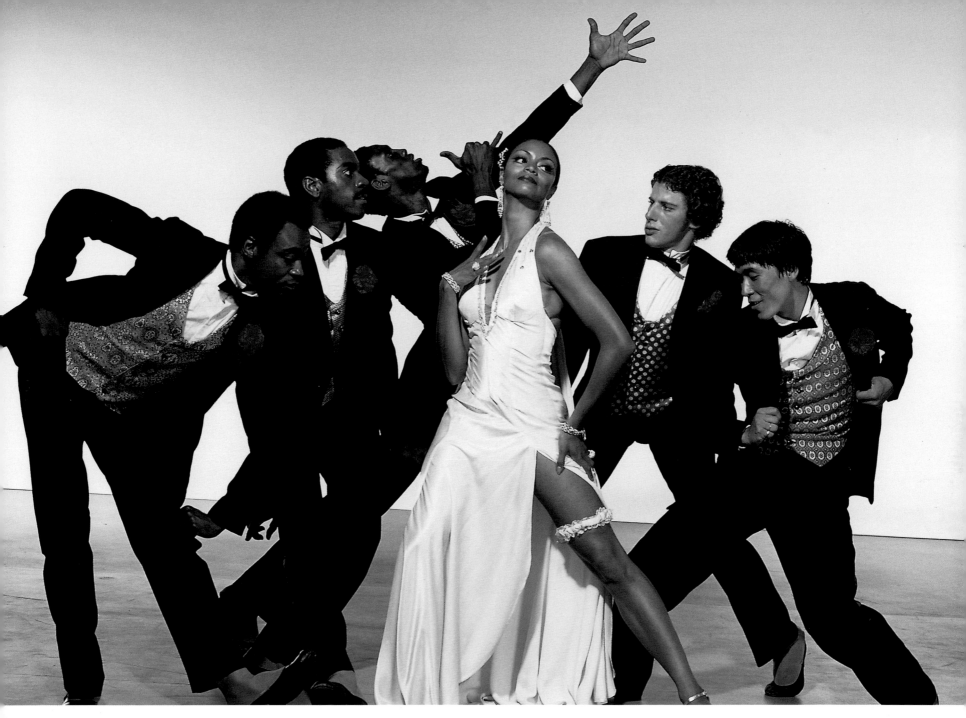

Donna Wood with (left to right)
Melvin Jones, Ulysses Dove,
Alistair Butler, Richard Orbach,
and Masazumi Chaya in Donald
McKayle's *District Storyville*,
in 1976.

Photographer: Jack Mitchell

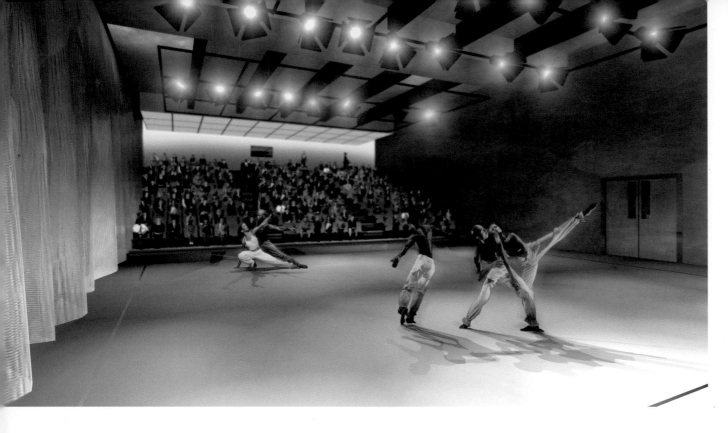

LEFT: Architect's rendering of the black-box theater inside the Ailey's new bulding, Joan Weil Center.

LEFT: Judith Jamison and students parade to the site of the new building for the groundbreaking on October 9th, 2002.

Photographer: Kwame Brathwaite

Architects rendering of the new home of the Alvin Ailey American Dance Theater.

Our new home will be a landmark reminder of the genius of Alvin Ailey. His legacy lives on every day in the brilliant artists who perform the Ailey magic all over the world. *Judith Jamison*

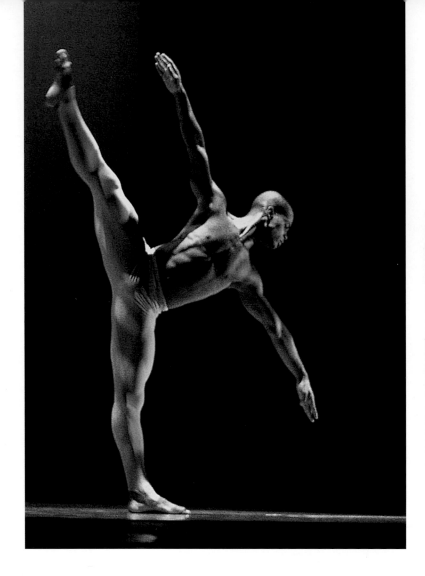

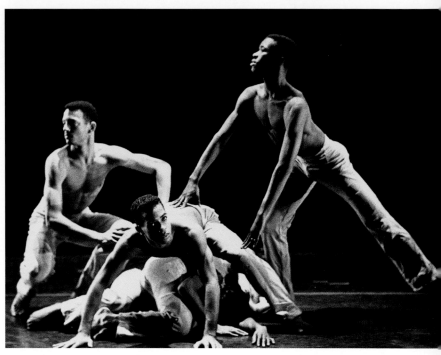

LEFT: Alvin Ailey's *Streams* with Vernard Gilmore.

Photographer: Beatriz Schiller

BELOW: Ulysses Dove's *I See the Moon...and the Moon Sees Me*, his first ballet, for Ailey II; with Ali Dixione, Aubrey Lynch, and Troy Powell, in 1979.

Alvin Ailey was a man with a large, embracing spirit. His enthusiasm for what was innovative, unusual, and daring, and his ability to rapidly sketch, from thin air, the most exciting ideas for new projects made him an almost quicksilver energy force. *Denise Jefferson*

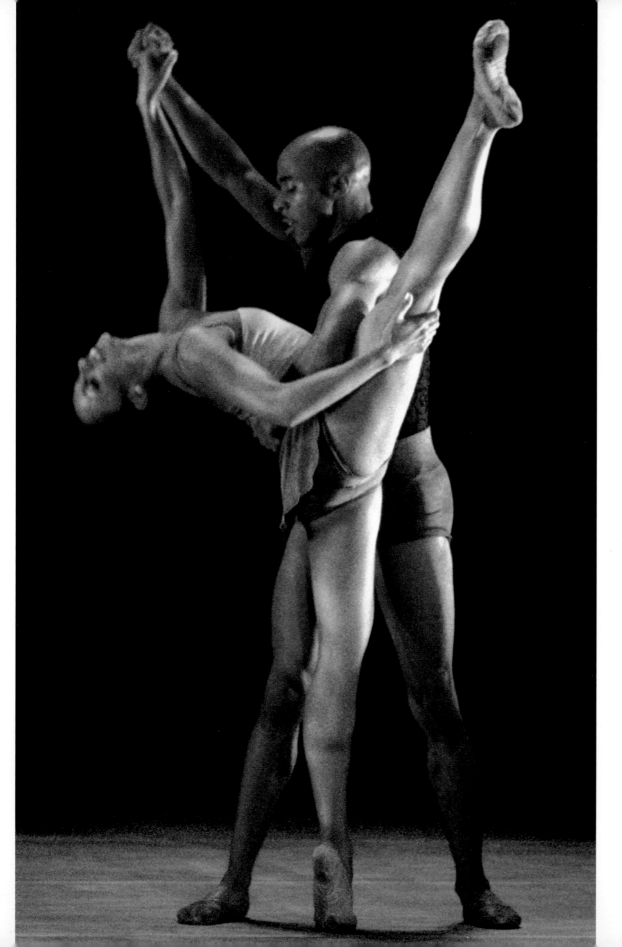

LEFT: Linda Celeste Sims and Matthew Rushing in Alonzo King's *Following the Subtle Current Upstream.*

Photographer: Paul Kolnik

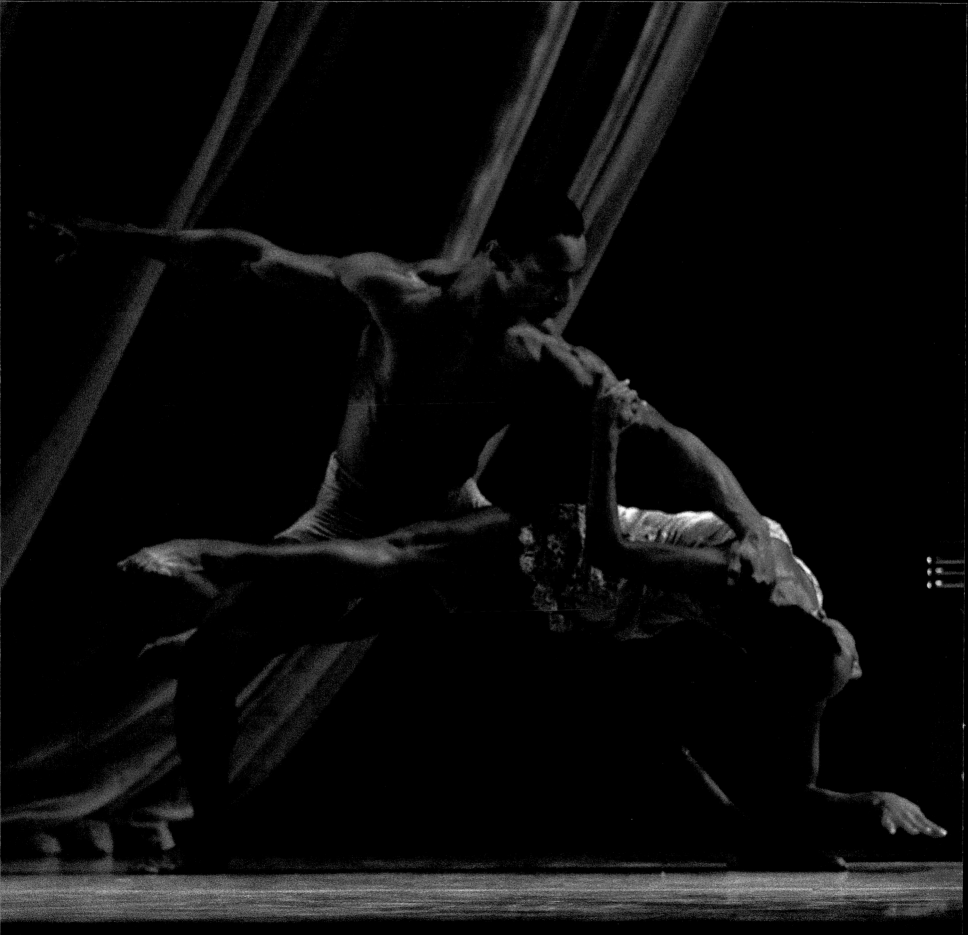

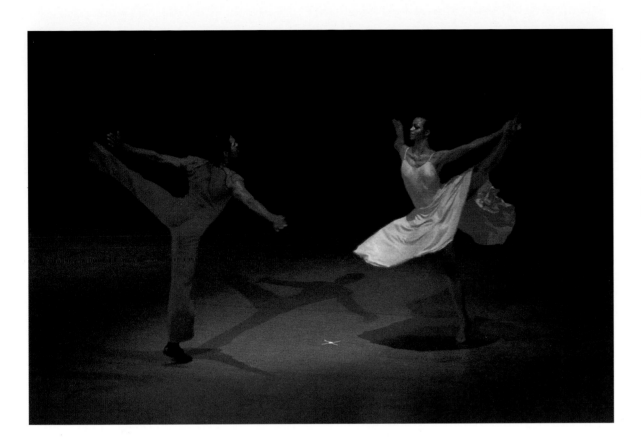

OPPOSITE: Judith Jamison's *Sweet Release;* with Uri Sands and Karine Plantadit-Bageot, in 1996.
Photographer: Johan Elbers

LEFT: Donna Wood and Ulysses Dove in *Suite Otis,* by George Faison.
Photographer: Jack Vartoogian

There are all kinds of idiosyncrasies that contribute to what you envision artistically. It is an evolution that is happening in front of me. I am seeing what was there and where I have to go with it today. *Judith Jamison*

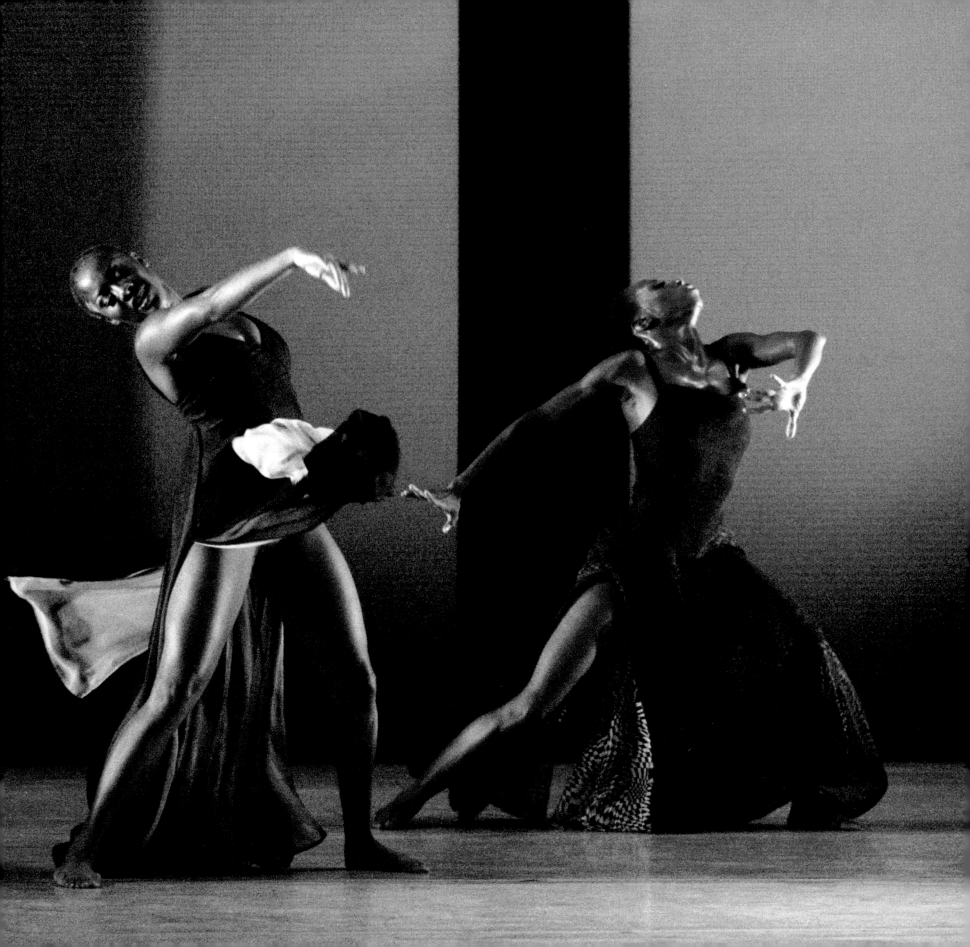

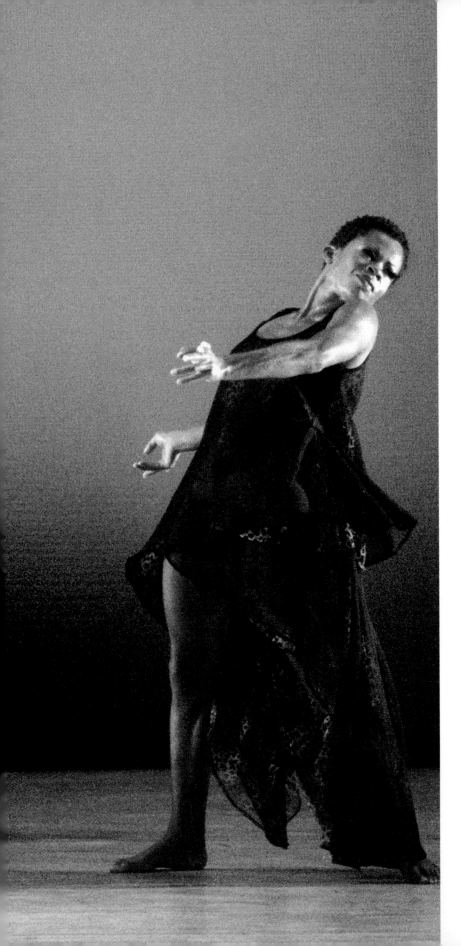

Experiencing Alvin Ailey makes you feel that to live life is to live in a place that is full of wonder and full of grace. *Kenneth Pearl*

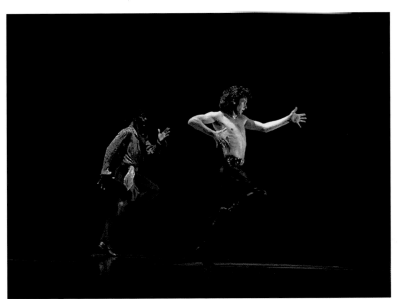

ABOVE: Alvin Ailey's *Precipice;* with Ralph Glenmore and Patrick Dupond, in 1984.

Photographer: Jack Vartoogian

LEFT: Judith Jamison's *Double Exposure,* with Asha Thomas, Dwana Adiaha Smallwood, and Bahiyah Sayyed-Gaines.

Photographer: Paul Kolnik

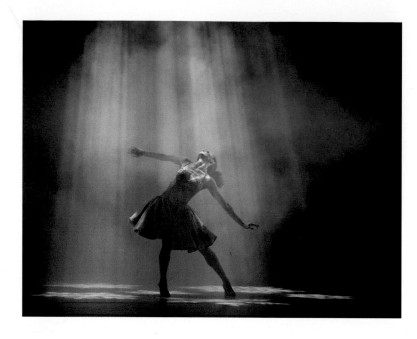

LEFT: Laura Rossini in *The Winter in Lisbon,* by Billy Wilson, 2003.
Photographer: Basil Childers

RIGHT: Richard Witter and Wendy White Sasser with Dwana Adiaha Smallwood and Glen A. Sims in Dwight Rhoden's *Chocolate Sessions.*
Photographer: Paul Kolnik

The incentive is that Alvin's spirit is still with us, and as intangible as that sounds and as ethereal as it may be in theory, it's true! *Judith Jamison*

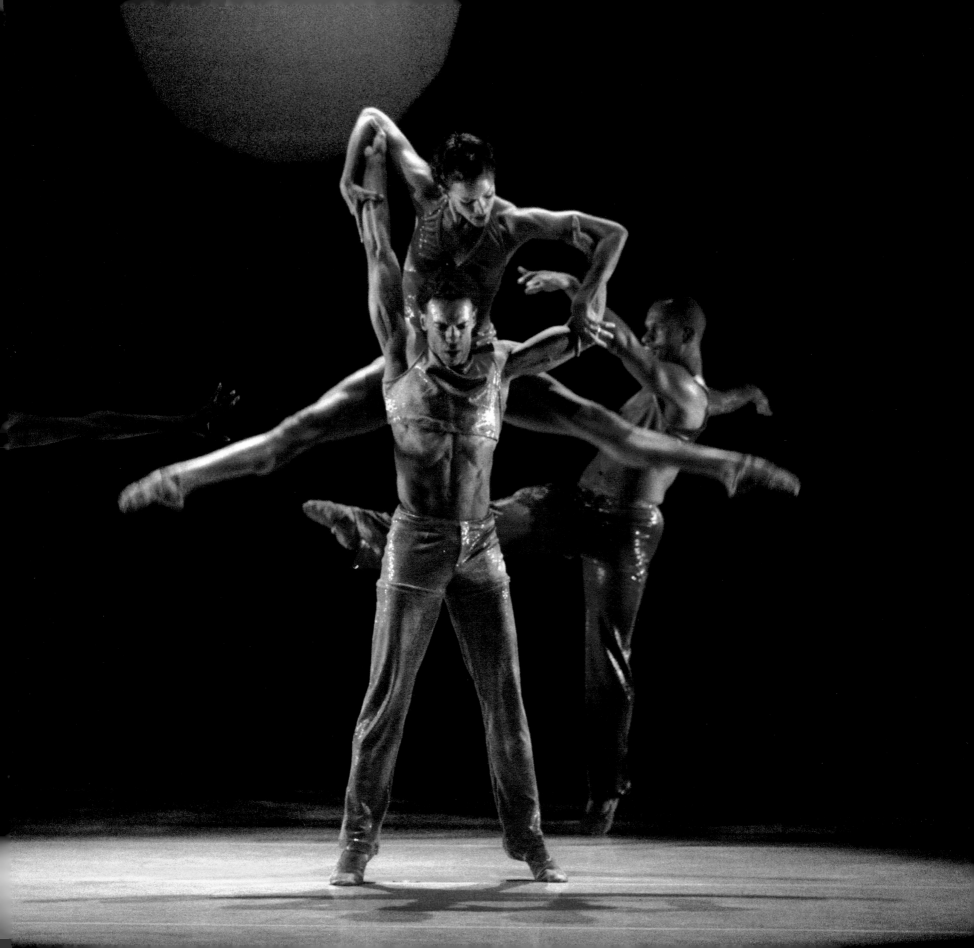

In Memoriam

Alvin Ailey	Ulysses Dove	Charles Moore
Consuelo Atlas	Miguel Godreau	Michihiko Oka
Carl Bailey	Raymond Harris	Ernest Pagnano
Talley Beatty	Thelma Hill	Michael Peters
Roger Bellamy	Paul Hoskins	Harold Pierson
Enid Britten	Herman Howell	Robert Powell
Roman Brooks	Wesley Johnson III	Ramon Segarra
Kevin Brown	Mari Kajiwara	Brother John Sellers
Alistair Butler	Bernard Lias	Gregory Stewart
Sergio Cal	William Louther	Danny Strayhorn
Bill Chaison	Ed Love	Joyce Trisler
Daniel Clark	Minnie Marshall	James Truitte
Gary DeLoatch	Keith McDaniel	Lester Wilson
Joan Derby	John Medeiros	Morton Winston

OPPOSITE: William Louther in Alvin Ailey's solo *Hermit Songs* in 1963.
Photographer: Anthony Crickmay

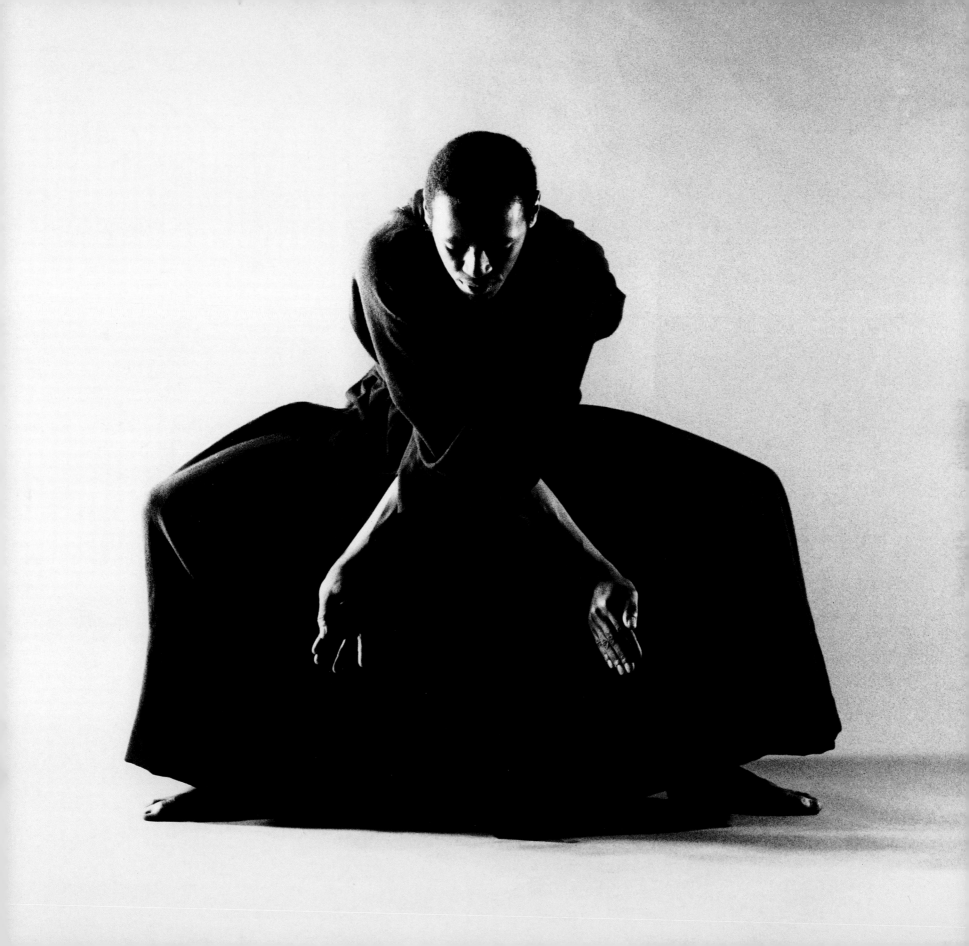

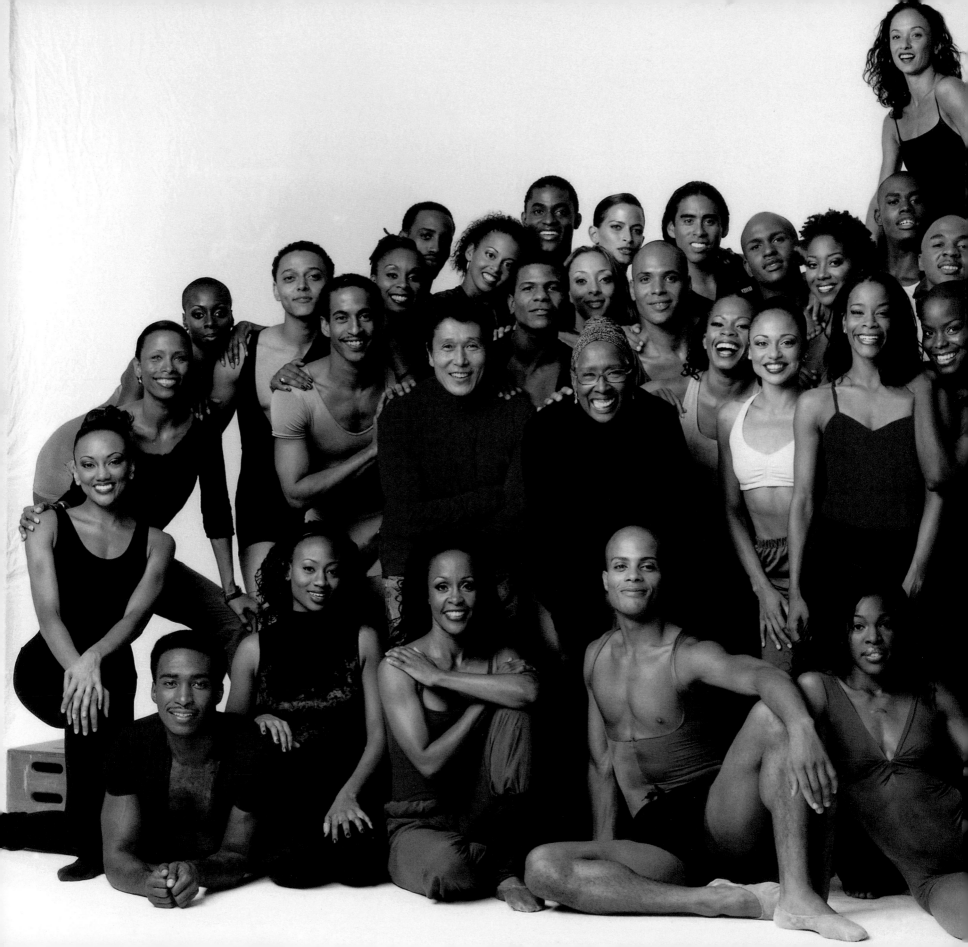

The space in me that used to be filled up by performing is now filled up by sitting out in the audience and watching these extraordinary young dancers do their thing. I look at them and think, "Yeah, it's their time!" *Judith Jamison*

The company, 2003

Photographer: Andrew Eccles

Ailey Repertory 1958-1979

YEAR	CHOREOGRAPHER	BALLET	COMPOSER
1958	Alvin Ailey	Ode and Homage	Peggy Glanville-Hicks
	Alvin Ailey	Blues Suite	Traditional Folk
	Alvin Ailey	Ariette Oubliee	Claude Debussy
	Alvin Ailey	Cinco Latinos	Traditional
1959	Alvin Ailey	Sonera	Alejandro Caturia
1960	Alvin Ailey	Revelations	Traditional
	John Butler	Letter to a Lady	Ravel
	Lester Horton	Variegations	John Wilson
	Alvin Ailey	Knoxville Summer of 1915	Samuel Barber
	Alvin Ailey	Creation of the World (New Version)	Darius Milhaud
	Alvin Ailey	Three for Now— Modern Jazz Suite	Lalo Schifrin
1961	Alvin Ailey	Roots of the Blues	Traditional
	Alvin Ailey	Hermit Songs	Samuel Barber
	Alvin Ailey	Gillespiana	Lalo Schifrin
1962	Alvin Ailey	Been Here and Gone	Traditional Folk
	Alvin Ailey	Reflections in D	Duke Ellington
	Glen Tetley	Mountainway Chant	Carlos Chavez
1963	Alvin Ailey	Labyrinth	Lawrence Rosenthal
	Alvin Ailey	Rivers, Streams, Doors	Traditional Folk
	Alvin Ailey	First Negro Centennial —Light —The Blues Ain't —My Mother, My Father	Duke Ellington

YEAR	CHOREOGRAPHER	BALLET	COMPOSER
1964	Alvin Ailey	The Twelve Gates	Traditional Folk
[1960]	Talley Beatty	Toccata	Lalo Schifrin
[1960]	Talley Beatty	Congo Tango Palace	Ellington/Strayhorn
[1960]	Talley Beatty	The Road of the Phoebe Snow	Ellington/Strayhorn
[1959]	Lester Horton	To Jose Clemente Orozco (from Dedications in Our Time)	Kenneth Klauss
[1947]	Lester Horton	The Beloved	Judith Hamilton
[1955]	Anna Sokolow	Rooms	Kenyon Hopkins
[1958]	Joyce Trisler	Journey	Charles Ives
[1953]	Louis Johnson	Lament	Heitor Villa-Lobos
[1964]	Paul Sanasardo	Metallics	Henk Badings, Henry Cowell
[1960]	Talley Beatty	Come and Get the Beauty of it Hot	Mingus, Davis, & Schifrin
1967	Alvin Ailey	Riedaiglia	George Riedel
	Talley Beatty	The Black Belt	Duke Ellington
1968	Alvin Ailey	Quintet	Laura Nyro
	Geoffrey Holder	The Prodigal Prince	Geoffrey Holder
[1964]	Lucas Howing	Icarus	Shin Ichi Matsushita
	Robert Schwartz	Scrum	Various
1969	Alvin Ailey	Masekela Langage	Hugh Masekela
	Pauline Koner	Poeme	Samuel Barber
	Michael Smuin	Panambi	Alberto Ginastera
	Joyce Trisler	Dance For Six	Antonio Vivaldi
	Richard Wagner	Threnody	Tadeusz Baird
1970	Alvin Ailey	Streams	Miloslav Kabelac
	Alvin Ailey	Gymnopedies	Eric Satie
	Miguel Godreau	Paz	Traditional
[1964]	Geoffrey Holder	Adagio for a Dead Soldier	Tomaso Albinoni
	John Parks	Black Unionism	John Coltrane
	Kelvin Rotardier	The Cageling	Nat Adderly
	Kelvin Rotardier	Child of the Earth	Hugh Masekela

YEAR	CHOREOGRAPHER	BALLET	COMPOSER
1971	Alvin Ailey	Flowers	Various
	Alvin Ailey	Archipelago	Andre Boucourechiev
	Alvin Ailey	Choral Dances	Benjamin Britten
	Alvin Ailey	Cry	Various Contemporary
	Alvin Ailey	Mary Lou's Mass	Mary Lou Williams
	Alvin Ailey	Myth	Igor Stravinsky
[1962]	Brian McDonald	Time Out of Mind	Paul Creston
	Mary O'Donnell	Suspension	Ray Green
1972	Alvin Ailey	The Lark Ascending	Ralph Vaughn Williams
	Alvin Ailey	Shaken Angels	Various (Rock)
	Alvin Ailey	Love Songs	Various
	John Butler	According to Eve	George Crumb
[1943]	Katherine Dunham	Choros	Vadico Gogliano
[1959]	Donald McKayle	Rainbow Round My Shoulder	Traditional
	John Parks	Nubian Lady	K. Barron
[1936]	Ted Shawn	Kinetic Molpal	Jess Meeker
1973	Alvin Ailey	Hidden Rites	Patrice Sciortino
[1959]	John Butler	Carmina Burana	Carl Orff
	Marlene Furtick	How Long Have It Been	Lightnin' Hopkins
[1958]	Jose Limon	Missa Brevis	Zoltan Kodaly
	Norman Walker	Clear Songs After Rain	Lou Harrison
1974	Alvin Ailey	Such Sweet Thunder	Duke Ellington
	Alvin Ailey	Night Creature	Duke Ellington
	Alvin Ailey	The Blues Ain't	Duke Ellington
	Alvin Ailey	Sonnet for Caesar	Duke Ellington
	Alvin Ailey	Sacred Concert	Duke Ellington
	Jose Limon	Missa Brevis	Zoltan Kodaly
[1962]	Alvin Ailey	Feast of Ashes	Carlos Surinach
[1966]	John Butler	After Eden	Lee Hoiby
[1959]	John Butler	Portrait of Billie	Billie Holiday
	Janet Collins	Canticle of the Elements	JS Bach/Heitor Villa-Lobos
[1949]	Janet Collins	Spirituals	Traditional
	John Jones	Nocturne	Yusef Lateef
[1949]	Pearl Primus	Fanga	Traditional
[1961]	Pearl Primus	The Wedding	Traditional
1975	Milton Myers	Echoes in Blue	Duke Ellington
[1962]	Lester Horton	Liberian Suite	Duke Ellington
	Alvin Ailey	The Mooche	Duke Ellington
1976	Alvin Ailey	Black, Brown & Beige	Duke Ellington
	Alvin Ailey	Pas de Duke	Duke Ellington
	Alvin Ailey	Three Black Kings	Duke & Mercer Ellington
	John Butler	Facets	Various
[1971]	George Faison	Gazelle	Various
	George Faison	Hobo Sapiens	Stevie Wonder & Billie Preston
	Louis Falco	Caravan	Duke Ellington/ Kamen
	Donald McKayle	Blood Memories	Howard Roberts
1977			
[1971]	George Faison	Suite Otis	Various/Otis Redding
[1972]	Lar Lubovitch	The Time Before The Time After (After the Time Before)	Igor Stravinsky
	Diane McIntyre	Ancestral Voices	Cecil Taylor
	Jennifer Muller	Crossword	Burt Alcantara
	Milton Myers	The Wait	Antonio Vivaldi
[1966]	Rudy Perez	Countdown	Madaline Gray
[1966]	Rudy Perez	Coverage II	Various
1978	Alvin Ailey	Passage	Hale Smith
[1974]	Rael Lamb	Butterfly	Morton Subnotnik
	Eleo Pomare	Blood Burning Moon	Lateef, Ellington
1979	Alvin Ailey	Memoria	Keith Jarret
[1976]	Lar Lubovitch	Les Noces	Igor Stravinsky
[1975]	George Faison	Tilt	Various
	Donald McKayle	District Storyville	Dorothea Freitag
	Alvin Ailey	Mingus Dances	Charles Mingus

Ailey Repertory 1980-2004

YEAR	CHOREOGRAPHER	BALLET	COMPOSER
1980	Alvin Ailey	Phases	Various
	Ulysses Dove	Inside	Robert Ruggieri
	Kathryn Posin	Later That Day	Philip Glass
	Todd Bolender	The Still Point	Claude Debussy
1981			
[1970]	Alvin Ailey	The River	Duke Ellington
	Alvin Ailey	Landscape	Bela Bartok
	Alvin Ailey	Spell	Keith Jarret
	Elisa Monte	Treading	Steve Reich
	Billy Wilson	Concerto in F	George Gerschwin
	William Chaison	Places	Johann Sebastian Bach
	Choo San Goh	Spectrum	Johann Sebastian Bach
	Louis Johnson	Fontessa & Friends	Various
1982	Elisa Monte	Pigs & Fishes	Glenn Branca
	Rodney Griffin	Sonnets	John Dowland
	Alvin Ailey	Satyriade	Maurice Ravel
	Hans van Manen	Songs Without Words	Felix Mendelssohn-Bartholdy
	Kathryn Posin	Waves	
1983	Talley Beatty	The Stack-Up	Various Artists
	Bill T. Jones	Fever Swamp	Peter Gordon
	Gary DeLoatch	Research	John McLaughlin, Miles Davis, Earl Klugh & The Brothers
	John Butler	Seven Journeys	Pederecki, Britten, Ruggieri
	Talley Beatty	Blueshift	Various Contemporary
	Billy Wilson	Lullabye for a Jazz Baby	Arthur Cunningham & Talib Rasul Hakim
1984	Alvin Ailey	For 'Bird'—With Love	Charlie Parker, Dizzy Gillespie, Count Basie, Jerome Kern & Coleridge-Tatlor Parkinson

YEAR	CHOREOGRAPHER	BALLET	COMPOSER
1984	continuted		
	Alvin Ailey	Isba	George Winston
	Loris Anthony Beckles	Anjour	Keith Jarret
	Donald McKayle	Collage	L. Subramaniam
	Judith Jamison	Divining	Kimati Dinizulu & Monti Ellison
[1983]	Alvin Ailey	Precipice	Pat Methany & Lyle Mays
1985	Bill T. Jones & Arnie Zane	How To Walk An Elephant	Conlon Nancarrow
[1982]	Ulysses Dove	Night Shade	Steve Reich
1986	Alvin Ailey	Survivors	Max Roach
	Alvin Ailey	Caverna Magica	Andreas Vollenweider
	Alvin Ailey	Witness	Traditional sung by Jessye Norman
[1984]	Ulysses Dove	Bad Blood	Laurie Anderson
1987	Katherine Dunham	The Magic of Katherine Dunham	Numerous Composers
[1986]	Ulysses Dove	Vespers	Mikel Rouse
[1974]	Jennifer Muller	Speeds	Burt Alacantara
1988	Rovan Deon	From the Mountains of Taubalu	The Winans
	Alvin Ailey	Opus McShann	Jay McShann & Others
	Donald Byrd	Shards	Mio Morales
	Kelvin Rotardier	Tell It Like It is	Terry Callier
1989	Barry Martin	Chelsea's Bells	Robert Ruggieri & Melissa Etheridge
[1987]	Ulysses Dove	Episodes	Robert Ruggieri
[1950]	Lester Horton	Sarong Paramaribo	Les Baxter

YEAR	CHOREOGRAPHER	BALLET	COMPOSER
1990			
[1989]	Judith Jamison	Forgotten Time	Le Mystere des Voix Bulgares
[1951]	Donald McKayle	Games	Traditional
[1952]	Pearl Primus	Impinyuza	Traditional
[1987]	Lar Lubovitch	North Star	Philip Glass
[1988]	Kris World	Read Matthew 11:28	Bobby McFerrin
1991	Donald Byrd	Dance At The Gym	Mio Morales
[1981]	Louis Falco	Escargot	Ralph MacDonald
	Judith Jamison	Rift	Nona Hendryx
1992	Donald Byrd	A Folk Dance	Mio Morales
	Dwight Rhoden	Frames	Various Contemporary
	Billy Wilson	The Winter in Lisbon	Dizzy Gillespie
	Jawole Willa Jo Zollar	Shelter	Junior Wedderburn
1993	Judith Jamison (Libretto: Anna Deavere Smith)	Hymn	Robert Ruggieri
	Garth Fagan	Jukebox for Alvin	Antonin Dvorak, Taj Mahal, Keith Jarrett, Sly Dunbar & Robbie Shakespear
	Jerome Robbins	N.Y. Export, Op. Jazz	Robert Prince
1994			
[1958]	Brenda Way	Scissors, Paper, Stone	John "Mighty Mouth" Moschitta, John Lee Hooker, Loudon Wainwright III, Jimi Hendrix
	Elisa Monte	Mnemonic Verses	Jon Hassell
1995	Judith Jamison	Riverside	Kimati Dinizulu
	Shapiro & Smith	Fathers and Sons	Scott Killian
	Lar Lubovitch	Fandango	Maurice Ravel
	Ulysses Dove	Urban Folk Dance	Michael Torke
1996	Judith Jamison	Sweet Release	Wynton Marsalis
	Lar Lubovitch	Cavalcade	Steve Reich
	Hans van Manen	Polish Pieces	Henryk-Mikolaj Górecki

YEAR	CHOREOGRAPHER	BALLET	COMPOSER
1997	Donald Byrd	Fin de Siecle	Mio Morales
	Earl Mosley	Days Past, Not Forgotten	Mark Flanders & Victor See Yuen
[1971]	George Faison	Slaves	Various Artists
1998	Judith Jamison	Echo: Far From Home	Robert Ruggieri
	Redha	Lettres d'Amour	Various Artists
	Lisa Johnson	Restricted	Michael Mays
	Troy O'Neil Powell	Ascension	Michael Wimberly
1999	Ronald K. Brown	Grace	Duke Ellington, Roy Davis, Fela Anikulapo Kuti
	Jawole Willa Jo Zollar	C# Street– Bb Avenue	David Murray, Michael Wimberly & Ntozake Shange
	Donald McKayle	Danger Run	Frederic Rzewski
2000	Judith Jamison	Double Exposure	Robert Ruggieri
	Alonzo King	Following the Subtle Current Upstream	Zakir Hussain, Miguel Frasconi & Miriam Makeba
	Carmen de Lavallade	Sweet Bitter Love	Various
	Dwight Rhoden	Chocolate Sessions	Antonio Carlos Scott
2001	Ronald K. Brown	Serving Nia	Roy Brooks, Branford Marsalis, Mamadouba Mohammed Camara, Dizzy Gillespie
	Judith Jamison	HERE…NOW.	Wynton Marsalis
2002	Lynne Taylor-Corbett	Prayers from the Edge	Peter Gabriel
	Francesca Harper	Apex	Rolf Ellmer
[1984]	Ohad Naharin	Black Milk	Paul Smadbeck
2003	Robert Battle	Juba	John Mackey
	Alonzo King	Heart Song	Bouchaib Abdelhadi, Yassir Chadly and Hafida Ghanim
	Jennifer Muller	Footprints	Lawrence Nachsin
	Dwight Rhoden	Bounty Verses	Various

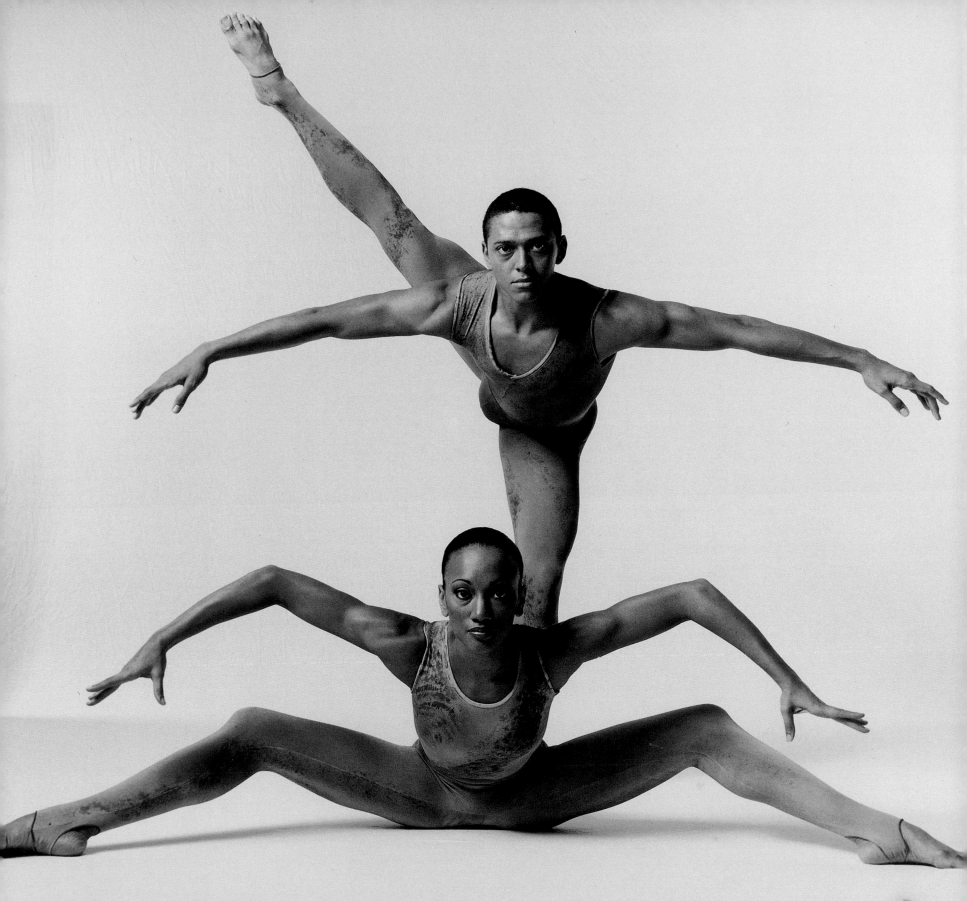

Ailey Timeline

1958, MARCH 30
Alvin Ailey and a group of young, black, modern dancers perform for the first time as members of Alvin Ailey American Dance Theater at New York's 92nd Street YM-YWHA.

1958–1960
The company travels on what Alvin Ailey calls "the station wagon tours."

1960
AAADT becomes a resident company of the 51st Street YWCA's Clark Center for the Performing Arts—the company's first official residence.

Alvin Ailey choreographs *Revelations*.

1962
AAADT is chosen to go on an extensive tour to the Far East, Southeast Asia, and Australia as part of President John F. Kennedy's progressive "President's Special International Program for Cultural Presentations."

1963
AAADT performs in a Chicago program entitled "My People: First Negro Centennial," a collaboration between Duke Ellington and Talley Beatty.

AAADT performs at the Rio de Janeiro International Arts Festival.

1965, OCTOBER 30
Judith Jamison dances with AAADT for the first time.

1966
AAADT participates in the first Negro Arts Festival in Dakar, Senegal.

1967, JUNE
AAADT embarks on a two-and-a-half month, 10-country tour of Africa for the State Department.

1968
Alvin Ailey sets *Revelations* on Ballet Folklorico for the opening ceremonies of the 1968 Olympics in Mexico City. This becomes the only performance of *Revelations* by a company other than AAADT or Ailey II.

AAADT performs at the White House for President Johnson.

1969
Alvin Ailey American Dance Theater moves to Brooklyn Academy of Music. Alvin Ailey establishes a school.

AAADT's first season in Manhattan at the Billy Rose Theater.

1970
Alvin Ailey American Dance Theater and the school relocate to 229 East 59th Street in Manhattan. AAADT and the Pearl Lang Dance Company share rehearsal space while Alvin Ailey and Pearl Lang co-direct their joint school, the American Dance Center.

AAADT's second State Department-sponsored tour of North Africa and Europe.

AAADT establishes itself as a non-profit, tax-exempt organization in order to seek sustaining funds for the company.

AAADT goes on a six-week tour of the USSR—the first for an American modern dance company since the days of Isadora Duncan.

Alvin Ailey choreographs *The River* for American Ballet Theatre.

1971
AAADT appears for the first time at New York's City Center. The company is such a success that it is invited to perform there again three months later.

Alvin Ailey choreographs *Cry* for Judith Jamison as a birthday present to his mother.

AAADT participates in the inaugural gala performance of Leonard Bernstein's *Mass* at the John F. Kennedy Center for the Performing Arts in Washington, D.C.

1972
Alvin Ailey is awarded an honorary Doctorate of Fine Arts degree from Princeton University.

Masazumi Chaya joins AAADT as a dancer.

Judith Jamison receives the distinguished *Dance Magazine* Award.

AAADT becomes City Center's first resident modern dance company.

1974
Alvin Ailey Repertory Ensemble (now known as Ailey II) a professional dance company with a full touring schedule, is created.

CBS airs "Ailey Celebrates Ellington," Alvin Ailey's dance tribute to the American jazz legend.

1975
Alvin Ailey receives the *Dance Magazine* Award. The Company performs at the Duke Ellington Festival at Lincoln Center with the Ellington Orchestra.

1976
Alvin Ailey choreographs *Pas de Duke* for Judith Jamison and Mikhail Baryshnikov and they receive keys to New York City.

The NAACP awards Alvin Ailey the prestigious Spingarn Award.

1977
AAADT performs at President Jimmy Carter's inaugural gala at the White House.

1978
AAADT celebrates its 20th Anniversary.

Ailey Timeline

1978, DECEMBER 31

AAADT gives its fabled "midnight performance" for the Crown Prince of Morocco. Yielding to the Crown Prince's insistence that the company celebrate the new year with him, the dancers do not actually perform until 3 a.m., following a full Moroccan New Year feast!

1979

Alvin Ailey receives the Capezio Dance Award for his contributions to dance.

The company moves into its new home at 1515 Broadway.

1981

Alexander Godunov and Judith Jamison perform *Spell* as guest performers at AAADT's opening night gala.

1982

Alvin Ailey receives the United Nations Peace Medal.

Alvin Ailey American Dance Center is accredited by the National Association of Schools of Dance.

1983

AAADT celebrates its 25th Anniversary.

1984

Judith Jamison premieres her first ballet, *Divining*, for AAADT.

Alvin Ailey's *For 'Bird'—With Love* is created and performed to honor AAADT's relationship with Kansas City Friends of Alvin Ailey.

1985

AAADT is the first modern dance company to go on a U.S. government-sponsored tour of the People's Republic of China since the normalization of Sino-American relations.

1987

Alvin Ailey receives the Samuel H. Scripps American Dance Festival Award, modern dance's greatest honor.

1988

Alvin Ailey receives The Kennedy Center Honor for lifetime contribution to American culture through the performing arts—the nation's highest official distinction for creative artists.

Alvin Ailey receives New York City's highest cultural honor—the Handel Medallion.

AAADT celebrates its 30th Anniversary.

1989

The entire Ailey organization moves to West 61st Street on the Upper West Side of Manhattan. Judith Jamison becomes Artistic Associate for the U.S. tour. Kansas City Friends of Alvin Ailey launches the first AileyCamp program.

1989, DECEMBER 1

Alvin Ailey passes away at the age of 58. Honoring Mr. Ailey's wish, Judith Jamison becomes the Artistic Director of AAADT after his death.

1990

The company makes a triumphant return to Russia.

1991

Masazumi Chaya accepts the position of Associate Artistic Director at the request of Judith Jamison.

Dance in America features *Episodes* by Ulysses Dove and *For 'Bird'—With Love* by Alvin Ailey in "Alvin Ailey: Steps Ahead."

1992

AAADT performs at the televised inaugural gala for President Bill Clinton.

The company performs for the first time at the Paris Opera.

1993

AAADT celebrates its 35th Anniversary. Judith Jamison choreographs *Hymn*, her powerful tribute to Alvin Ailey, in collaboration with the Tony Award-nominated actress and playwright Anna Deavere Smith.

Ailey in the Park attracts 30,000 spectators, who congregate in New York City's Central Park to see the live performance.

1995

Judith Jamison choreographs *Riverside*, set to music composed by Kimati Dinizulu, for the company.

1996

Sweet Release, choreographed by Judith Jamison to an original score by Wynton Marsalis, premieres at

the Lincoln Center Festival, accompanied by the Lincoln Center Jazz Orchestra.

1997

AAADT embarks on a historic residency in South Africa, signaling the end to a long cultural boycott of the old apartheid regime by the international performing arts community. The event is covered by *Time* Magazine and *The New York Times*.

AAADT dances at the opening night gala performance of the New Jersey Performing Arts Center and is named its Principal Resident Affiliate.

1998

AAADT celebrates its 40th Anniversary.

The Ailey organization pioneers its new B.F.A. program—a joint venture between Alvin Ailey American Dance Center and Fordham University.

AAADT is the only dance company to perform at *Time* Magazine's 75th Anniversary gala.

Judith Jamison is the youngest person ever to receive the Dance USA Award during the Spoleto Festival USA. Alvin Ailey Repertory Ensemble travels to Cuba.

AAADT makes a triumphant return to South Africa.

1999

Orlando Bagwell's documentary "A Hymn for Alvin Ailey," inspired by Judith Jamison's work *Hymn,* is broadcast nationally on PBS *Great Performances.* Judith Jamison wins her first Prime Time Emmy Award in the category of Outstanding Choreography.

Alvin Ailey Repertory Ensemble and Alvin Ailey American Dance Center are re-named Ailey II and The Ailey School, respectively.

AileyCamps are successfully launched in Chicago, IL and Bridgeport, CT.

Ailey II enters its 25th Anniversary season of performances and outreach programs. Sylvia Waters celebrates her 25th year as Artistic Director.

Kansas City Friends of Alvin Ailey celebrates its 15th Anniversary and the 10th Anniversary of AileyCamp. *Divining,* created in 1984 by Artistic Director Judith Jamison, is revived as a new production. Judith Jamison receives The Kennedy Center Honor for lifetime contribution to American culture through the performing arts—the nation's highest official distinction for creative artists.

2000

Alvin Ailey American Dance Theater returns to the Lincoln Center Festival and premieres Judith Jamison's new ballet, *Double Exposure.*

2001

Members of Alvin Ailey American Dance Theater and young students from The Ailey School perform on *Sesame Street,* dancing alongside Big Bird and Elmo.

During AAADT's engagement in Paris, France, Judith Jamison receives the Vermeille Medal, the city of Paris's highest award.

2002

Judith Jamison carries the Olympic torch in Salt Lake City, UT prior to the opening ceremonies of the 2002 Winter Olympics. AAADT performs Jamison's *HERE...NOW.* commissioned by the Olympic Arts Festival.

President Bush and First Lady Laura Bush award the distinguished National Medal of Arts to both Judith Jamison and Alvin Ailey Dance Foundation. This is the first time ever that an arts organization and its artistic director have been recognized independently for this prestigious award. The Foundation is the first dance organization in history to be awarded a National Medal of Arts.

Masazumi Chaya celebrates his 30th Anniversary with Alvin Ailey American Dance Theater during the Company's annual New York season.

Alvin Ailey Dance Foundation breaks ground on its new building in Manhattan, scheduled to open in 2004. New York City Mayor Michael Bloomberg joins in the festivities and *The New York Times* covers the event with a front-page photo.

Ailey II is the first company to perform after September 11, 2001, in the reconstructed Winter Garden of the World Financial Center in lower Manhattan.

Judith Jamison is honored by the National Theatre of Ghana and The National Dance Company of Ghana. In recognition of her great achievement in the arts, she is named Naa (Queen Mother) Akuyea Shika.

The Ailey/Fordham B.F.A. in Dance program graduates its first class.

Alvin Ailey American Dance Theater performs *Revelations* at the Rockefeller Center Christmas tree-lighting ceremony, broadcast on NBC television.

2003

Alvin Ailey American Dance Theater celebrates its 45th Anniversary.

Judith Jamison receives the Making a Difference Award presented by the NAACP ACT-SO.

The Capezio Ballet Makers Dance Foundation presents the 52nd annual Capezio Dance Award to Alvin Ailey American Dance Theater in recognition of the Company's significant contribution to American dance. The Award celebrates recipients that bring respect, stature and distinction to the field of dance.

Sylvia Waters is honored with a New York Dance and Performance ("Bessie") Award for Sustained Achievement in recognition of her outstanding commitment to young and emerging artists as Artistic Director of Ailey II.

Ailey II performs for an audience of 4500 as part of the Lincoln Center Out of Doors festival.

The Ailey returns to the world-famous Apollo Theater for the first time in nine years for a one-night-only gala performance and reception.

Denise Jefferson is named president of The National Association of Schools of Dance.

2004

The United States Postal Service issues a first-class postage stamp honoring Alvin Ailey as part of the American Choreographers stamp series, which also includes George Balanchine, Agnes Mille, and Martha Graham.

Denise Jefferson celebrates her 30th anniversary at The Ailey School and marks 20 years as School Director.

Executive Director Sharon Gersten Luckman receives the Encore Award for excellance in arts management from the Arts & Business Council.

Fall international tour to China, Singapore, and Hong Kong arranged by Paul Pzilard in his 35th tear with the company.

Ailvin Ailey American Dance Theater's new building (Joan Weill Center for Dance), the nation's largest facility dedicated exclusively to dance, opens at 55th Street and 9th Avenue in Manhattan.

Love Stories, a ballet choreographed in three sections by Judith Jamison, Robert Battle, and Rennie Harris, premieres during the Company's annual New York season.

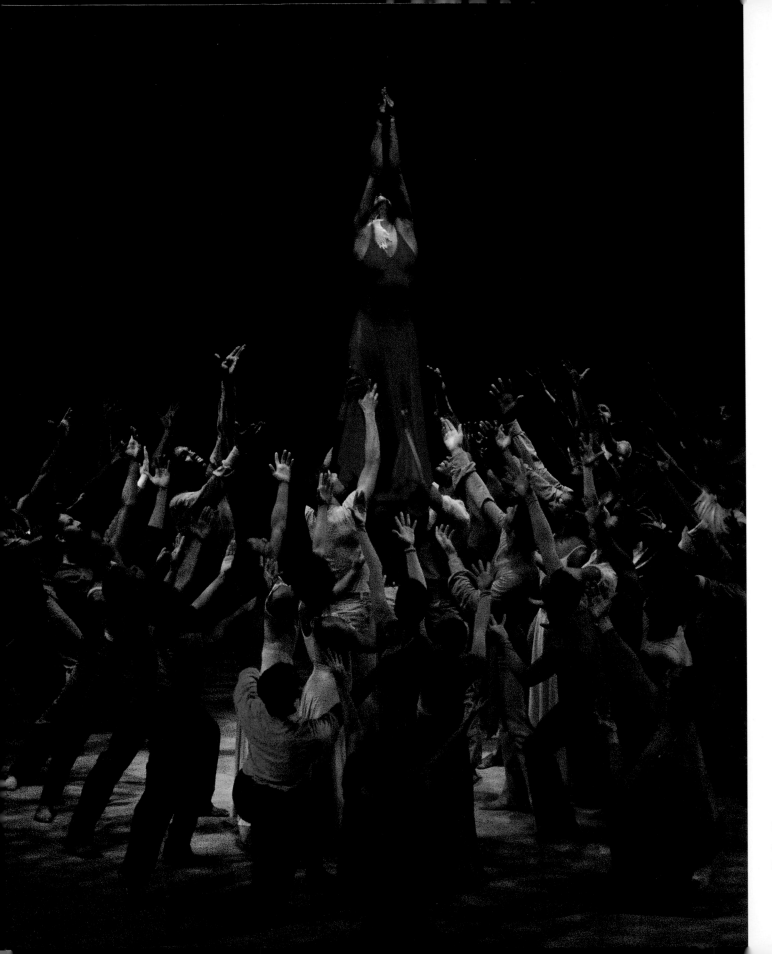

LEFT: Donna Wood in
Alvin Ailey's *Memoria*, 1981.

Photographer: Jack Vartoogian

Acknowlegments

The members of the Alvin Ailey American Dance Theater, foundation, school, and camp gave their time and energy, as well as tapped their memories, to help create this book. Thanks are due to, among others: Amadea Edwards Andino; Mickey Bord; Stephen Brown; Masazumi Chaya; Joe Chiplock; Samuel Coleman; E.J. Corrigan; Ronni Favors; Jennifer Fyall; Joe Gaito; Justin Garlinghouse; Dr. Guido Goldman; James Grant; Calvin Hunt; Tracy Inman; Denise Jefferson; Orna Jones; Rachel Knowles; Jodi Pam Krizer; Keith Lewis; Sharon Gersten Luckman; Ethel Newbold; Beth Olsen; Sathi Pillai-Colucci; Bennett Rink; Lynette Rizzo; Pamela Robinson; Kathleen Rose; Nasha Thomas-Schmitt; Joanna and Nick Vergoth; Sylvia Waters; and Christopher Zunner.

The text for the book was built on sharing; not only memories and experiences, but also feelings, patience, and time. Thanks to the many people, both in and out of the dance world, who gave these things and much more: Thomas de Frantz; Carmen de Lavallade; Geoffrey Holder; Siobhan Dunham; Bonnie Egan; André Knights; Earle Mack; Judith, Samuel, and Elizabeth Peabody; Annie Readick; Dr. Malcolm Reid; the Richardson family; Rosalie Wilson; and Mary Ellen Tracy.

Thanks to the creative publishing group at Stewart, Tabori & Chang, especially Anne Kostick, Galen Smith, Anne Kerman, and publisher Leslie Stoker, who made this book a reality. Peg Haller, Amanda Wilson, Danny Maloney, Diana Trent, Amanda Darrach, and Eileen Conlan also played vital roles.

And first, last, and always—thanks to Judith Jamison.

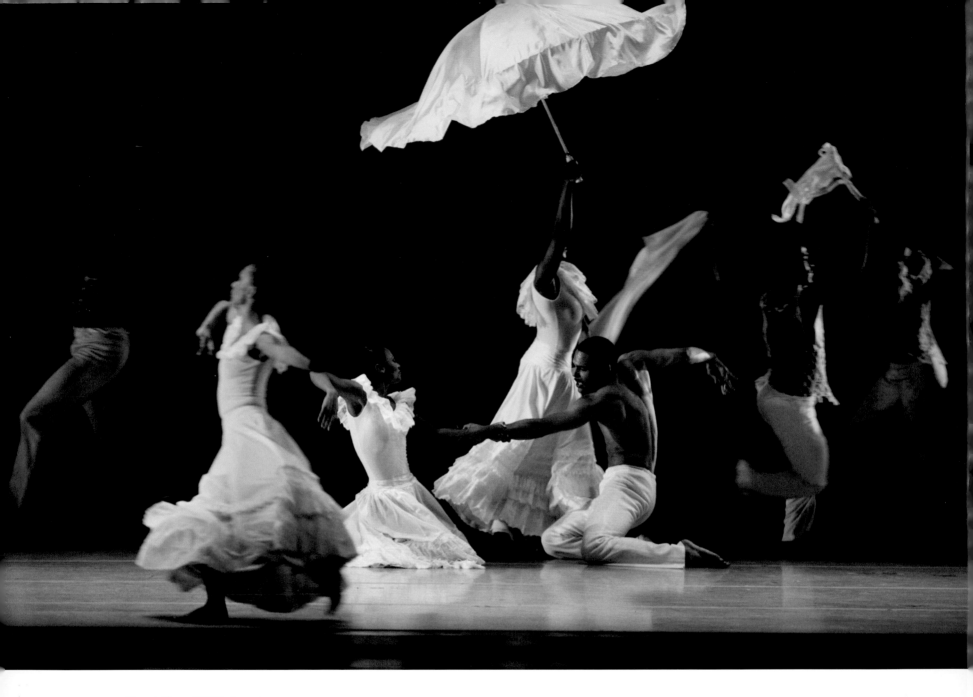

Revelations, 2003; Jamar
Roberts, Laura Rossini,
Linda Celeste Sims, Benoit-
Swan Pouffer, Samuel
Deschauteurs, Juan-Antonio
Rodriguez.
Photographer: Basil Childers

Photography credits

Alvin Ailey Dance Foundation Archives: Pages 29 (right), 108 (top right), 144 (right)/ courtesy of Alvin Ailey Dance Foundation Archives

Alan Bergman: Page 41/ copyright © Alan Bergman, courtesy of Alvin Ailey Dance Foundation Archives

Kwame Brathwaite: Page 142 (bottom)/ copyright © Kwame Brathwaite

Basil Childers: Pages 35, 125 (right), 150 (left), 166/ copyright © Basil Childers

Ellen Crane: Page 137 (left)/ copyright © Ellen Crane

Anthony Crickmay: Page 153/ Theater Museum, London, copyright © V&A Images

Zoe Dominic: Pages 22 (left), 37 (upper left), 42-43/ copyright © Zoe Dominic, courtesy of Alvin Ailey Dance Foundation Archives

Andrew Eccles: Pages 54, 68, 110, 121, 154-155, 160/ copyright © Andrew Eccles

Johan Elbers: Pages 6-7, 8, 30-31, 58, 61 (right), 70, 76, 89 (top right), 90, 101, 102-103, 106-107, 146/ copyright © Johan Elbers

Tamesha Eley: Page 117/ copyright © Tamesha Eley, courtesy of Alvin Ailey Dance Foundation Archives

Fred Fehl: Pages 46-47, 116, 140 (right)/ copyright © Fred Fehl, courtesy of Alvin Ailey Dance Foundation Archives

Iu + Architects LLP: Pages 142 (top), 143/ courtesy of Iu + Bibliowicz Architects LLP, renderings by Darin Gregory Reynolds

Paul Kolnik: Pages 11, 12-13, 34, 37 (bottom left), 49, 55, 57, 78, 80, 82-83, 84-85, 87, 98, 108 (upper left, middle left, bottom right), 109 (top left, bottom left), 120, 123, 126-127, 131, 132-133 (all), 134, 139, 145, 148-149, 150-151/ copyright © Paul Kolnik

Gert Krautbauer: Page 88 (left), 89 (bottom right), 109 (bottom right)/ copyright © Gert Krautbauer

Janet P. Levitt: Page 99/ copyright © Janet P. Levitt

Nan Melville: Page 115/ copyright © Nan Melville

Jack Mitchell: Pages 14, 20 (right), 25, 28, 29 (left), 32, 38, 42 (left), 51, 59, 60 (bottom right), 66, 67, 69, 104 (left), 129, 141/ copyright © Jack Mitchell

James O. Mitchell: Page 18, 19/ copyright © James O. Mitchell, courtesy of Alvin Ailey Dance Foundation Archives

Laurie Richards: Page 20 (left)/ copyright © Laurie Richards, courtesy of Alvin Ailey Dance Foundation Archives

Beatriz Schiller: Pages 5, 56, 71, 81 (top), 94, 95, 97, 136 (right), 137 (right), 144 (left)/ copyright © Beatriz Schiller

Marbeth Schnare: Page 136 (left)/ copyright © Marbeth Schnare

Eric Smith: Pages 22-23/ copyright © Eric Smith, courtesy of Alvin Ailey Dance Foundation Archives

Jack Vartoogian: Pages 2, 21, 27, 36 (both), 48, 50 (both), 52, 53, 60 (bottom left and top right), 61 (left), 62, 72 (both), 73, 74-75, 77, 79, 81 (bottom), 86, 88 (both), 89, 104-105, 100, 118 (both), 122, 124-125, 128, 130, 140 (left), 147, 149 (right), 164/ copyright © Jack Vartoogian/ FrontRowPhotos

Linda Vartoogian: Page 37 (bottom right)/ copyright © Linda Vartoogian/ FrontRowPhotos

Roy Volkmann: Page 119/ copyright © Roy Volkmann, all rights reserved

Rose Mary Winckley: Pages 33, 44/ copyright © Rose Mary Winckley, courtesy of Alvin Ailey Dance Foundation Archives